Views of Windsor

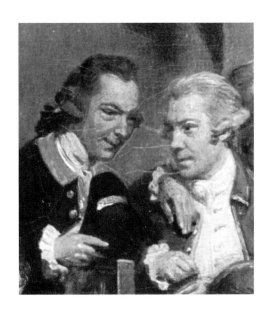

Views of Windsor

WATERCOLOURS
BY THOMAS AND PAUL SANDBY

FROM THE COLLECTION OF HER MAJESTY QUEEN ELIZABETH II

JANE ROBERTS

MERRELL HOLBERTON
PUBLISHERS LONDON

Published to accompany the exhibition
Views of Windsor: Watercolours by Thomas and Paul Sandby
at the following locations:

Amsterdam, The Rijksmuseum
3 June – 13 August 1995

Portland, Oregon, The Portland Art Museum
4 February – 21 April 1996

Memphis, The Dixon Gallery and Gardens
5 May – 7 July 1996

Dallas, Dallas Museum of Art
14 July – 29 September 1996

Manchester, The Whitworth Art Gallery
24 October 1996 – 4 January 1997

Text by Jane Roberts, Oliver Everett and Alan Donnithorne
and reproductions of all Royal Collection items
copyright © 1995 Her Majesty Queen Elizabeth II

First published by Merrell Holberton Publishers Ltd.,
Axe and Bottle Court, 70 Newcomen Street, London SE1 1YT

ISBN 1 85894 021 4 (paperback)
ISBN 1 85894 020 6 (hardback)

Produced by Merrell Holberton
Designed and set by Roger Davies
Printed and bound by Graphicom, Vicenza

Front cover: detail of cat. 19

Back cover: detail of cat. 8

Half title: Paul and Thomas Sandby,
detail of *The Royal Academicians,* 1771–72,
by Johann Zoffany,
Royal Collection (Millar 1210)

Titlepage: detail of cat. 8

Contents

Preface

In the eighteenth century watercolour painting became an independent and highly appreciated form of art, and watercolours were for the first time displayed alongside gouaches and oils at exhibitions in London. Following in the footsteps of his elder brother Thomas, Paul Sandby played an important rôle in bestowing a professional status on watercolour painting, both as a teacher and as a Royal Academician. After his death in 1809 Paul Sandby was termed "the father of modern landscape painting in watercolours".

Among the many treasures on paper in the Royal Collection at Windsor Castle, the watercolours by the Sandby brothers, especially those of the younger brother Paul, occupy a special place. The Collection contains the largest extant group of works by these artists, and the majority of these works originated in and around the Castle. It is with gratitude that the directors of the participating museums present to the public a selection of these works from the collection of Her Majesty Queen Elizabeth II.

While in past centuries the British have assembled impressive numbers of works of art by Continental artists, other countries have often failed to enrich their collections with works by British artists. Only during this century has British art been collected on a broader scale outside the United Kingdom, not only in the United States, but also, although to a lesser extent, in Europe. However, the public outside Britain does not often have the opportunity to see works by British artists. For this exhibition watercolours by two artists, Thomas and Paul Sandby, who elevated this art form and excelled in the medium have been selected. It is the first travelling exhibition of works by these artists to be arranged by the Royal Library.

The idea for this exhibition originated with J.W. Niemeijer, formerly Director of the Print Room at the Rijksmuseum, Amsterdam, and Oliver Everett, Librarian at Windsor Castle. The plans were developed in collaboration between The Hon. Mrs Roberts, the Curator of the Print Room at Windsor, Miss Theresa-Mary Morton, Curator of Exhibitions at Windsor, and the present Director of the Print Room at Amsterdam, Peter Schatborn. Mrs Roberts is also the author of the catalogue and we are very grateful for the beautifully illustrated book she has produced on this occasion, and to the publishers Merrell Holberton.

In Amsterdam the exhibition marks the seventy-fifth anniversary of the Genootschap Nederland Engeland, a society which fosters friendship and broadens cultural relations between the Netherlands and Britain. After its showing in Amsterdam the exhibition will travel to three museums in the United States, The Portland Art Museum (Oregon), The Dixon Gallery and Gardens, Memphis (Tennessee), The Dallas Museum of Art (Texas), and finally to the Whitworth Art Gallery in Manchester, England. The directors of the American Museums are grateful that this selection of watercolours is to be shown in their galleries where it will be appreciated by a large audience. The Director of the Whitworth Art Gallery also expresses his gratitude for being allowed the opportunity of presenting this exhibition in Manchester as the last venue of its tour.

HENK VAN OS
General Director
The Rijksmuseum

JOHN E. BUCHANAN JNR.
Director
The Portland Art Museum

KATHERINE C. LAWRENCE
Acting Director
The Dixon Gallery and Gardens

JAY GATES
Director
Dallas Museum of Art

ALASTAIR SMITH
Director
The Whitworth Art Gallery

Foreword

The Royal Collection of 20,000 Old Master drawings and 10,000 watercolours, which has been housed in the Royal Library, Windsor Castle, since the 1830s, is best known for its incomparable holding of Italian drawings from the fifteenth to the eighteenth century. But it also contains a comprehensive holding (about 550 works) by two British artists, Thomas and Paul Sandby, who occupy an important position in the history of painting in watercolour. In 1764 Gainsborough described Paul Sandby as "the only Man of Genius ... [for] *real Views* of Nature" and an obituary of 1809 referred to him as "the father of modern landscape painting in water-colours". Both Paul and his elder brother Thomas were founder members of the Royal Academy in 1768 under its enthusiastic royal patron, King George III (1760–1820).

It is most fortunate for the Royal Collection that in 1746 Thomas Sandby entered the employment, as military topographer and architect, of George III's uncle, Prince William Augustus, Duke of Cumberland. In the same year the Duke won his famous victory against Bonnie Prince Charlie at the Battle of Culloden. Later in 1746 he was made Ranger of Windsor Great Park and it is this which brought Thomas Sandby to live in the Great Park for the latter part of the eighteenth century. Indeed he occupied a house close to the Duke's Windsor residence, Cumberland Lodge, in the heart of the beautiful Park. Thomas's house, which became known as the Deputy Ranger's Lodge, has an endearing link with the present day since it is now, albeit in a considerably changed form and renamed Royal Lodge, the Windsor home of Queen Elizabeth The Queen Mother.

Windsor Castle had for centuries been a major symbol and residence of the British Royal Family. King George III developed a particular attachment to Windsor and took much interest in the Castle and in the development of farms in the Great Park. He looked upon Windsor as his country home, where he could live an informal life as a country squire. It was therefore fitting and fortunate that Thomas and Paul Sandby, two leading landscape watercolourists, should come to Windsor. Although Paul did not reside there, he often came to stay with his brother and between them they made a superb record in numerous watercolour paintings of what the Castle and its neighbourhood looked like at the time when George III was taking such an interest in it.

It is, however, a mystery and an irony that none of the many Sandby watercolours in the Royal Collection can be proved to have been acquired by George III. A large number were bought by his son, George, from 1799 onwards – as Prince of Wales, Prince Regent and, from 1820, King George IV – who loved Windsor too, but in a different way from his father. He looked upon it as an additional means to illustrate and demonstrate the power, success and grandeur of Britain and its monarchy by enlarging the Castle's architectural outline in a grand Gothic style. These are the external features of the Castle which the visitor sees today and it is fascinating to compare them with the Sandby watercolours of the more modest Castle in the latter part of the eighteenth century. As Prince Regent, George IV also took over Thomas Sandby's house in the Great Park in 1811 and had it converted by John Nash into an elaborate *cottage orné*, as his Windsor country residence.

The Royal Collection in large part reflects the tastes of successive Sovereigns. The Royal Family's interest in and enthusiasm for watercolours of Windsor by the Sandby brothers has continued until the

present day. The present Queen and Queen Elizabeth The Queen Mother have both acquired a number of their works.

For all the above reasons the present exhibition is a particularly appropriate one to be organized by the Royal Collection. I am most grateful to our colleagues in Amsterdam, the United States and Manchester for providing the opportunity to show this exhibition. It has been a great pleasure working with them. I would also like to express my gratitude to my colleagues in the Royal Library who have worked so well on this project. Jane Roberts, Curator of the Print Room and author of this catalogue, has been interested in the Sandbys' works during the twenty years she has lived and worked in Windsor. Her study of them also forms part of her fascinating book on the Gardens and Parks of Windsor which is to be published soon. Alan Donnithorne, the Royal Library's Chief Restorer of Drawings, has made an admirable study of the media, paper, watermarks and mounts associated with the Sandbys' work. Julian Clare and David Westwood have made valuable contributions to the preparation of the exhibits; and Theresa-Mary Morton has applied great energy, enthusiasm and hard work to the many administrative details of the exhibition.

Particular thanks are also due to T. Rogers & Co., Shipping and Forwarding Agents, and to Kent Services for their help and support for this exhibition.

<div align="center">
OLIVER EVERETT

Librarian, Royal Library, Windsor Castle
</div>

Author's Acknowledgements

This study of the Sandbys and of their contribution to the topographical history of Windsor Castle and its area has been assisted and encouraged by many colleagues, past and present, in the Royal Collection Department. The exhibited works have been conserved and prepared for exhibition in the Drawings Conservation Department at Windsor. The photographs of the Castle in the 1990s have been taken by Eva Zielinska-Miller.

Valuable discussions concerning various aspects of the work of the Sandby brothers have been held with John Balston, Anthony Browne, Mungo Campbell, Jessica Christian, Bill Drummond, Ann Gunn, Luke Herrmann, Yolande Hodson, James Holloway, Ralph Hyde, Anne Lyles, John Morton Morris, Patrick Noon, Charles Nugent, Roberta Olson, Margaret Richardson, Bruce Robertson, Georg Sauerwein, Peter Schatborn, Kim Sloan, Lindsay Stainton, Catherine Whistler and Andrew Wilton. Staff of the Paul Mellon Centre for Studies in British Art have also been continuously helpful.

Those who have generously shared their detailed knowledge of local history have included Roy and Dorothy Davis, Helen Hudson, John Mills and Eileen Scarff. Grateful thanks are offered to all of these.

All items in the Royal Collection are reproduced by gracious permission of Her Majesty The Queen. Her Majesty Queen Elizabeth The Queen Mother has graciously permitted the reproduction of three of the Sandby paintings in her collection (16.2, 26.1 and 39.2). Permission to reproduce items in their collections has been gratefully received from the following: National Trust, Anglesey Abbey (10.2), National Gallery of Ireland, Dublin (23.1), Staatliche Museen Greiz (2.2, 8.2, 15.1, 17.1, 25.2, 27.2), British Library Board, London (fig.9), British Museum, London (7.2, 7.3, 11.2, 18.1, 18.2, 18.4, 40.1, 42.3, 44.1), Courtauld Institute, University of London (2.1), Guildhall Library, Corporation of London (fig.8), Public Record Office, London (21.1, V.2, V.3), Victoria and Albert Museum, London, by courtesy of the Board of Trustees of the Victoria and Albert Museum (43.1), National Gallery of Victoria, Melbourne (9.2), Yale Center for British Art, New Haven (4.1, 12.1, 13.1, 17.2, 17.3, 18.3), Castle Museum and Art Gallery, Nottingham (23.2), The Bodleian Library, Oxford (45.1), The Musem of New Zealand Te Papa Tongarewa, Wellington, NZ (1.1). In addition, the Duke of Buccleuch and Queensberry KT (32.1, 36.3), the Duke of Northumberland (21.2), Thomas & Brenda Brod, Fine Paintings and Drawings, London (4.2), Mr and Mrs Paul Mellon (47.1) and two private collectors (20.1, 33.1) have kindly consented to the reproduction of works in their collections.

Introduction

I The early history of Windsor Castle

Windsor Castle is the oldest continuously occupied fortress in the world. Soon after the arrival in England of William the Conqueror (1066), a stronghold was built on the natural chalk outcrop which overlooked the River Thames at Windsor. This was one of a series of such bastions erected by the Normans in southern England. An earlier defensive structure may already have occupied the site on which the Castle was built. In addition to its importance as a strategically positioned stronghold, Windsor had an enduring attraction because of the great forest to its south. The various opportunities offered for sport in Windsor Park and Forest have been enjoyed by the sovereign from the early Middle Ages to the present day.

The Normans built their fortresses to a standard pattern based on a 'motte and bailey'. The motte was a massive, flat-topped mound of earth, surmounted by wooden defences and encircled by a ditch. Beyond the ditch lay the bailey, a spacious area where men and their animals could take refuge, and buildings could be erected for shelter. At Windsor the motte is still clearly recognisable in the mound surmounted by the Round Tower. Unusually, it was situated in the centre of the bailey, thus dividing the Castle into three parts: the Lower Ward to the west, the Upper Ward to the east, and the Middle Ward including the Round Tower and its ditch and the area in its immediate vicinity.

The original wooden structures were rebuilt in stone, and a proliferation of subsidiary buildings was erected. The stone curtain-wall surrounding the Castle was punctuated

Fig.1 John Norden, *Description of the Honor of Windesor*, 1607 (showing the Castle from the north with west to the right), watercolour and pen and ink on vellum, 16⅝" × 35⅛" (422 × 892 mm), Royal Library

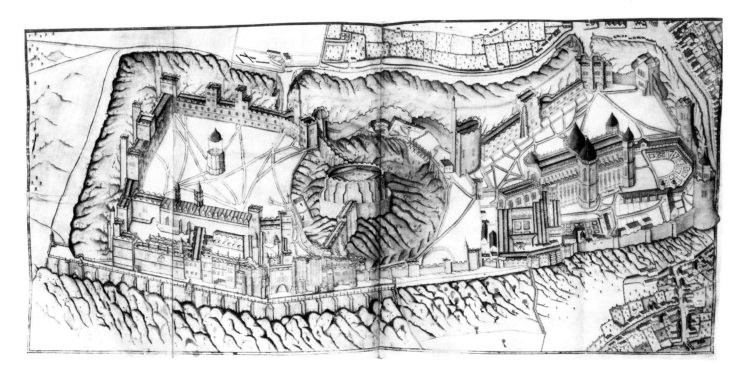

with towers. Those built during the reign of Henry II (1154–89) are rectangular in plan. Following the siege of 1216 some of the towers were rebuilt with curved outer faces. Thus, of the towers shown by Sandby, the square towers on the east front and the majority of those at the east end of the south front date from the twelfth century, while the curved outer faces of the Henry III Tower and Garter House (on the west end of the south front) and the Salisbury, Garter and Curfew Towers (on the west front) are basically thirteenth-century works. The position of the curtain wall established in the twelfth century has remained unchanged to this day and encloses an area of around ten acres.

Over the years, as the defensive requirements of these walls have diminished, the openings – whether gateways or windows – have increased in both number and size. The principal entrance to the Castle has probably always been through a gateway in the curtain wall in the south-western corner of the Lower Ward. The present gateway on this site (see 1, 2 and 24) is named after the monarch in whose reign it was erected, King Henry VIII (1509–47). It was built early in the reign and has remained largely unaltered. From the Henry VIII Gateway the visitor to the royal apartments would have proceeded up the Lower Ward, through another gateway (demolished before the Sandbys' time) into the Middle Ward. He would then have turned left before entering the Upper Ward through a third gateway adjoining the north wall of the Castle at the foot of the Round Tower. The present building on the site – the confusingly named Norman Gateway (see 11–13) – was erected *ca.* 1360 but replaces an older building. At an early date another entrance to the Upper Ward was introduced at its south-western corner: this was the so called Rubbish Gate, leading to the road between the town and the Little Park, to the south of the Castle ditch. This entrance was replaced in the 1820s by the King George IV Gate, situated slightly further to the east and on axis with the Long Walk.

The foundation of the Order of the Garter at Windsor in 1348 by King Edward III (1327–77) provided the incentive for a considerable programme of works at Windsor during the middle years of the fourteenth century. The buildings housing the royal apartments in the Upper Ward were renewed at this time, as was the tower adjoining the Rubbish Gate (see 15 and 28). The original constitution of the Order provided for twenty-six Poor Knights of gentle birth with a distinguished military record. The Knights – renamed the Military Knights in the 1830s – have remained an important part of the foundation. Their principal duty, to represent the Knights of the Garter at the services in St George's Chapel, has endured to the present day.

Several of the buildings in the Lower Ward shown by the Sandbys were works of the fifteenth century. A new Vicars' Hall (the present Chapter Library) was built *ca.* 1415, during the reign of Henry V. In 1475 the first king of the House of York, Edward IV (1461–83), began work on a splendid new chapel, the present St George's Chapel, in conscious emulation of the nearby Eton College Chapel, which had been generously endowed by his predecessor, Henry VI (of the House of Lancaster). During Edward IV's reign the Horseshoe Cloister was first laid out and the Curfew Tower was adapted as the belfry for the new Chapel (see 5).

Work on the Chapel continued well into the reign of King Henry VIII. In addition to the gateway which bears his name, this King also introduced a wooden 'wharf' or terrace along the north side of the royal apartments in the Upper Ward. This was replaced by a stone structure – the basis of the modern North Terrace – in the 1570s. Henry VIII reestablished the position of the Poor Knights, while halving their number. By the terms of his will, he provided for the accommodation of thirteen knights. It was left to his elder daughter, Queen Mary Tudor (1553–58), to carry out his wishes. Her name was subsequently given to the central tower of the southern range in the Lower Ward – the former belfry of St George's Chapel – which she transformed into accommodation for the Governor of the Knights (see 7). The houses to the east of this tower were converted into homes for six of the Knights, and a new range of six ashlar-faced houses was built between the Mary Tudor Tower and the Henry VIII Gateway.

During the reign of Queen Mary's younger half-sister, Queen Elizabeth I (1558–1603), the brick entrance gateway known as the Town Gate (see 25), leading to Castle Hill and the roadway along the south side of the Castle, was introduced. In the Upper Ward a new gallery was built at the west end of the north front, overlooking part of the strengthened North Terrace. The appearance of the Castle

in 1607, soon after the end of Queen Elizabeth's reign, is recorded in Table I of John Norden's pictorial *Description of the Honor of Windesor* (fig. 1).

Apart from Crane's Building, built *ca.* 1631–58 at the west end of the Lower Ward to accommodate five additional Poor Knights (see 8), little important work was carried out on the exterior of the Castle between 1607 and the reign of Charles II (1660–85). As part of that King's policy to enhance the image and position of the monarchy after the Civil War and Commonwealth, a major building campaign was initiated at Windsor. The appearance of the Castle at the time of the Restoration is recorded in a series of etchings by Wenceslaus Hollar, in particular one in bird's-eye view (fig. 2). The work of Charles II's builders was chiefly concentrated on the royal apartments in the Upper Ward, which

were refurbished by the architect Hugh May, assisted by the sculptor Grinling Gibbons and the painter Antonio Verrio. Between 1675 and 1680 a major part of the northern range of the Upper Ward was totally rebuilt to provide apartments for the Queen (to the south and west) and the King (to the north and east). This block – the so called Star Building – is clearly distinguishable in the Sandbys' views of the Castle from the north (for instance, 34 and 36), with the vast gilt Garter Star, 12 feet (3.7 m) in diameter, in its centre. The Sandbys' views of the North Terrace (including 16) also indicate the cusped edges of the broadened Terrace immediately opposite the Star Building.

At the same time considerable building and refurbishment work was carried out on the apartments allocated to the King's brother, the future King James II, in the eastern

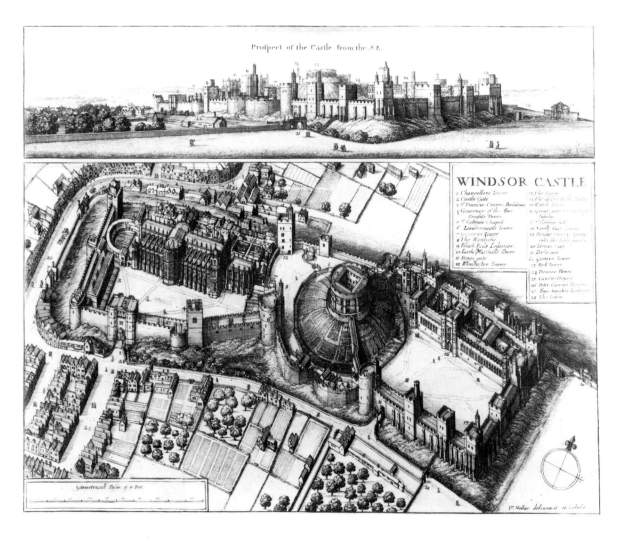

Fig. 2 Wenceslaus Hollar, *Bird's-eye view of Windsor Castle with (above) view of the Castle from the south-east*, *ca.* 1660, etching, platemark 12¼" × 14⅝" (311 × 371 mm), Royal Library (Parthey 1072)

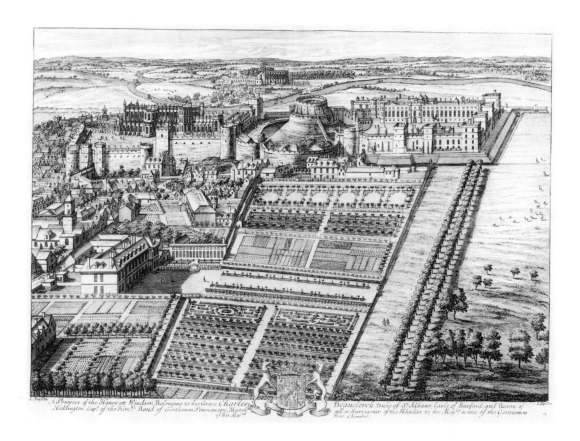

Fig. 3 Jan Kip after Leonard Knyff, *Burford House, Windsor, with a view of the Castle from the south, ca.* 1708, engraving, 12½" × 18¼" (317 × 464 mm), Royal Library

and southern blocks of the Upper Ward. The Terrace along the northern front was extended around the exterior of both the eastern and southern sides of the Upper Ward.

Comparison between Hollar's views of the exterior of the Castle in the mid-seventeenth century and the next reliable record of the appearance of the Castle, Knyff's semi-aerial prospect from the south (fig. 3) of around half a century later, shows that Charles II allowed May to tidy up and regularize the skyline in the Upper Ward. A hallmark of May's work was the substitution of the medieval pointed openings for round-headed windows. These can still be seen clearly in the Sandbys' views of the Quadrangle (15) and the exterior of the Upper Ward (28–31). Charles II's builders were also employed to repair some of the buildings in the Lower Ward. May's windows can thus be recognised in the watercolours of both the Salisbury Tower (3) and the Henry III Tower. But whereas they were later swept away from both the Quadrangle and the Salisbury Tower, they have survived in the Henry III Tower to this day.

These features of May's work have been retained – albeit very partially – in the Lower Ward because the great works commenced at Windsor by the architect Sir Jeffry Wyatville for George IV (1820–30) were concentrated in the Upper Ward. The historical accumulation of different building materials and styles, which is recorded by Sandby but was so effectively removed by Wyatville from much of the Upper Ward, has therefore survived until the present day in some, at least, of the remainder of the Castle.

II

Windsor Castle in the eighteenth century

Many of the changes and additions made at Windsor in the medieval and Early Modern period reflect the gradually changing rôle of the Castle from fortress and stronghold to home of the Royal Family. Queen Anne (1702–14) was only one of a long line of monarchs who enjoyed following the

hunt in the Great Park and Forest to the south of the Castle. While at Windsor she preferred to reside not in the Castle itself but in a small brick building to the south of the South Terrace which she had first used before her accession. When at Windsor, the Queen "would daily withdraw from the royal lodgings and the state and splendour of a victorious court to enjoy a happy retirement" in her "neat little seat" – described by Celia Fiennes as "a little box" – which came to be called the Queen's Garden House. The house, with a low building to the east, can be clearly seen immediately to the south of the Castle both in Knyff's view (fig. 3) and – somewhat enlarged – in Paul Sandby's of around sixty years later (29). Meanwhile to the north work was commenced on

an elaborate formal garden, the Maestricht Garden, which was to occupy the entire area between the Castle and the River Thames. A plan of the projected scheme, and of the somewhat shapeless pond which resulted from these uncompleted works, is shown at top right in Collier's plan of Windsor and the Little Park published in 1742 (fig. 4). A few years later Paul Sandby recorded the area in the foreground of one of his Windsor views (36).

Although the Castle had been used regularly by monarchs between the eleventh century and the beginning of the eighteenth century, neither of the first two Hanoverian kings, George I (1714–27) and George II (1727–60), was attracted to Windsor and both preferred to use Hampton

Fig. 4 W. Collier, *Plan of the Town and Castle of Windsor and Little-Park, Town and College of Eton*, 1742 (with north to lower right), engraving, 23" × 35" (584 × 890 mm), Royal Library

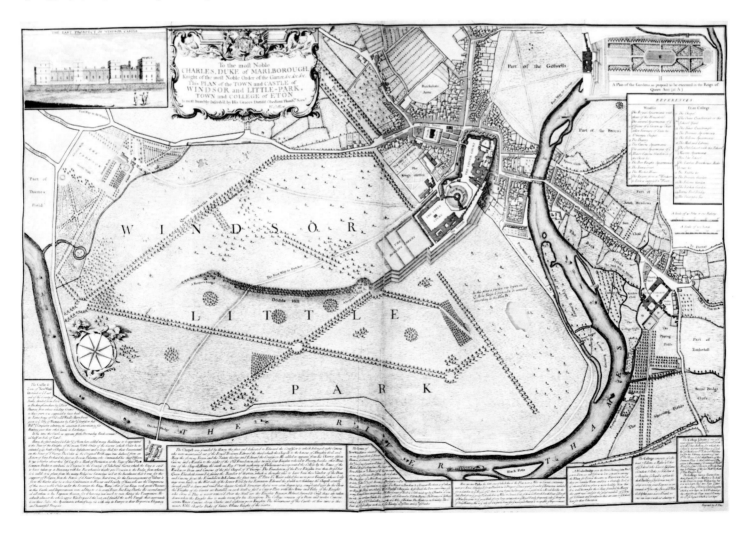

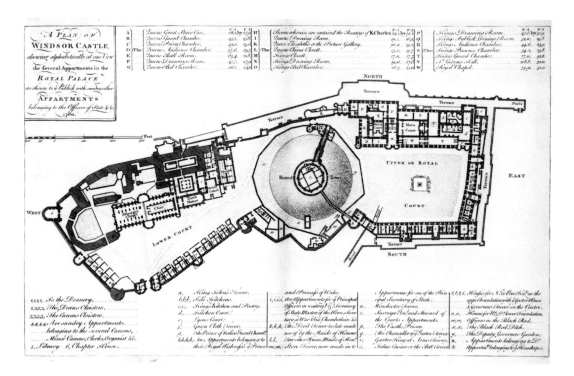

Fig. 5 R. Benning, *A Plan of Windsor Castle shewing Alphabetically at one View the several Appartments in the Royal Palace as shewn to ye Publick with sundry other Appartments belonging to the Officers of State &c &c*, 1760, engraving, 8½" × 14" (216 × 355 mm), Royal Library

Court Palace as their rural retreat. The royal apartments fell into disrepair and much of the east and south ranges of the Upper Ward were occupied by retainers (see fig. 5). The informality of the life in the Castle recorded by the Sandbys was a direct result of the prolonged absence of the Royal Family from Windsor.

Another symptom of this informality is the series of small, comparatively insignificant features introduced somewhat inharmoniously to the Castle during the first half of the eighteenth century, for which the Sandbys' views are sometimes the only visual records. These features included the pediments on the inside of the Town Gate (25) and over the entrance to the houses occupied by the Military Knights (3 and 7); the peristyled entrance to the Guardroom to the east of St George's Chapel (fig. 8); the new façade added to the apartment facing on to the Moat Garden by the Norman Gateway (11 and 12); and – in the Home Park – the wooden summerhouse (33). The sash windows shown by the Sandbys in many parts of the Castle were presumably also introduced at this time.

In 1776 King George III (1760–1820) decided that he and his growing family should return, on an occasional basis, to Windsor. They found that the Castle was uninhabitable

without the expenditure of large sums of money which the government was unwilling to make available. Queen Anne's house to the south of the Castle was brought into use again and was re-named the Upper or Queen's Lodge. As the Royal Family came to spend more and more time at Windsor, it was soon realised that additional accommodation was required, so Burford House – built for Nell Gwynn by Charles II to the south-west of the Castle, and the principal subject (in the left foreground) of Knyff's view (fig. 3) – was purchased from the Duke of St Albans in 1779 and was re-named the Lower Lodge. The Upper Lodge was enlarged at the same time (see fig. 6 and V.3) and finally apartments were prepared for the Royal Family in the Castle itself, resulting in a major refurbishing campaign in the eastern and northern blocks of the Upper Ward which was only completed in 1805. In the same way that Queen Anne had used her "neat little seat" as a retreat from the Castle, so (from the early 1790s) did George III's consort, Queen Charlotte, have her own retreat at nearby Frogmore. But Sandby does not record these features of Windsor life: the majority of his views of Windsor record the Castle as it was before 1776.

So far as the accessibility of the Castle and Parks to the public was concerned, there were few changes after 1776,

although the rules were perhaps more rigorously applied. Among the General Orders issued by the Castle Governor in 1781 were the following instructions: "The centries [*sic*] at the Round Tower, King's and Town Gates, are to keep every thing quiet about their respective posts. No beggars or disorderly persons are upon any account to be allowed to pass their posts and no coaches are to be allowed to stand in any of the Gate ways ... The sentries at the Kings Gate and Governor's door, are not to permit any servants or boys to gallop about the court. No Higglers to be allowed to bring any meat, fish or greens to sell in the Court yard of the palace, nor are any articles to be cried out for sale in any part of the palace. No beggars or disorderly persons women in red cloaks or pattens are to be allowed to walk upon the Terrace at any time" (Tighe and Davis, II, pp.539–40). The locking of gates and the introduction of fast-growing plantations to protect the Royal Family from the public gaze was instead the work of George III's more reclusive, but more flamboyant son and heir, King George IV (1820–30).

During the eighteenth century the Castle precincts were open to the public, and access was given to the State Apartments (in the Upper Ward) on application to the Housekeeper. In 1749 Joseph Pote of Eton received a royal licence to publish both his *History and Antiquities of Windsor Castle* (in quarto) and "a lesser work on the same subject, and extracted from the above History, in French and English, for the Use and Accommodation of Strangers, and other Persons who visit this Royal Castle". The latter work, a pocket edition in duodecimo, entitled *Les Delices de Windsore*, did not appear until 1755. The prices of Pote's two guides were 10s. 6d. (unbound) for the *History*, and 2s. (neat bound) for the *Delices*. The licence gave Pote exclusive rights of publication for fourteen years, until 1763. Pote's *History* included a plan "shewing Alphabetically at one View the several Appartments in the Royal Palace as shewn to ye Publick with sundry other Appartments belonging to the Officers of State &c &c" (fig.5), from which it is clear that the State Apartments open to the public in the 1990s are

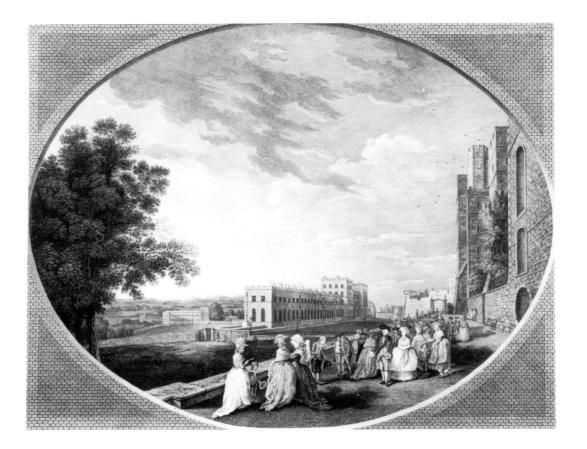

Fig.6 James Fittler after George Robertson, *South East View of Windsor Castle, with the Royal Family on the Terrace* and *A View of the Queen's Palace* (*i.e.* Queen's Lodge to the left), 1783, engraving, 17" × 22½" (432 × 572 mm), Royal Library

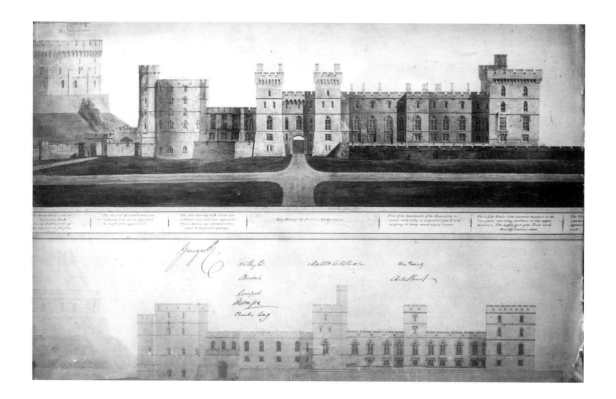

Fig. 7 Sir Jeffry Wyatville, *The southern façade of the exterior of the Upper Ward, (below) before and (above) after the architect's proposed alterations,* 1824, watercolour and pen and ink, 20½" × 32½" (520 × 825 mm), Royal Library (RL 18431)

virtually the same as those that could be visited in the eighteenth century. Although it is hard to identify any of the figures in Sandby's views as tourists – whether from England or elsewhere – the fact that Sandby continued to produce Windsor subjects, particularly views of the North Terrace (16 and 17), until the end of his life indicates the popularity of the Castle for visitors, and for collectors.

The introductory text to Pote's pocket guide rightly observed that the royal apartments visited by the eighteenth-century visitor were the creation of Charles II, in whose reign

the Face of the upper Court was intirely new changed, and brought into its present Order and Beauty, the Royal Lodgings were richly furnished, the Windows enlarged and made regular, a large Magazine of Arms for greater State was erected ... and the several Apartments were greatly adorned and decorated ...; insomuch that this Castle, for its Situation, State, and Grandeur, may justly vie with the most boasted Palaces of foreign Princes, and has constantly been the Admiration of all Visitors.

The Castle is divided into two Courts or Wards, with a large Keep or Round Tower between them, called the Middle Ward, being heretofore separated from the Lower Ward, by a strong Wall

and Drawbridge: The whole is of large Extent as is observed above, containing more than twelve Acres of Land, and has many Towers and Batteries for its Defence, though at present the Strength of this Castle is considerably abated, by the Currency of many Years, and from the Excellency of our national Constitution, whereby Fortresses and strong Holds are not thought necessary in this Kingdom, and a happy Union between the Prince and Subject is the great Security of both.

III

The later history of the Castle

Although work on the repair and refurbishment of Windsor Castle had been commenced by George III (in St George's Chapel (see 6) and the north and east ranges of the Upper Ward (see 9)) it was left to his son, George IV, to instigate the major rebuilding programme which transformed the Castle into a palace once again fit for a king. With the inspired assistance of the architect Sir Jeffry Wyatville (the

nephew of George III's architect, James Wyatt), major works were carried out in the Upper and Middle Wards between 1823 and 1840. Wyatville himself provided clear demonstrations of the changes which he sought to introduce so singlemindedly at Windsor (*e.g.* fig.7). The most recognisable feature of the Castle, the Round Tower, was given its present appearance *ca.* 1830, when it was heightened and a flag turret was added. Whereas Sandby's Windsor Castle was largely the creation of Charles II and Hugh May, the external appearance of the Castle enjoyed by so many visitors in the twentieth century is essentially the achievement of George IV and Sir Jeffry Wyatville.

In the reign of Queen Victoria (1837–1901), further works were undertaken in the Middle and Lower Wards. Wyatville had already regularized the appearance of the Military Knights' houses between the Henry III Tower and the Henry VIII Gateway (1830), and had replaced the brick walls and chimneys with stone constructions. After Wyatville's death in 1840, Edward Blore was employed to complete a number of projects. Blore rather than Wyatville is responsible for the present appearance of the Military Knights' houses and the Salisbury Tower. In the 1860s more incisive changes were introduced by the architects Anthony Salvin and George Gilbert Scott. The striking profile of the Curfew Tower and the austere inner façade of the new Guardroom at the western end of the Lower Ward are the responsibility of Salvin. Meanwhile Scott was employed to work on both the west and the east ends of St George's Chapel, and also largely rebuilt the Horseshoe Cloister. Very few changes have been made to the external fabric of the Castle in the hundred and twenty years since these works were undertaken, although the process of decay and replacement – shown so well in Paul Sandby's view of the Horseshoe Cloister (5) – has continued to the present day. Even the disastrous fire of November 1992, which destroyed many of the rooms in the north-eastern corner of the Castle, failed to make more than a minimal impact on the ancient walls of this great medieval stronghold.

IV
Thomas Sandby (1721/23–1798)

Little is known of the early years of the Sandby brothers. The family was based in Nottingham, a thriving market town around 120 miles (190 km) to the north of London. The boys' father, also called Thomas, was a framework knitter (a middle-class manufacturer). The younger Thomas was baptized on 8 December 1723; as his first works (designs for Deering's *Historical Account of Nottingham*; see also Herrmann 52p) are dated 1741 it is possible that he was born some time before the date of his baptism, and that the birth-date 1721 inscribed (many years after his death) on his tombstone is approximately correct. Both Thomas and Paul may have been apprenticed to Thomas Peat, a land surveyor in Nottingham (Colvin, p.713).

Deering's publication was produced under the patronage of John Plumptre, Member of Parliament for Nottingham; Plumptre was also Treasurer of the Board of Ordnance, the department of state responsible for the defence of the realm. After learning of Thomas's skill at perspective drawing, Plumptre appears to have arranged for his employment as Military Draughtsman in the Ordnance Office in the Tower of London, commencing in 1741 or 1742; Thomas continued to be paid by the Ordnance Office (at the rate of 2s. 6d., then 3s., per day) until his death, although he undertook no work for them after 1746. This early period in London was interrupted in April 1743, when Thomas was sent by the Board of Ordnance to Scotland for a period of around six months. According to an early source (Pasquin), he had returned to Scotland by the time of the arrival of the Young Pretender at Prestonpans in July 1745. In the first half of 1746 Thomas joined the household of William Augustus, Duke of Cumberland, Captain General of British land forces since March 1745, as Draughtsman at an annual salary of around £100. Works of this period include a plan and view (Oppé 150 and 151) of the Battle of Culloden (April 1746), when Cumberland won a decisive victory over the Jacobite forces.

Thomas Sandby followed the Duke south in the summer of 1746. He married Margaret Bowes in London on 2 December 1746; she may have died soon after for Thomas remarried, to Elizabeth Venables, in 1753. Between 1747 and

1748 Cumberland's household, including Sandby, was chiefly based in the Netherlands, during the final stages of the War of the Austrian Succession. As Draughtsman Thomas Sandby made watercolour records of the landscape in the different areas in which the British troops were camped (Robertson 17, 18a, 20; Oppé 155 and 156; British Library Add. 15968a-c; also Millar 600). These duties were adapted to the Duke's peacetime interests following his victorious return to England at the end of 1748: Cumberland had been appointed Ranger of Windsor Great Park in July 1746 and Thomas was soon put to work providing drawn and painted records of the Park (see 37, 42 and 44). Although three of the Park views are dated 1752, Thomas appears to have been based in Poultney Street, London, at that time and there are a number of watercolour views of London from the early 1750s (see fig.8). In February 1753 "Poet Tom and Painter Paul" issued their rhyming invitation to attend a sketching class at Poultney Street (Ramsden, p.15) and in December 1754 came Thomas's proposals for engraving the *Eight Views in Windsor Great Park* (fig.13). It is possible that by the latter date Thomas had left London to live at Windsor, where he was chiefly based for the next five years. Although he had rooms at both Cumberland Lodge and Cranbourne, the Sandby family appear to have lived initially at Clay Hall, Old Windsor (see fig.9 and Oppé 418/63).

However, Thomas retained close links with the London art establishment and in around 1760 he moved back to London, living first in St James's Palace and then, from 1761, in Great Marlborough Street. By mid-1765 he had returned again to Windsor where he lived continuously until his death in 1798.

The first reference to Thomas's activity as an architect occurs in 1759 when he is listed among the subscribers to Chambers's *Treatise on Civil Architecture* as "Architect to HRH the Duke". His name was included among the Architects appointed to the Committee of the new Society of Arts in 1760 and in December 1768 he became the first Professor of Architecture at the newly founded Royal Academy of Arts (see half-title illustration). The Professorship involved him in the delivery, every year from 1770 to 1796, of a series of six lectures; the lectures were illustrated by his own drawings, which included a view of the "Bridge of Magnificence" (see under Herrmann 45–47). Among other things, in these lectures Thomas Sandby demonstrated the advantages of the "perspective view" (as

Fig.8 Thomas Sandby (?), *The west front of Old Horse Guards, Whitehall, ca.* 1750, watercolour and pen and ink, 5" × 12¼" (125 × 310 mm), Guildhall Library, London (Pr W2/HOR)

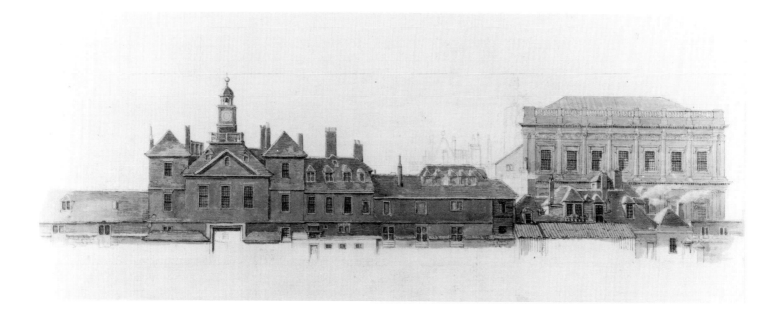

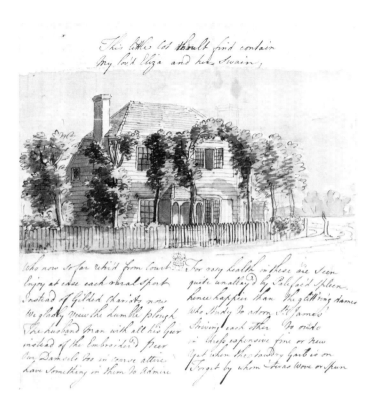

Fig. 9 Thomas Sandby, Verse letter to Theodosius Forrest with a view of the cottage at Clay Hall, *ca.* 1755, pen and ink and watercolour, 11⅞" × 7⅜" (302 × 187 mm), British Library, London (Add. MS 36994, f.2v)

opposed to a frontal view) of a building (Worsley, p. 23), another result of his exceptional talents in perspective drawing. There are large groups of Thomas Sandby's architectural drawings in the Soane Museum, London, the Bodleian Library, Oxford (Gough collection), and Vassar College (see Palmer), with smaller groups elsewhere (see Oppé and Herrmann).

From 1764 Thomas's position within the Duke's household was transformed for he became Steward to the Duke, and therefore effectively Deputy Ranger of Windsor Great Park, with a salary of £400. He is probably shown in this rôle in 37.1. After the death of William Augustus in October 1765, Sandby continued *en poste* and faithfully served the new Ranger, William Augustus's nephew, Henry Frederick, Duke of Cumberland, for the next twenty-five years, overseeing all aspects of the Park's management, paying wages and liaising with the Treasury over expenditure. From *ca.* 1770 he lived in a house in the Park, close to the Ranger's

residence, Cumberland Lodge (see 39 and 40). He was involved in local affairs and was named as chairman of the local Turnpike Trust in 1768 (information from John Mills). As well as designing buildings in the Park, he was the architect of a number of houses in the vicinity – for instance, St Leonard's Hill for the new Duchess of Gloucester (late 1760s). He was also very closely involved in works around Virginia Water in the 1780s and 1790s (see 45 and 46), and with designs for a new bridge at Staines (1792–97).

Meanwhile there are continuing references to projects away from Windsor, including several that called on Thomas's skills as an architectural draughtsman. Horace Walpole's new Gallery at Strawberry Hill was drawn by Thomas in 1770; the view was eventually completed (with the help of Paul and of Edward Edwards) in 1781 (Herrmann 44). The King sent Sandby to Cambridge to draw King's College Chapel in 1771, and in 1771 and 1772 his Royal Academy exhibits were London views not related to architectural projects; the beautiful views of New Somerset House under construction in the 1780s (LB 20, 22) are likewise not related to Thomas's own architectural work. In the mid-1770s he was commissioned to design a new house for William Locke at Norbury in Surrey and the Freemasons' Hall in Lincoln's Inn Fields, London. He was appointed, with James Adam, Architect of the King's Works in 1777; Sandby was promoted Master Carpenter in the Office of Works in 1780, but the post was abolished in 1782, the year in which work began on the new altar wall of St George's Chapel, Windsor (see 6).

It is clear from the catalogue of his posthumous sale that Thomas made numerous landscape sketches in Windsor and elsewhere. The few signed works from after 1760, together with his frequent collaboration with Paul, make it extremely difficult to distinguish the hands of the two brothers, particularly as Paul appears to have imitated Thomas's 'tight' style from the 1750s. The fact that from the 1750s Thomas worked contemporaneously in both a meticulous and dry style and a more fluid and loose one (compare 42 and fig. 9) compounds the problem. Colouristically, however, there appear to be certain clear distinctions between the two brothers' work: Thomas used an acid green (see 42 and 43) and a somewhat limited palette, whereas Paul used richer, denser and more varied colours.

From 1796 illness prevented Thomas Sandby from delivering his lectures at the Royal Academy. He made his will in April 1797 and died in June of the following year. The obituary notice in the *Gentleman's Magazine* for July 1798 was unstinting in his praise, stating that "By his decease, the King has lost an honest and valuable servant, the neighbourhood of Windsor an inhabitant universally esteemed, and his family and friends one of the gentlest and best of human beings".

V

Paul Sandby (1730–1809)

Paul Sandby was several years younger than Thomas. He was probably born at the end of 1730 for he was baptized in January 1731. The first secure information we have concerning his career is the date, 12 March 1746, *i.e.* 1747 (modern style), inscribed on the drawings which he submitted to the Board of Ordnance "as a Specimen of his performance" (see Herrmann 1 and LB 102–06). It may be no coincidence that Thomas Sandby was away from Britain (with Cumberland's forces in the Netherlands) from Spring 1747; Paul Sandby may have stepped (temporarily?) into Thomas's vacant position with the Board.

In September 1747 the Duke of Cumberland authorized the Survey of the Highlands, under David Watson and William Roy. Paul Sandby was intimately involved in the Survey: he was a member of one of the teams that surveyed the west coast and central Highlands during the first summers of the Survey, and was the Survey's chief draughtsman for about four years from its commencement (see Christian). But in addition to the making of maps and plans, Paul made quantities of topographical studies of buildings, especially castles, in Scotland and in 1747 his first etchings were published in London. By 1750 Paul's watercolours included both finely delineated buildings and characterful figures for unlike Thomas, Paul had an innate talent, practised throughout his life, for drawing and painting figures. Another talent, for making accurate records of the landscape, led to a small commission in March 1751 to make a series of views of Drumlanrig for the Duke of Queensberry. Very shortly after this date Paul left Scotland and appears to have spent the summer with Thomas at Windsor, beginning the series of interiors at Sandpit Gate Lodge (fig. 10 and Oppé 245–47). He had to return north in early 1752, to work on a reduction of the Military Survey, but left that project in the following autumn.

By 1753 Paul Sandby was closely involved with the group of artists, particularly engravers, of the St Martin's Lane Academy, who hoped to set up an official art academy; Paul himself issued a series of etchings entitled *The Analysis of Deformity* to counter Hogarth's *Analysis of Beauty*. His skill as an etcher and engraver was put to good use in the three plates on which he worked for Thomas's *Eight Views in Windsor Great Park* (*e.g.* 44.2). Meanwhile Paul's painting progressed too: a fine bodycolour dated 1755 (Guildhall Art Gallery, London, 836) seems to show the influence of Marco Ricci's paintings, both in technique and in subject matter. In 1757 the name of "Mr Paul Sandby, Painter" was listed among the subscribers to Chambers's *Designs of Chinese Buildings*, to which he had also contributed some engravings. In the same year Paul married Anne Stogden (died 1797); they had two sons and a daughter.

By 1760 Paul Sandby had a number of pupils, both aristocratic amateurs and professionals, and had issued various series of etchings, including several sets of *London Cries*. But his career as a painter was now to be assured, too. Paul's painting of *The Welsh Bard*, exhibited in 1761, was described with rapture by William Mason: "If it is not the best picture that has been painted in this century in any country I'll give up all my taste to the bench of Bishops" (Herrmann, p.23; see also Robertson, *Turner Studies*). The painting (which does not appear to have survived) was a relatively rare departure into subject painting. Paul's exhibits at the Society of Artists and the Royal Academy, nearly every year from 1760 to 1809, were chiefly landscapes. When his portrait by Francis Cotes was engraved in mezzotint in 1763 it was entitled "Paulus Sandby. Ruralium Prospectuum Pictor". In the following year Gainsborough wrote that he considered Paul "the only Man of Genius … [for] *real Views* from Nature" (Herrmann, pp.23–25).

Between 1763 and 1768 Paul exhibited a number of Windsor views, alongside views of other parts of the country. Among the few exhibited works that can be identified today is the *North-west view of Wakefield Lodge* of 1767 (Yale

Center for British Art, New Haven). Kentish views became plentiful after Paul's appointment in 1768 as Chief Drawing Master, at a salary of £150, at the Royal Military Academy in Woolwich (to the south-east of London); he continued in this position until 1796, when he was succeeded by his son Thomas Paul. After 1770 Paul made several visits to Wales, which were recorded in watercolours and reproduced in two series of aquatints (see Media, figs.6, 7), a medium which he first popularized in England. The 1773 tour of Wales was made in the company of Sir Joseph Banks, the great explorer and naturalist, who was the owner of many of the drawings shown here (see pp.136–38). Engravings of many of Paul's small-scale views of country houses and other sights throughout the land were issued as *The Virtuosi's Museum* between 1778 and 1781.

None of Paul's paintings is recorded in the collection of George III but, since both Paul and Thomas were founder members of the Royal Academy in 1768, they were certainly known personally to the monarch. In 1771 Paul was named in the list of subscribers to *Vitruvius Britannicus Volume the Fourth,* as Drawing Master to the Prince of Wales, but this association is otherwise undocumented.

Paul Sandby's home from 1772 was 4 St George's Row, Oxford Road, Bayswater, London (now 23 Hyde Park Place). There he had a studio, probably designed by Thomas (see Herrmann, p.41), in which lessons were given and *'conversazioni'* were held. Like Thomas, he was evidently a delightful companion and had many friends. He was a pall-bearer at Gainsborough's funeral in 1788, alongside Chambers, Reynolds, West, Cotes and Bartolozzi.

Paul's house was ideally placed when it came to recording the military encampments in Hyde Park and elsewhere from June to August 1780 following the Gordon Riots. But with the rise of the 'Picturesque' taste and of a new generation of artists including Girtin and Turner, Sandby's careful style became outdated, even though the old subjects were repeated over many decades in watercolour, in bodycolour and, in his last years, in oils. In 1808 Paul appealed to the Royal Academy for assistance, "owing to advanced age and infirmities and failure of employment" (Herrmann, p.64), but according to his son's *Memoir,* he continued to paint until a few days before his death in November 1809.

Paul Sandby made a considerable collection of paintings

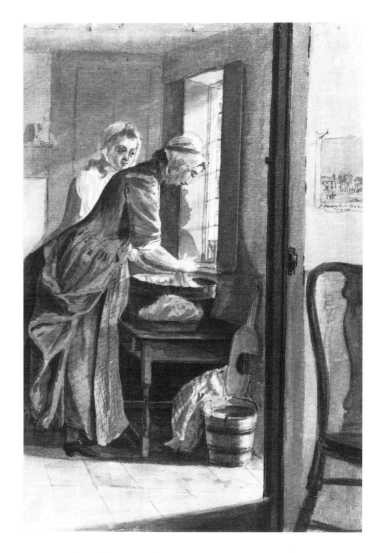

Fig. 10 Paul Sandby, *At Sandpit Gate*, 1750, watercolour and pen and ink over graphite, 9¼" x 6¾" (236 × 170 mm), Royal Library (RL 14330; Oppé 248)

and drawings by earlier masters (including Marco Ricci) and contemporaries (such as Richard Wilson). These works and the contents of his studio were disposed of in a series of sales from 1811. After the first of these sales Farington noted "There was a large Collection of drawings by the late P. Sandby. & I could not but sensibly feel the great difference between His works & those of Artists who now practise in Water Colours. His drawings so divided in parts, so scattered in effect – detail prevailing over general effect" (*Diary,* XI, p. 3922).

VI

Views of Windsor
by Thomas and Paul Sandby

The views of Windsor by Thomas and Paul Sandby included in this catalogue were produced over a period of around fifty years. They were executed as part of the recent tradition of drawn and painted views of great houses and their parks, developed in England during the early eighteenth century by artists such as Tillemans, Rigaud, Lambert and P.A. Rysbrack. As their *raison d'être* was the accurate depiction of Windsor, the views are here presented in topographical rather than chronological order. The collaborative nature of the working practice of Thomas and Paul Sandby means that it is often difficult – even impossible – to be certain which of the two was responsible for a particular work. However, in general it can be said that Paul was more concerned with the Castle and Thomas with the Great Park. It is possible to identify a few other salient features concerning their respective contributions by dividing their Windsor views into three groups.

The best known and largest of these groups comprises the views of the Castle by Paul Sandby, which appear to date from the 1750s to *ca*. 1800. Many of these can be related to the compositions of the eight Windsor Castle subjects which Paul exhibited at the Society of Artists between 1763 and 1768 (see Herrmann, p.69). His exhibits were almost certainly in bodycolour, and have been tentatively identified with paintings now widely dispersed but reproduced here as comparative illustrations (3.1, 4.1, 4.2, 12.1, 16.2, 17.2–3 and 30/31.1). Owing to the fragile nature of the medium of bodycolour and to the fact that this exhibition is travelling to various locations, the early Royal Collection bodycolours backed on panel (*i.e.* 3.1 and 30/31.1) have been omitted from this selection. However, the exhibition includes two fine early bodycolours backed on card of the Castle from the Little Park (31 and 34), and the *Rejoicing night* dated 1768 (19).

The success of the Society of Artists exhibits inspired Paul to repeat these and other early subjects in watercolour, on a smaller scale. These reductions form the core of the series of views of the Castle executed before the early 1770s, at which

time they were acquired by Sir Joseph Banks (1743–1820). Twenty-two items in this exhibition were formerly part of the Banks collection (see pp.136–37). Only one (22) is mainly in bodycolour and is therefore possibly identifiable as a Society of Artists exhibit. The remainder are watercolours, six of which (2, 3, 4, 12, 23 and 30) are reductions of identified bodycolours; others are small (28), medium-sized (5, 11, 14, 15, 24, 25, 26 and 27) or large, *i.e.* wide (8, 32, 33, 35 and 36) views which do not appear to be related to earlier subjects, although they were repeated afterwards.

The exhibition includes a small group of watercolours by Paul Sandby datable to the 1760s and 1770s not related to the Banks collection: 29 is possibly connected to one of Thomas's late equestrian commissions for the Duke of Cumberland (see further below, p.25) and 1 and 31 are repetitions of early bodycolours.

Paul's Windsor subjects were repeated throughout the 1770s, 1780s, 1790s and 1800s. A series of seven wide watercolours now at Drumlanrig were produced *ca*. 1780 for the Duke of Montagu, Governor of Windsor Castle 1752–90; these include repetitions of finished Banks watercolours (*e.g.* 32.1 and 36.2). Other Windsor subjects of the 1780s and 1790s were disposed of in the posthumous Sandby sales. Amongst these were views from the Black Rod (9 and 10), of the North Terrace (16 and 17), and of the Castle from Datchet Lane (20 and 21). With the passing of the meteor in 1783 (see 18) a variant was added to the view of the North Terrace looking east. Several other new Windsor subjects were introduced in connection with Thomas Sandby's residence from the 1770s in the Deputy Ranger's Lodge in the Great Park. Paul appears to have spent some time at his brother's Windsor home in 1792, leading to a series of watercolours of the woodyard which adjoined Thomas's house (see 41). Two views of the Lodge itself (39 and 39.2) probably date from the end of Thomas's life, *ca*. 1795–98.

Windsor Castle was for Paul Sandby what Venice was to Canaletto: an assemblage of buildings, some grand, some humble, views of which, produced and reproduced over several decades, had an instant appeal to the art-buying public. The Castle was recorded by Sandby from numerous angles and viewpoints. The most popular subjects were the Castle gates and the North Terrace, but Sandby was free to wander throughout the Castle and he recorded numerous

other less familiar aspects. Fifty-nine Windsor subjects were included in the Banks collection sale in 1876, each one probably a separate and individual view. To this we may add a further ten, to cover the subjects which do not appear to feature in the Banks sale but which are recorded among Sandby's drawings of the Castle. During recent conservation work faint studies for (or offsets of) previously unrecorded Windsor subjects were uncovered on the versos of 1 and 14.

The date of the first Sandby view of the Castle is unknown. A watercolour of Engine Court (Eton College collection) appears to be dated 1756 (see Herrmann, fig. 9 and p. 35, note 8). Some Windsor views may be even earlier, on the evidence of a small watercolour view of Old Horse Guards, London, demolished in 1750 (fig. 8). At this period Paul was based chiefly in Scotland while Thomas was in London and Windsor; if, as appears likely, the Horse Guards view is by Thomas, the elder brother's close collaboration with the younger for the early Windsor views seems certain. These views are a logical sequel to the sketches made by Thomas in London and by Paul in Scotland (and in particular Edinburgh), whence Paul moved to Windsor in the early 1750s. By the 1760s Paul's attention had become securely focussed on the Castle and the scale of each view was enlarged and the degree of finish advanced so that they could be exhibited, reproduced and sold as works of art in their own right.

The means by which Paul's Windsor subjects were repeated with such regularity (and success) can only be guessed at. From early in their careers both brothers had been involved in reproductive printing, and Paul produced a number of his own etchings. The ability (inherent in the process of designing and drawing on the etching plate) to produce sure and telling outlines was also used to produce pencil drawings of the Windsor views. Two series of pencil drawings of Windsor were offered for sale after Paul Sandby's death. Lot 20 of the third day of the 1811 sale consisted of twelve fixed pencil sketches of the Castle "in 1777"; it was purchased by Colnaghi for the Prince Regent and the drawings are now in the Royal Collection (see Oppé 1); they are closely associated with Paul's outline etchings of 1777. Lot 28 of the third day of the 1817 sale was a volume containing "a large collection of views of the Castle, and St George's Chapel at Windsor, taken before His Majesty's improvements, many from the surrounding country"; it was purchased by Harding, Queen Charlotte's librarian. It

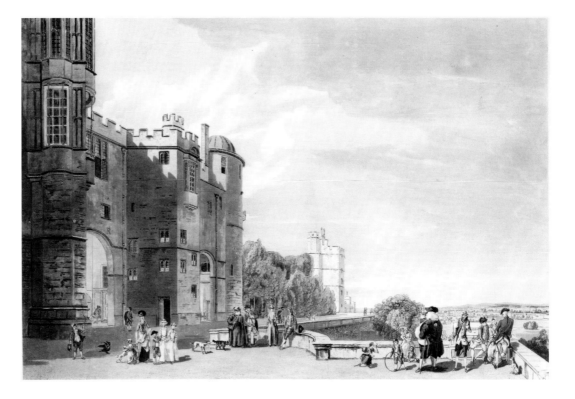

Fig. 11 Paul Sandby, *Windsor terrace looking westward*, 1776, hand-coloured aquatint, 11½" × 17⅜" (292 × 440 mm), Royal Library

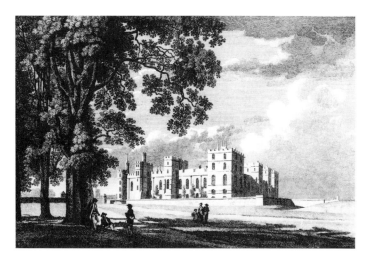

Fig. 12 Michael Angelo Rooker after Paul Sandby, *South East view of Windsor Castle*, published 1776, engraving, platemark 5⅛" × 7¼" (130 × 184 mm), Royal Library

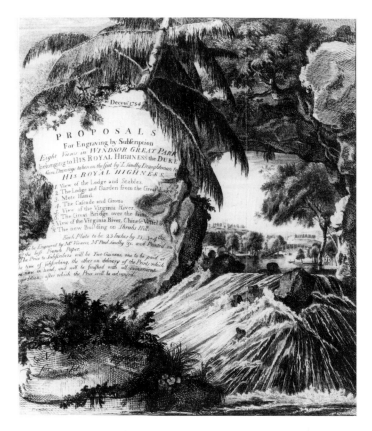

Fig. 13 Paul Sandby after Thomas Sandby, *Proposals for engraving the Eight Views*, 1754, etching and engraving, sheet size 12½" × 11" (316 × 278 mm), Royal Library

appears that this later (and larger) group of Sandby drawings is now contained in an album in the Staatliche Museen, Greiz (Thuringia). The Greiz album (for which see Becker) is part of the large group of papers from the collection of Princess Elizabeth (1770–1840), Landgravine of Hesse-Homburg and daughter of Queen Charlotte and King George III; it may have been taken to Germany following the Princess's marriage in 1818. Among its eighty or so drawings relating to Windsor are several associated with the watercolours in this exhibition (2.2, 8.2, 15.1, 17.1, 25.2 and 27.2). The album includes studies both of architectural details in the Castle (17.1) and of parts of the larger Sandby views (2.2 and 25.2). Although the preparatory studies may date from the 1760s (or even the 1750s), and individual drawings are dated 1768, 1775, 1776 and 1782, the majority of the Sandby drawings at Greiz are probably works of the 1770s, made to record a successful view (after a finished bodycolour or watercolour) and to prompt Sandby's memory, just as many of his surviving figure studies at Windsor and elsewhere (5.1, 25.1 and 38.2) are later *aides-mémoire* rather than studies from the life (7.3, 33.1, 36.2, 42.2, 42.3 and 47.1).

The pencil drawings were part of the working material of Paul Sandby's studio and were continuously added to as new subjects evolved. In addition, the artist made available printed reproductions of his works. The series of Windsor aquatints published in 1776 with a dedication to the Castle Governor, the Duke of Montagu (figs. 11 and I.1), and the Windsor views included in the *Copperplate Magazine* in the 1770s (*e.g.* fig. 12), would have appealed principally to collectors and visitors. However, the outline etchings of Windsor subjects issued in 1777, 1780 and 1782 (*e.g.* 7.2 and 11.2) would have served both as teaching aids to Paul's numerous pupils, and as (additional) reminders to the artist of his earlier painted views.*

The second group of Windsor subjects comprises the

* The most complete set of these views is contained in a volume (189*.b.2) presented in 1902 to the British Museum by William Sandby. In a manuscript note (dated 1872) inside this volume William Sandby explained: "Many others [*i.e.* prints by Paul Sandby] were merely outlines for what were termed 'tinted drawings', and were intended to be coloured, the first by the artist, and the remainder by his pupils, as studies and exercises in the art of colouring. As I possess specimens of these in Books of coloured Views, those only in mere outline are inserted in this Volume."

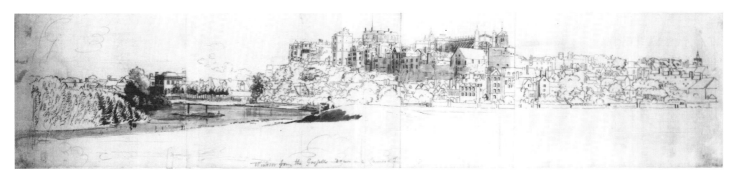

Fig. 14 Thomas Sandby, *"Windsor from the Goswells drawn in a Camera [obscura]"*, *ca.* 1770, pen and ink with watercolour and graphite, 4⅞" × 22¾" (124 × 577 mm), Royal Library (Oppé 78; RL 14602)

views of the Great Park and Cranbourne made by Thomas Sandby in the 1750s and 1760s in connection with three distinct projects for his patron, William Augustus, Duke of Cumberland (second son of King George II and Ranger of Windsor Great Park from 1746 until his death in 1765): first, a series of six landscape panoramas in watercolour of *ca.* 1752, to which 42 and 42.4 belong; secondly, the *Eight Views in Windsor Great Park*, with which 37 and 44 are closely associated – Thomas Sandby issued his proposals to publish this series of views (fig. 15) in December 1754 and the resulting prints, engraved by a number of artists including Paul Sandby, were probably released soon after (they were re-issued by Boydell in 1772); thirdly, a series of large watercolours illustrating Cumberland's equestrian interests, with particular reference to Windsor Great Park – of this series 47 was the only subject to be completed. Whereas five of the panoramas have remained in the Royal Collection, the originals of the *Eight Views* have not. Those elements of the last (equestrian) series which had been completed prior to Cumberland's death appear to have remained with the artist. Thomas Sandby was the commissioned artist for all three of these early projects but may have involved Paul increasingly in the execution of the individual subjects. The invention of the figures in 42, 44 and 47 is demonstrably the work of Paul, even if they were copied by Thomas (or, in the case of 47, by Sawrey Gilpin).

The last group of Windsor views contains the rather later work of Thomas Sandby, whose main home was Windsor between *ca.* 1755 and his death in 1798. Thomas's posthumous sale in 1799 included thirty-four lots of Windsor subjects. Most were described as views of the Park, or "from"

or "of" St George's Chapel; a few others, which remain unidentified, were entitled "Palace Yard", and some must relate to Thomas's architectural work in the Castle (*e.g.* Oppé 66–68). Thomas's later watercolours in this exhibition may be divided into topographical views and architectural designs. Among the former is the meticulous record of the Gothic architectural detail of St George's Chapel (6), the watercolour of his unfinished chapel at the Great Lodge (38), and a distant prospect of the Castle (43). Among the latter are the design for a castellated bridge (46) and a proposal for the new pondhead at Virginia Water (45).

The principal characteristic of Paul and Thomas Sandby's records of the Castle was their skilled mastery of perspective. Several eighteenth-century artists, including both Sandby brothers, also occasionally made use of a drawing aid known as a 'camera obscura' (see fig. 14 and Robertson 109–10). However, the ability to "draw after real Buildings without the use of Rules and Compasses, in the manner of the Landskip Painters" was recommended by Thomas Sandby to his students at the Royal Academy (Worsley, p. 24) and that ability was present to a remarkable degree in both the Sandby brothers. The almost photographic appearance of some of the Windsor views depends on an extraordinary amount of detailed drawing (in graphite and pen and ink) and control of the watercolour medium. Towards the end of the century Joseph Farington recorded that *"Accuracy* of drawing seems to be a principal recommendation to Sir Joseph [Banks]" (*Diary*, I, p. 113). Paul Sandby's views of Windsor (and elsewhere) would therefore have had a natural appeal to Joseph Banks, an appeal which they continue to exert to this day, over two hundred years later.

A PLAN OF WINDSOR CASTLE, shewing alphabetically at one View the several Appartments in the ROYAL PALACE as shewn to y.ͤ Publick with sundry other APPARTMENTS belonging to the Officers of State &c.
1760.

			F-I	F-I			
A		Queens Great Stair Case.	28.1.	by 27.0.	H		Room wherein
B		Queens Guard Chamber.	45.2.	27.8.	I		Queens Dresse
C		Queens Privy Chamber.	40.0.	23.0.	K		Queen Elizabeth
D	The	Queens Audience Chamber.	37.6.	23.7.	L	The	Queens China
E		Queens Ball Room.	63.4.	21.8.	M		Kings Closett
F		Queens Drawing Room.	45.7.	27.0.	N		Kings Dresse
G		Queens Bed Chamber.	26.1.	24.0.	O		Kings Bed Ch

Feet
100 50 0 100 200 300

Terrace

Guard Room

Deans Court

Tomb House

Round

Choir

St George's Chapel

WEST

LOWER COURT

1,1,1,1, As the Deanery.
2,2,2,2, The Deans Cloisters.
3,3,3,3, The Canons Cloisters.
4,4,4,4, Are sundry Appartments belonging to the several Canons, Minor Canons, Clerks, Organist &c.
5, Library. 6, Chapter House.

a, King John's Tower.
b,b,b, Side Kitchens.
c,c, Kings Kitchen and Pastry.
d, Kitchen Court.
e, Lyons Court.
f, Green Cloth Tower.
g, The Prince of Wales's Guard Chamb.
h,h,h,h, Are Appartments belonging to their Royal Highness's y.ͤ Prince

and Pr
i,i,i,i, Are Appa
Officers i
of State
tary at t
k,k,k, The De
use of by
l,l, Tow othe
m,m, Store

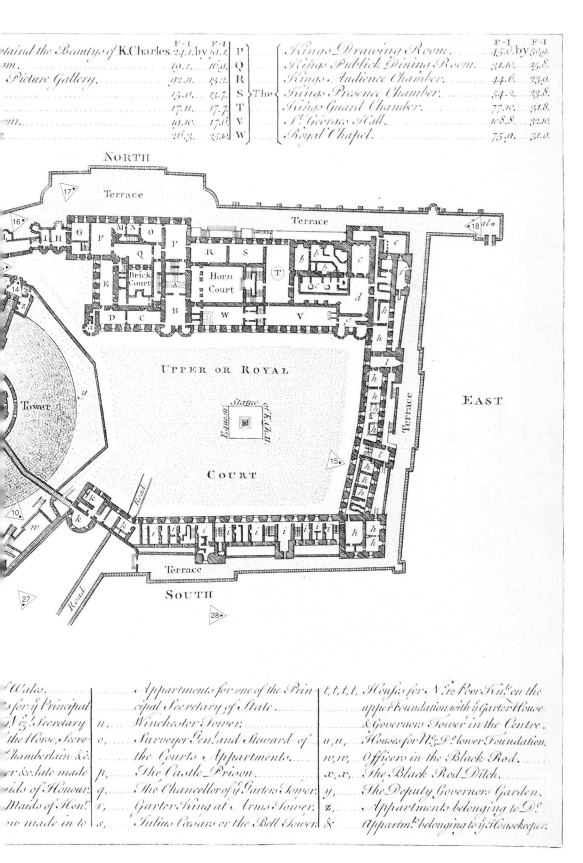

The Catalogue

	F-I	F-I				F-I	F-I
...taind the Beauty of K.Charles	24.1.	by 10.1.	P		Kings Drawing Room.	45.0.	by 30.9.
...m.	19.1.	16.9.	Q		Kings Publick Dining Room.	31.10.	25.8.
Picture Gallery.	92.11.	13.2.	R		Kings Audience Chamber.	44.6.	23.9.
	15.0.	13.7.	S	The	Kings Presence Chamber.	54.2.	23.8.
	17.11.	17.7.	T		Kings Guard Chamber.	77.10.	31.8.
...m.	19.10.	17.0.	V		S.t Georges Hall.	108.8.	32.10.
	26.3.	25.10.	W		Royal Chapel.	75.9.	31.0.

NORTH

Terrace

Terrace

UPPER OR ROYAL

COURT

Tower

Statue K.C.II

EAST

SOUTH

Road

Road

Terrace

...f Wales.		Appartments for one of the Prin-	t, t, t, t,	Houses for N.o 12 Poor Kn.ts on the	
...s for y Principal		cipal Secretary of State.		upper Foundation with y Garter House	
...viz.t Secretary	n,	Winchester Tower.		& Governors Tower in the Centre.	
...the Horse, Secre-	o,	Surveyor Gen.l and Steward of	u, u,	Houses for N.o D.o lower Foundation.	
...Chamberlain &c.		the Courts Appartments.	w, w,	Officers in the Black Rod.	
...r &c late made	p,	The Castle Prison.	x, x,	The Black Rod Ditch.	
...ids of Honour.	q,	The Chancellor of y Garters Tower.	y,	The Deputy Governors Garden.	
...Maids of Hon.r	r,	Garter King at Arms Tower.	z,	Appartments belonging to D.o	
...w made in to	s,	Julius Cæsars or the Bell Tower.	&,	Appartm.ts belonging to y Housekeeper.	

NOTE

In the following descriptions the measurements relate to the drawn sheet, excluding the mount; height precedes width. The reproductions show the whole sheet, within a line and wash border where this has survived. Different mount types are discussed on pp.142–43. The marks placed on the watercolours by King Edward VII's librarian have not been noted consistently.

In the plan on the left the white triangles indicate the viewpoints from which the watercolours in the catalogue were taken. The small black triangles inside the white triangles indicate where the artist was positioned: he looked out from the apex through the base of the white triangle.

27

I The Lower Ward

The main entrance to the Castle, the Henry VIII Gateway, leads from the town of Windsor into the Lower Ward of the Castle. According to Pote's *Les Delices de Windsore* (1755, pp. 5–6),

The Lower Court [or Ward] is larger than the Upper, and may be said to be divided into two Parts by St George's Chapel, which stands in the Middle [...]; on the South and West Sides of the outer Part of this Court, are the Houses of the Alms, or Poor Knights of Windsor; On the North, or inner Side, are the several Houses and Apartments of the Dean and Canons of St George's Chapel, also of the Minor Canons, Clerks, and other Officers of this Foundation.

In this Ward are also several Towers, belonging to the officers of the Crown when the Court is at Windsor; also to the Officers of the Order of the Garter, viz. the Bishop of Winchester Prelate, the Bishop of Salisbury Chancellor, and Garter King at Arms, but the Tower of this last Officer is at present in decay. A Company of Foot Guards constantly do Duty here under the Command of an Officer, but at all Times subject to the Constable or Governor of the Castle; to whom alone pertains the sole Command of the Place, or any Garrison here, as also of the Magazine of Arms, Stores, and Houses.

Of the towers mentioned in this description, the Winchester Tower is seen at the far right-hand edge of 8 and the Salisbury Tower at right in 3 (and in 25); traces of the ruinous walls of the Garter Tower are just visible at the far left in 4. The foot guards responsible for defending the Castle were housed in a rectangular late seventeenth-century building which abutted the east side of the old wall separating the Lower and Middle Wards and was therefore actually within the Middle Ward, as was the Winchester Tower. The pedimented portico leading into the Guard-room is shown to the right of centre in 8, but its relationship to the Chapel and the Deanery Garden is best understood in Sandby's aquatint entitled *Windsor Castle from the Lower Court on the 5th November*, published in 1776 (I.1), and related views (*e.g.* Oppé 36).

Pote described the make-up of the "Several Foundations within this Royal Castle" as follows (p. 8):

I. The Royal College of St George; which consists of a Dean, twelve Canons, or Prebends, seven Minor Canons, eleven Clerks, one Organist, one Verger, and two Sacrists.

II. The most noble Order of the Garter; which consists of the Sovereign and twenty-five Knights-Companions.

III. The Alms-Knights; who are eighteen in Number, viz. Thirteen of the Royal Foundation, and five of the Foundation of Sir Peter le Maire, in the Reign of King James I.

Few of the houses occupied by members of the College of St George were shown in Sandby's views (but see Oppé 46): the crowded arrangement of houses and gardens in the area to the north of the Chapel made it a less picturesque and popular subject than the rest of the Castle. However, the Horseshoe, or Singing Men's, Cloister, with the Curfew Tower in the background, and the entrance to that cloister from the south were the subjects of a series of fine water-colours and gouaches by Paul Sandby (see 5 and 4). These record the appearance of the thirteenth- and fifteenth-century tower and the late fifteenth-century cloister before their transformations respectively by Salvin in 1863 and by Scott from 1870. A rare interior view by Thomas Sandby of the choir of St George's Chapel (6) provides a precious (albeit unfinished) record of the Chapel at the start of the changes made with the active support of George III in the 1780s and 1790s.

Accommodation for the "Alms-Knights" (*i.e.* the Poor or Military Knights) was divided between two ranges occupying respectively the whole of the south wall of the Lower Ward (between the Henry III Tower and the Henry VIII Gateway) and the west wall between the Salisbury and the Garter Tower. The southern range (commenced in the fourteenth century and extended in the sixteenth) contained the houses of the twelve knights of the first (or royal) foundation, with the Governor's (or Mary Tudor) Tower in the centre (7), while the western range (built in the first half of the seventeenth century) contained the houses of the five knights of the second (or lower) foundation. These five houses were provided for in the wills of Sir Peter le Maire

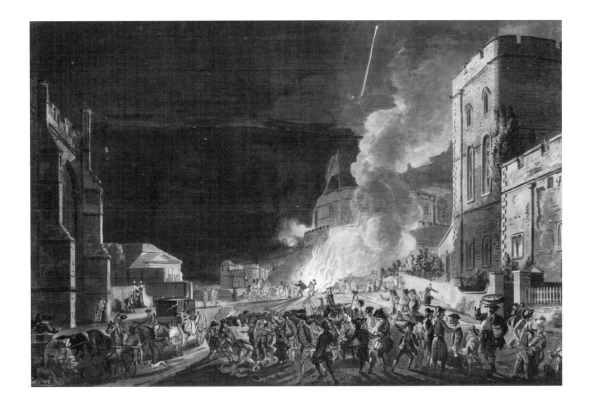

Fig.I.1 Paul Sandby, *Windsor Castle from ye Lower Court on ye 5th of Novr. 1776*, hand-coloured aquatint, 11⅝" × 17¼" (295 × 438 mm), Royal Library

(1631) and of his brother-in-law Sir Francis Crane (1635). A clear view of the newly completed Crane's Building is included in Hollar's etched bird's-eye view of *ca.* 1660 (fig. 2). It is also shown to the right of centre in Sandby's great view of the Lower Ward (8). The block was demolished in 1847; in 1863 its place was taken by Salvin's new Guardroom.

The main entrance to the Lower Ward was the Henry VIII Gateway (1). Confusingly, both this and the gateway to the south-east, at the entrance to the road along the south side of the Castle (see 25), were described as the Town Gate at varying times. For our present purposes, the main Castle entrance will be called the Henry VIII Gateway , and the lesser archway (no longer extant) to its south-east will be called the Town Gate. Pedestrian access to the Lower Ward was also provided by the Hundred Steps (see 23), scaling the northern face of the Castle and leading into the Canons' Cloister.

1. PAUL SANDBY

The Henry VIII Gateway with a view of St George's Chapel, ca. 1775

Watercolour and touches of bodycolour with pen and ink over traces of graphite, 13" × 18" (331 × 458 mm)
VERSO offset drawing of the Curfew Tower from the north and the houses below; the medium has the appearance of charcoal
WATERMARK countermark IV
MOUNT Type 1. Faintly inscribed in graphite: *Town Gate Windsor Castle.* Drawing inlaid into wash border during conservation, 1990
PROVENANCE Paul Sandby (sale, Christie's, 2 May 1811, lot 90); purchased (£3. 2s.) by Colnaghi for the Prince Regent (later King George IV); by descent
Oppé 26; RL 14548

1.1 Paul Sandby, *The Henry VIII Gateway with a view of St George's Chapel*, 1767, watercolour and bodycolour, 14½" × 18½" (368 × 470 mm), The Museum of New Zealand Te Papa Tongarewa, Wellington

The Henry VIII Gateway, the main entrance to the Castle from the Middle Ages to the present day, gave Sandby a number of artistic opportunities: the central arch could be used as a framing device for the vista beyond; the fall of light in the foreground contrasted with the more brightly lit area within the Castle walls; and the various activities of the foreground figures provided continuing interest to both the artist and his audience. A water-carrier's waggon is shown leaving the Castle, and an elegant carriage has just entered. A knife-grinder is at work on the right, while a chimney-sweep and his diminutive assistant wait by his side. The two military figures beside the sentry-box on the left of the arch are a reminder that in the eighteenth century, as today, the Castle was defended as a military fortress.

The Castle gateways were popular subjects with Paul Sandby. His first publicly exhibited view of Windsor Castle, at the Society of Artists in 1763, was *A gateway in Windsor Castle*. The title inscribed on the old mount of 1 ("Town Gate, Windsor Castle") is the same as that for one of his exhibits at the same institution five years later. It is possible that the gouache dated 1767 in the Museum of New Zealand (1.1) is the picture exhibited by Sandby in 1768, while 1 is a later variant. A further version of this popular view was reproduced in an engraving published in 1780 (no.4 of Sandby's series of *150 Select Views*). Although the gateway remains relatively unchanged in these views, the accompanying figures vary.

The view of the west end of St George's Chapel included in this watercolour, as in the other painted and engraved versions, can only be seen from a more advanced viewpoint than that from which the gateway itself is drawn; the juxtaposition shown here combines two separate viewpoints. Sandby's habit of employing his large stock of figure types, which would be traced, offset, enlarged or reduced from independent drawings and used in a variety of different compositions, occasionally resulted in the figures being out of scale – as in both the Windsor (1) and the Wellington (1.1) versions of this subject.

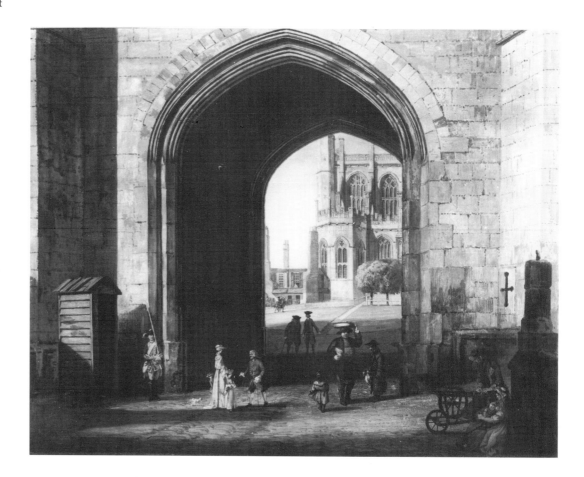

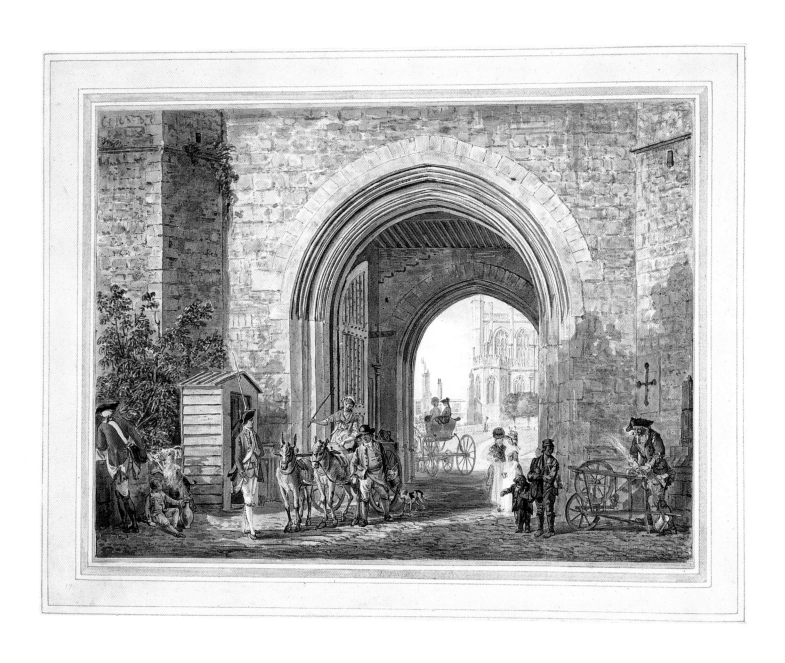

2. PAUL SANDBY

The Henry VIII Gateway from within the Lower Ward, ca. 1770

Watercolour and touches of bodycolour with pen and ink over traces of graphite, within black ink line, 11¼" × 14⅛" (285 × 359 mm)
Inscribed on placard in pen and ink: *Pray Remember the Poor Confin'd Debtors*
WATERMARK countermark IV
MOUNT later reproduction of Type 1
PROVENANCE Sir Joseph Banks; Sir Wyndham Knatchbull (sale, Christie's, 23 May 1876, lot 13); purchased (£7) by Holmes, the Royal Librarian
Oppé 28; RL 14550

This view is the reverse of the previous one and is taken from inside the Castle, looking out through the Gateway towards the town. Details in the right-hand area indicate the use of rooms over the gateway as prison cells. According to one of the guidebooks produced after Pote's copyright had expired (*Windsor and its Environs*, 1768), "The Constable [of the Castle], as a civil Officer, is Judge of a Court of Record, held by Prescription over the Town Gate [Henry VIII Gateway] in the Lower Ward, for the Determination of Pleas between Party and Party, within the Precincts of Windsor Forest, which comprehends many Towns, over which this Court has Jurisdiction." A prisoner is here shown behind a grille top right, holding a long rod from which is suspended a bucket, in which he presumably hopes to receive some sustenance. A wall tablet below his window is inscribed: "Pray Remember the Poor Confin'd Debtors". In 1790 a correspondent wrote to the *Gentleman's Magazine* to complain that the prison was "a disgrace, not only to the sight, but to the feelings", and it was removed soon after.

Numbers 2–4 belong to the series of small watercolours of the interior of the Castle from the collection of Joseph Banks; each is related to a more finished version of the same view in bodycolour. The bodycolour related to 2 is in the Courtauld Institute collection (2.1). It may be a companion to the reverse view in Wellington (1.1); both are dated 1767.

In its turn, 2 is rather more worked up than the fine preparatory study of the same subject also in the Royal Collection (Oppé 27), but remains more sketchy and chromatically limited than other Castle views. Typically, the figure content of the different versions of this view varies considerably. There is a pencil outline drawing of the central area of 2 at Greiz (2.2); it excludes both a vertical strip at the right and the figures.

2.1 Paul Sandby, *The Henry VIII Gateway from within the Lower Ward*, 1767, watercolour and bodycolour, 14½" × 18½" (368 × 470 mm), Spooner Bequest, Courtauld Institute Galleries, London

2.2 Paul Sandby, *Town Gate of the Castle, entrance to the Lower Court, ca.* 1760, graphite, 7½" × 7¼" (189 × 183 mm), Staatliche Museen Greiz (E 456)

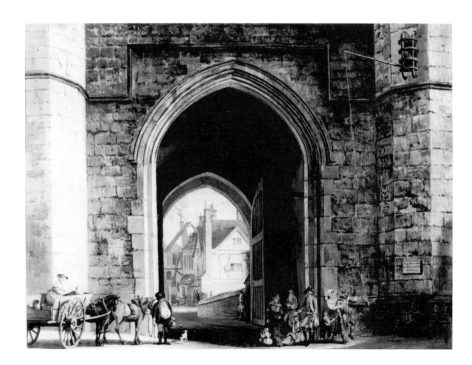

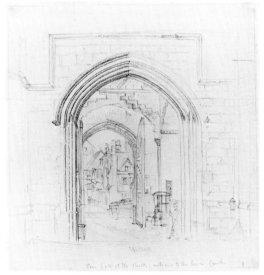

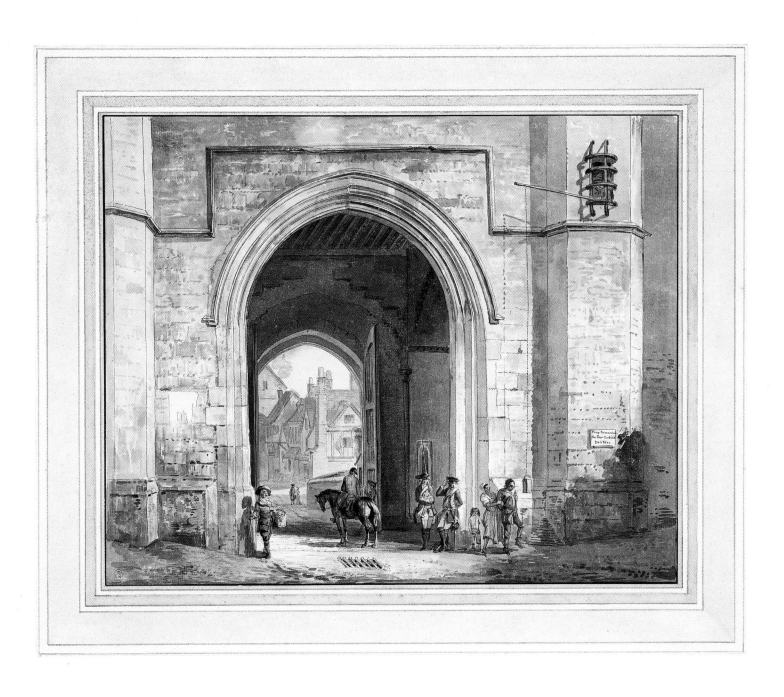

33

3. PAUL SANDBY

The Henry VIII Gateway and the Salisbury Tower from within the Lower Ward, ca. 1770

Watercolour with pen and ink over graphite, within black ink line, 8¾" × 13½" (224 × 342 mm)
WATERMARK Strasburg Lily/LVG
MOUNT Type 4. Verso inscribed in graphite, by Paul Sandby (?): *Windsor. The Town Gate and Chancellor of the Garter's Tower from the Lower Court*
PROVENANCE Sir Joseph Banks; Sir Wyndham Knatchbull (sale, Christie's, 23 May 1876, lot 15); purchased (£5) by Holmes, the Royal Librarian
Oppé 29; RL 14551

This view records the south-western corner of the Lower Ward, with the stone gateway occupying most of the composition. The western end of the range of houses built by Mary Tudor for the Military Knights is shown to the left. To the right is the Salisbury Tower and the southern end of Crane's Building.

When the nineteenth-century programme of works in the Castle reached this area, the most significant changes involved the removal of inharmonious additions such as the wooden platform and balustrade and the standardizing of features such as chimneys and windows. The brick walls were replaced with stone, and the roofline above the centre of the gateway was crenellated. The numerous additions made to the inner face of the corner tower – the Salisbury Tower, built between 1227 and 1230 – were swept away during Blore's alterations of *ca.* 1840 (see 3.2). The tower was previously known as the Chancellor's Tower, as the residence of the Chancellor of the Order of the Garter, a position occupied *ex officio* by the Bishop of Salisbury.

As in the case of 2, this watercolour was acquired from the Banks collection and is related to a more finished version of the same view. The finished version, in bodycolour, was itself acquired for the Royal Collection in 1982 (3.1). The increased depth of tonality in the latter allows for an intensified contrast between the various construction materials. The buildings on the left and far right are ashlar-faced, the gateway is built of ragstone, the low walls to the left and right are made of brick, the platform with balustrade to the left of the gateway is painted wood, while the façade of the corner tower (the Salisbury Tower) is limewashed. The number of figures shown by Sandby is greatly increased in the more finished version. The figures are excluded from the pencil drawing of the same subject (squared for transfer) at Greiz (E 462).

As the other known finished views of the main Castle gateways (1.1, 2.1 and 13.1) are all dated (and to the same year, 1767), while 3.1 is not, it is possible that this last is identifiable with Sandby's exhibit, *A gateway in Windsor Castle*, at the Society of Artists in 1763.

3.1 Paul Sandby, *The Henry VIII Gateway and the Salisbury Tower from within the Lower Ward*, ca. 1763, watercolour and bodycolour, 15⅛" × 21½" (385 × 547 mm), Royal Library (RL 23996)

3.2 Photograph of the Henry VIII Gateway and the Salisbury Tower, October 1994

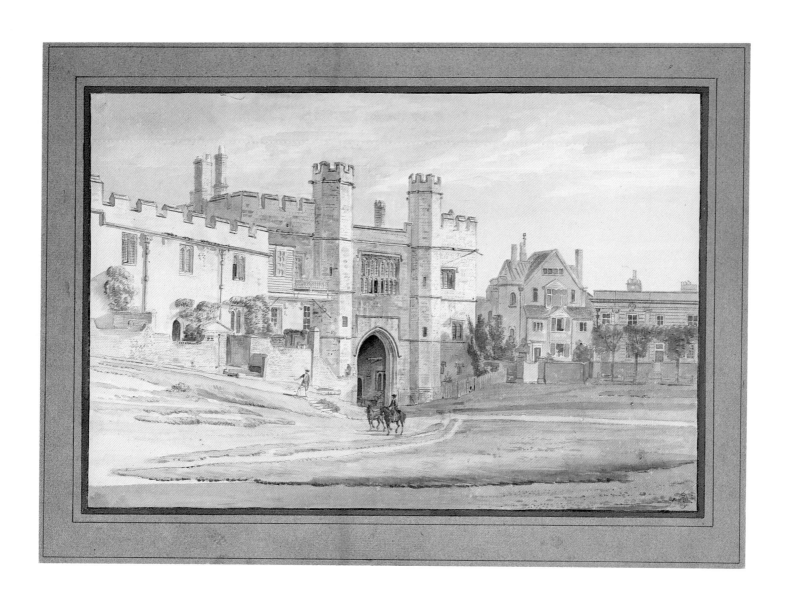

4. PAUL SANDBY

The entrance to the Horseshoe Cloister with the west end of St George's Chapel, ca. 1770

Watercolour with pen and ink over graphite, within black ink line and buff wash border, 9⅜" × 12⅝" (239 × 322 mm)
WATERMARK countermark IV
MOUNT Type 2. Verso (laid down) inscribed in graphite, by Paul Sandby (?): *View of Part of St. George's Chapel from Henry VIII's Gate* (last four words in a different hand, over *from Town Gate*) *with the Entrance to the Singing Men's Cloister*
PROVENANCE Sir Joseph Banks; Sir Wyndham Knatchbull (sale, Christie's, 23 May 1876, lot 14); purchased (£4) by Hogarth, probably for the Royal Collection; Royal Collection by 1892 (Sandby, p.215)
Oppé 31; RL 14553

The very regular outline of the buildings that made up the Horseshoe Cloister as shown by Hollar (fig.2) had evidently been elaborated upon by the mid-eighteenth century. Like the principal (inner) façade of the cloister (5), the chimney stacks with their curious accretions and the other irregular additions to the backs of the choristers' houses shown here were swept away during Scott's rebuilding from 1870.

At the right in this watercolour is the west end of St George's Chapel, with the Beaufort Chapel (*ca.* 1500) projecting to its south. Traces of the two sundials shown by Sandby on the south and south-western faces of the Beaufort Chapel are still evident today. The Chapel has now regained its ogival roof, shown in views of the seventeenth and early eighteenth centuries (see figs.1–3) but gone by Sandby's time. The lines of trees depicted by Sandby along both the western and the northern sides of the Lower Ward were removed in the nineteenth century.

This view appears in more finished and elaborate form in a gouache formerly in the Molyneux and Harewood collections and now at New Haven (4.1). Either that picture or the slightly larger view of the

same buildings from further to the north-west (4.2) may be identified with Paul Sandby's exhibit at the Society of Artists in 1765: *Entrance into the Singing Men's Cloister and the West End of H.M. Chapel of St George's in Windsor Castle* (no.232). There is an outline tracing of this view at Greiz (E 507). A watercolour from a viewpoint slightly closer to St George's Chapel is also in the Royal Collection (Oppé 32); like 4, this was formerly in the Banks collection.

As we might expect, the figures shown in the Windsor and New Haven versions differ considerably. In the Windsor watercolour a pair of figures in the right foreground approach the southern entrance to the Chapel. The purple gown of the right-hand figure identifies him as a Military Knight. Among the details concerning the Windsor Knights provided in the 1768 guidebook is the following: "These 18 poor Knights have a Pension of £18 a Year, and annually a Gown or Surcoat of scarlet Cloth, and a Mantle of blue or purple Cloth, on the left Sleeve of which is embroidered the Cross of St George in a plain Escutcheon." Long mantles were worn by the Military Knights until 1833.

4.1 Paul Sandby, *The entrance to the Horseshoe Cloister with the west end of St George's Chapel, ca.* 1765, watercolour and bodycolour, 15" × 21¼" (382 × 540 mm), Yale Center for British Art, New Haven (B1981.25.2692)

4.2 Paul Sandby, *The entrance to the Horseshoe Cloister with the west end of St George's Chapel, ca.* 1765, bodycolour, 17⅜" × 24" (442 × 608 mm), Thomas & Brenda Brod, Fine Paintings and Drawings, London

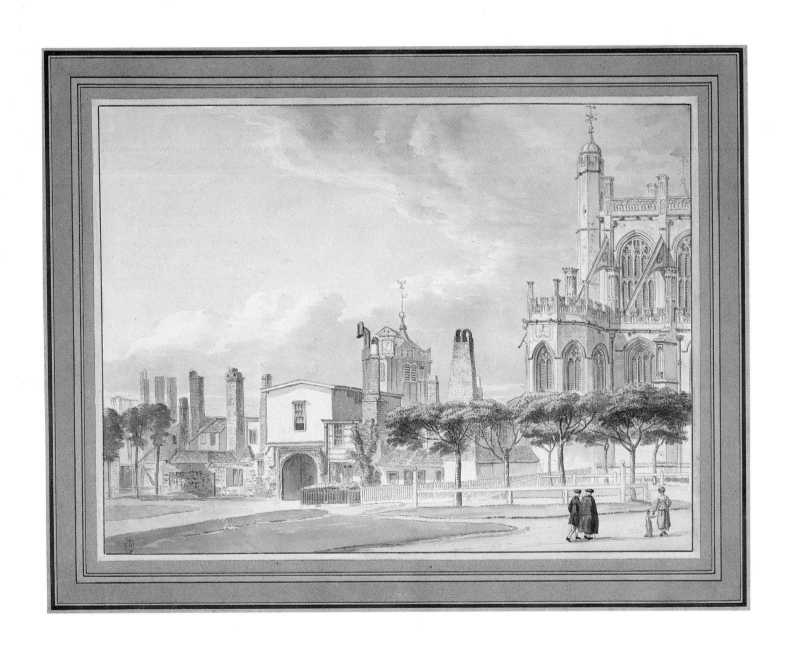

5. PAUL SANDBY

The Horseshoe Cloister and the Curfew Tower, ca. 1770

Watercolour with pen and ink over graphite, 13½" × 20" (342 × 508 mm)
WATERMARK countermark IV
MOUNT Type 2. Verso inscribed in graphite, by Paul Sandby (?): *Windsor / View of Julius Caesar's Tower from the West end of St George's Chapel.* Mount watermark: Strasburg Lily/LVG, with countermark IHS/I VILLEDARY
PROVENANCE Sir Joseph Banks; Sir Wyndham Knatchbull (sale, Christie's, 23 May 1876, lot 40); purchased (17 gns.) by Holmes, the Royal Librarian
Oppé 33; RL 14555

The houses occupied by the choristers of St George's Chapel were situated in Sandby's time, as in the twentieth century, around the three sides of the area to the west of the Chapel between the West Steps and the outer wall of the Castle. Although it has traditionally been described as a cloister, the eastern side is formed by the west end of the Chapel. In the eighteenth century it was known as the Singing Men's Cloister. At the time it was thought that its unusual shape – in the form of a 'fetterlock' or horseshoe – derived from one of the badges of its builder, King Edward IV.

The walls of the buildings which combined to form the Cloister, built *ca.* 1480, were of very varied structure and composition by the eighteenth century. The perceived antiquity of the Curfew Tower led to its being called the Julius Caesar Tower. The pitched roof to the right of the Curfew Tower covers the Chapter Library, originally built as the Vicars' Hall (*ca.* 1415). The bay window looking out on to the Horseshoe Cloister remains, but the tiles above have been stripped away. From 1870 the houses of the cloister were substantially rebuilt, to the designs of George Gilbert Scott.

The constant process of repair and renewal that has been applied to ancient buildings from the Middle Ages to the present day is charmingly recorded in this watercolour. To the left, one man saws through a block of stone while another works on a rather smaller block with a chisel. The bucket of water is there to cool the saw blade. A carved stone panel with Gothic decoration is propped up against the block on the right. The left-hand figure in Sandby's view recurs in various other Windsor subjects by Sandby, and is recorded in an independent study (5.1) recently acquired for the Royal Collection and formerly in the collection of Colonel Gravatt, a pupil and friend of Paul Sandby. However, the scale of the group is greatly reduced in 5.

The deep shading in the right-hand opening recalls the dark tonalities of Paul Sandby's early Sandpit Gate interiors (*e.g.* fig. 10). In the depiction of varied textures and gentle observation – the yawning child, the stonecutter interrupted by the discussion in the open doorway behind, the stone-carver with his chisel and the spray of stone-dust – this is a very characteristic work. Paul Sandby also recorded the view across the cloister from north-east to south-east in a bodycolour dated 1768 (with Leggatt, 1933) and in an engraving published in 1777.

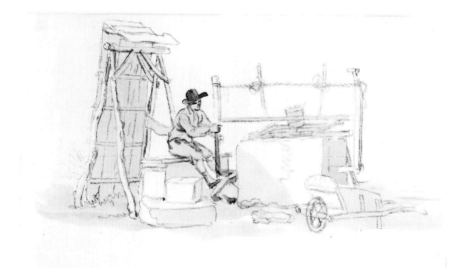

5.1 Paul Sandby, *Stonemason, ca.* 1770, graphite and wash, 4⅝" × 8⅛" (118 × 207mm),
Royal Library (RL 32457)

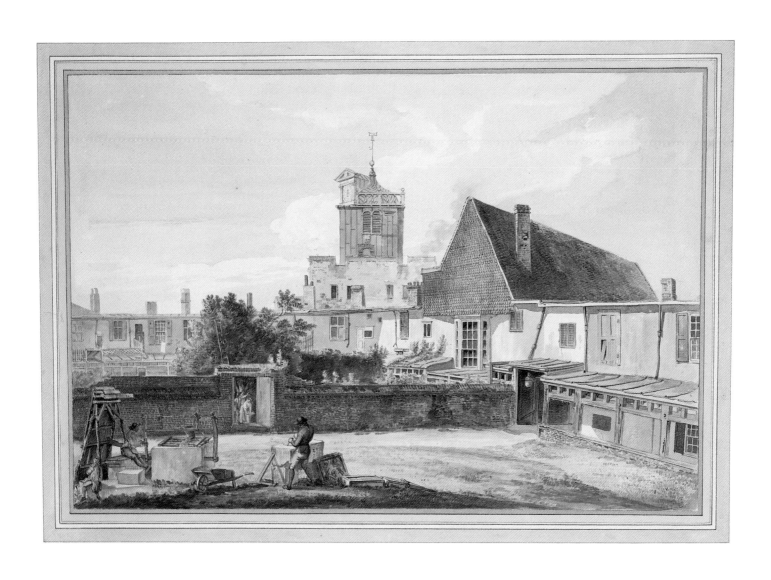

6. THOMAS SANDBY

The interior of the choir of St George's Chapel, ca. 1782

Watercolour with pen and ink over graphite, with compass, 22" × 21" (560 × 534 mm)
VERSO inscribed in graphite, twice: *St Georges Chapel / Windsor*
PROVENANCE [Thomas Sandby (1799 sale);] purchased 1909 from Palser, London
Oppé 435; RL 17455

The Choir of this Chapel of St George is set apart for the more immediate Service of Almighty God, and for the Use of the noble Order of the Garter. Tho' this Choir was built by King Edward III [*sic* for IV] it did not arrive at its present beauty till the Reign of Henry VII. to whom it is indebted for the elegant Carvings, with which it is adorned. On each Side are the Stalls of the Knights Companions of the most noble Order, with the Sword, Crest, Helmet, and Mantling of each Knight placed over his Stall, on a Canopy curiously wrought, over which is fixed the Banner or Arms of each of the Knights properly blazoned on Silk; and on the Back of the Stalls are the Arms and Titles of the Knights, engraved and blazoned on Copper [...]

The carved work of this Choir is worthy of particular Notice, especially the Canopies over the Stalls of the Knights. (*Windsor and its Environs,* 1768)

For an approximate visual record of the interior of the choir at the date of this description we must depend on Hollar's much earlier etched view

(Parthey 1078). Shortly after the above description was published, a programme of repair and refurbishment was commenced in the Chapel, under the direct patronage of the King; the total cost was over £20,000. The work started with the west window (1776) before moving to the east window and altar wall (1785–88), incorporating a new stained glass window and altarpiece by Benjamin West; the choir stalls (1786–91) and Edward IV's monument (1789–91) followed. A full description of this campaign is contained in the manuscript *Account of all the Great Works 1782–92* (see Roberts). The subtly changed appearance of the Choir which resulted from these works is shown in Frederick Nash's large engraved view published in 1804 (6.1).

Henry Emlyn (*ca.* 1729–1815) was the supervising architect throughout the Great Works. But the *Account* also mentions Thomas Sandby, whose design for the east wall "with some small alterations has been executed by Mr Emlyn". Sandby's work was undertaken in the context of his positions as Architect of the King's Works from 1777 and Master Carpenter in the Office of Works from November 1780 until the abolition of this post in 1782.

This watercolour shows the east end at a transitional phase, with the tracery for the new east window barely indicated in what remains (typically for Thomas Sandby) an unfinished work. It may contain Thomas's first thoughts for the new eastern wall, incorporated into a minutely detailed view of the choir before the alterations; it probably dates from a few years before the start of work on the east wall. Early in 1782 the King "ordered Dr Lockman [John Lockman 1722–1807, Canon of St George's from 1758; see also 18] to propose a plan for putting [a design for the east window] into execution". Some years later the antiquary John Carter (1748–1817) published a small etching of the choir, with the new proposed window and altarpiece, stating that the view had been "sketch'd" in 1784.

The posthumous sale of Thomas's collection of drawings (July 1799) included six lots of studies connected with St George's. These were described variously as "studies from" and "Gothic Designs for" the Chapel; the three drawings of details of the choir stalls in the Royal Collection (RL 17543, 17638 and 17943) were presumably among these (see also Hardie, plate 184).

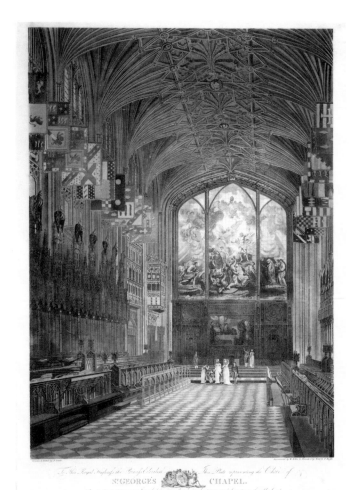

6.1 Frederick Nash, W. Ellis and I. Roffe, *The Choir of St George's Chapel,* 1804, aquatint and etching, 19½" × 14⅜" (495 × 365 mm), Royal Library

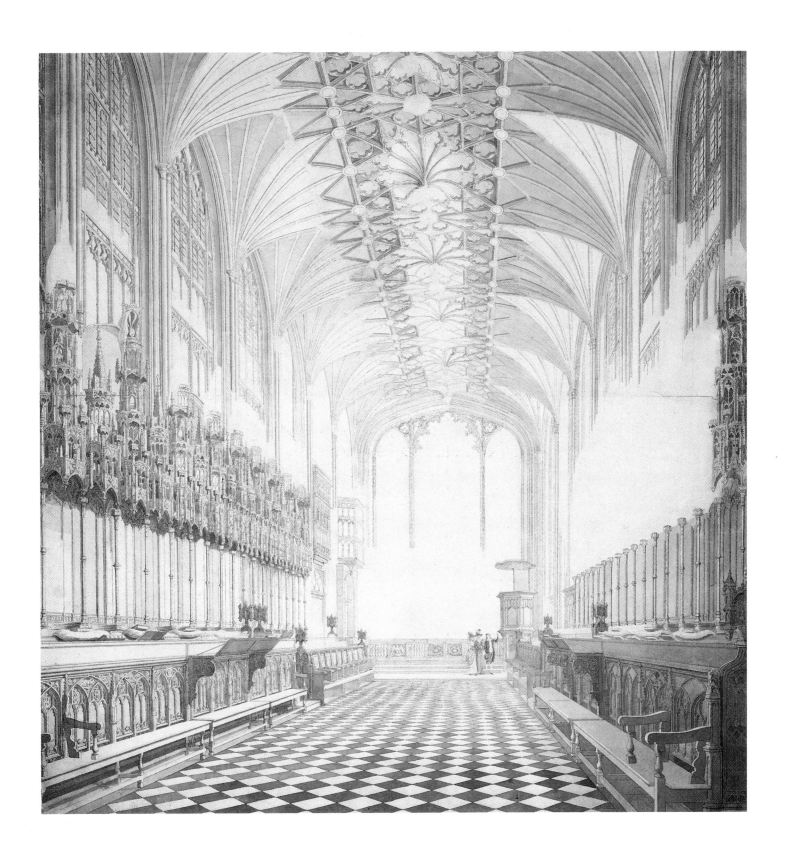

41

7. PAUL SANDBY

The Mary Tudor Tower, ca. 1765

Watercolour and bodycolour with pen and ink over graphite, within black ink line, 9¼" × 13¼" (236 × 336 mm)
WATERMARK Strasburg Lily/LVG
MOUNT Type 2. Verso inscribed, by Paul Sandby (?): *Windsor / View of the Governor of the poor Knights Tower & the Garter Chamber.* Mount watermark: monogram PvL
PROVENANCE Sir Joseph Banks; Sir Wyndham Knatchbull (sale, Christie's, 23 May 1876, lot 19); purchased (7 gns.) by Holmes, the Royal Librarian
Oppé 30; RL 14552

The Mary Tudor Tower and the houses to its east (to the left in this view) were built in the fourteenth century respectively as the belfry for St George's Chapel and to provide accommodation for the choristers. In the late fifteenth century these functions were transferred to the area to the west of the Chapel (the Curfew Tower and the new Horseshoe Cloister) and the buildings in the southern range of the Lower Ward were converted into accommodation for the Military Knights. In his will King Henry VIII left funds for the provision of further accommodation for the Knights, and the central tower – now The Mary Tudor Tower – became the home of the Governor of the Knights. The tower still bears the stone tablet with the arms of Queen Mary and her husband King Philip II of Spain that is shown by Sandby.

Immediately to the right of the Mary Tudor Tower in the watercolour is an apartment approached through gateposts each bearing the Garter Badge; there is a third Garter Badge over the front door. This apartment was described as the Garter Chamber in the eighteenth century and is today called Garter House. In views of the south front of the Castle the curved outer face of this apartment is clearly evident, immediately to the west of the square Mary Tudor Tower (figs. 2 and 3). The ashlar facing on the north façade was probably added when the range of houses to its west (to the right in this view) was erected in the mid-sixteenth century.

The brick wall running in front of the Military Knights' houses was rebuilt in stone in 1840. The small windows under the crenellations on the left have likewise been removed (7.1).

Sandby's view was taken from the Galilee porch, between the Lady Chapel and St George's Chapel. In the shaded foreground he has drawn two figures, a dwarf carrying a goose in a sling, and a pieman. They are reduced versions of figures shown in a sheet of studies in the British Museum (7.3). The same figures are included in the bodycolour view of the Henry VIII Gateway dated 1767 (1.1) and in the aquatint of Guy Fawkes Day, 1776 (I.1). Although this fine and delicate watercolour was one of the Banks series, no related works (in either bodycolour or pencil outline) are known. There is an upright view of the Mary Tudor Tower in outline etching dated 1782 (7.2).

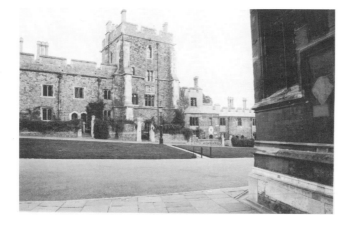

7.1 Photograph of the Mary Tudor Tower, November 1994

7.2 Paul Sandby, *The Black Rod and the Mary Tudor Tower,* 1782, etching, platemark 6¼" × 9⅜" (159 × 237 mm), British Museum, London (189*.b.2)

7.3 Paul Sandby, *Pieman, ca.* 1755, pen and ink with graphite and wash, 8⅝" × 6⅞" (218 × 176 mm), British Museum, London (LB 137(20))

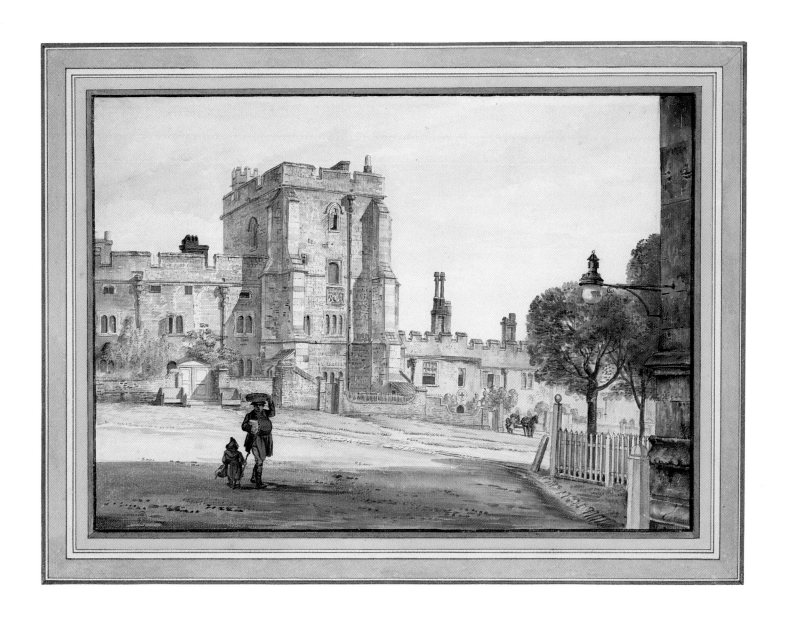

8. PAUL AND THOMAS SANDBY

The Lower Ward seen from the base of the Round Tower, ca. 1760

Watercolour with pen and ink over graphite, within black ink line, 11" × 24" (281 × 609 mm) Inscribed in ink, above the door to the inn: *Coffie and Tea*
MOUNT: Type 3. Verso inscribed in graphite, by Paul Sandby (?): *Windsor / A General View Westward from the base of the Curtain of the Round Tower.* Mount watermark: Strasburg Lily/LVG, with countermark IHS/I VILLEDARY; also monogram PvL
PROVENANCE Sir Joseph Banks; Sir Wyndham Knatchbull (sale, Christie's, 23 May 1876, lot 45); purchased (30 gns.) by Holmes, the Royal Librarian
Oppé 37; RL 14559

This beautiful panoramic view (see also detail, pp. 2–3) is framed on the left by the stark face of the low wall at the base of the Round Tower. The matching blocks to the left of centre and at the right edge of the watercolour are the Henry III and Winchester Towers, which were formerly linked by the wall dividing the Lower and the Middle Wards of the Castle (see figs. 1 and 2). A guardroom was built against the east face of the northern section of this wall in the late seventeenth century; its (later) south-facing portico (see I.1) and sloping roof with dormer windows occupy much of the right-hand side of Sandby's view (see fig. 5 for a plan). In the ground floor of this block there was a public house called The Royal Standard. The watercolour records, in microscopic letters, the words "Coffie and Tea" over the right-hand entrance doorway to this building.

In the centre of 8 is a view down the Lower Ward, with St George's Chapel on the right, the Military Knights' houses in steep perspective on the left, and the Salisbury Tower and Crane's Building at the far end. In the middle distance to the left are the buildings of the town of Windsor, including the tower of the parish church. Plumes of smoke are shown rising from the chimneys.

In view of the remarkable quality of this watercolour, it is not surprising that it was the most expensive royal purchase at the Banks sale in 1876, at

30 gns. It belongs to the same series of wide panoramic views as 32, 33, 35 and 36, all from Banks's collection. The tracing of 8 at Greiz (8.2) was probably made by Princess Elizabeth *ca.* 1810. A similar but more elevated viewpoint was selected by William Daniell for one of the plates in his series of aquatint views of Windsor published in the late 1820s (8.1). Although a few changes had been introduced by this time (particularly to the Winchester Tower on the right, which was Wyatville's residence), the majority of the alterations in the Middle and Lower Wards were carried out in Queen Victoria's reign.

Oppé described this as "the masterpiece in Paul Sandby's best series" and recorded that its inclusion in the *Exhibition of British Art* at Burlington House in 1934, together with that of 33 in Amsterdam in 1936, "did much to restore Sandby to the position that he had held in his lifetime" (Oppé, p. 26). In the context of early works by Thomas such as the Old Horse Guards view (fig. 8), it is arguable that the extraordinary breadth of vision and skill in perspectival drawing that it incorporates (together with the similarly depicted smoking chimneys) are the work of Thomas Sandby, who may thus have collaborated with his brother for this *chef d'œuvre* of English topographical watercolour painting. It is also possible that 8 was painted as early as *ca.* 1750.

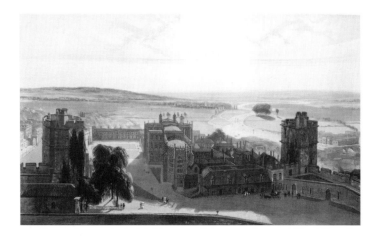

8.1 William Daniell, *The Lower Ward from the base of the Round Tower,* *ca.* 1827, hand-coloured aquatint, 11⅞" × 19¾" (302 × 500 mm), Royal Library

8.2 Princess Elizabeth (later Landgravine of Hesse-Homburg), copy of 8, *ca.* 1810, tracing on oiled paper, 11¼" × 21¼" (286 × 540 mm), Staatliche Museen Greiz (E 497)

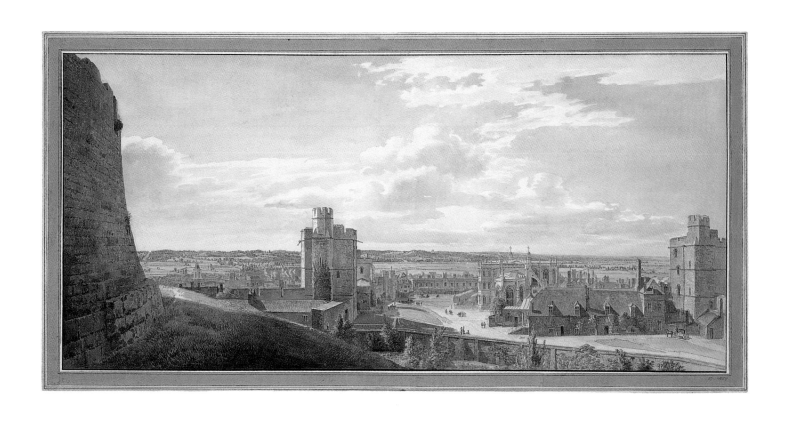

II The Middle Ward

The Middle Ward is dominated by the Round Tower, which is surrounded by a dry ditch. It also includes the area to the east of the Henry III Tower and the Winchester Tower (shown in the foreground of 8), the so called Norman Gateway with the steps leading from that building to the apartments in the Round Tower, and the buildings in and adjoining the dry ditch to the south, known collectively as the Black Rod.

According to Pote's *Delices de Windsore* (1755, p.5),

The Keep, or Round Tower, which forms the West Side of the upper Court, is the Lodging of the Constable or Governor, built in the Form of an Amphitheatre on the highest Part of the Mount; the Ascent into the Lodgings is by a large Flight of Stone Steps; the Apartments are large and noble, and here is a Guard Room, or Magazine of Arms for the greater State of the Officer, who has the intire Government of the Castle, and is an Officer of great Antiquity, Honour, and Power.

The Round Tower is shown under repair in a number of Paul Sandby's views. The problems caused by the addition to the top of the mound of ever more considerable structures, supported by no proper foundations, were greatly increased when the Tower was nearly doubled in height during Wyatville's campaign, *ca.* 1830. The major structural work carried out in 1990–91 to remedy these defects provided the opportunity for a thorough archaeological investigation of the Round Tower by English Heritage.

The Governor of the Castle from 1752 until his death was George Brudenell, Earl of Cardigan (1712–1790). In 1730 he had married Mary, daughter and heiress of the 2nd Duke of Montagu. In 1766 Cardigan was created 3rd Duke of Montagu; although his home was now Boughton House, Northamptonshire, he continued to serve as Governor of the Castle and was one of Paul Sandby's patrons.

The principal route from the Lower to the Upper Wards passes to the north of the Round Tower before proceeding through the Norman Gateway. This was not an independent structure but acted as a link between the buildings at the northern end of the north stairs from the Round Tower to those on the north front of the Castle. Far from dating from the time of the Normans, it was erected *ca.* 1360, on the site of an earlier structure. Around one hundred years later the steps to the Round Tower, to the east of the Gateway, were rebuilt in more permanent form (see 14). Until the second half of the eighteenth century the apartment adjacent to the entrance to the Round Tower was occupied by the Deputy Governor; thereafter it became the home of the Housekeeper of the Castle. It was described by Lady Mary Coke in 1764 as "one of the prettiest apartments I ever saw". For the last fifty years it has served as the home of the Governor of Windsor Castle; the Royal Archives now occupy the Round Tower.

The first two watercolours in this section (9 and 10) depict the picturesque group of buildings which in Sandby's day occupied the area to the south of the Round Tower, collectively called the Black Rod. They were the official residence of the Gentleman Usher of the Black Rod, an officer of the Order of the Garter with additional duties on behalf of the monarch in the Palace of Westminster. The buildings can be clearly seen in Hollar's aerial view of *ca.* 1660 (fig.2), in Kip's view of *ca.* 1708 (fig.3), and in Benning's plan of 1760 (fig.5). *The Windsor Guide* of 1783 reported: "The apartments belonging to the Usher of the Black Rod, together with some offices which were greatly out of repair, have lately been taken down to enlarge the space between the castle and the Queen's lodge, and to open a view towards the keep or round tower; other improvements are now carrying on which when completed will render this a most delightful spot." The remaining buildings in the Round Tower moat were pulled down in 1819. For a view of the exterior of the Castle wall at this point, see 27.

When writing of the Round Tower early in the nineteenth century, W.H. Pyne observed that "On this ancient and commanding tower the British standard is displayed whenever the royal family is at Windsor" (Pyne, I, p.188), a practice that has continued to the present day. The entire absence of the standard from the views of the Round Tower in this exhibition is an indication of the infrequency of the King's visits to Windsor at the time that Sandby was making his records.

Detail of 12

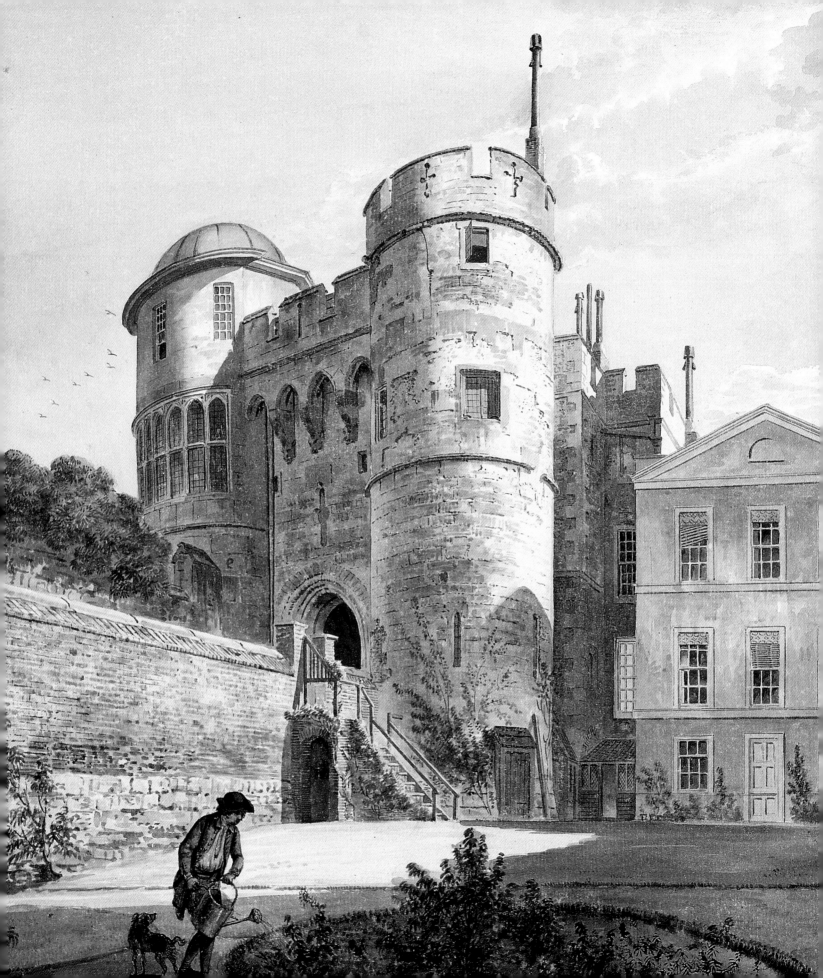

9. PAUL SANDBY

The Round Tower with the Black Rod and the Devil's or Maids of Honour Tower, ca. 1790

Watercolour and bodycolour with pen and ink over graphite, 11" × 17⅛" (280 × 434 mm)
WATERMARK countermark I VILLEDARY
MOUNT Type 1. Lettered in grey wash: *View from the Black Rod of the Round Tower Royal Court, and Devils Tower &c. in Winds [sic] Castle*
PROVENANCE Paul Sandby (sale, Christie's, 2 May 1811, lot 89); purchased (£2. 10s.) by Shepperd for the Prince Regent (later King George IV); by descent (mount bears VR drystamp)
Oppé 42; RL 14565

The view of the Round Tower in this watercolour is from the south-west, with the buildings of the Black Rod to the right, in front and out of the picture to the left. To the right of centre is a distant view of the north range of the Quadrangle, with the turretted entrance to the State Apartments. Steps lead from the Round Tower to the Devil's Tower, on the site of the present George IV Gate. The key to Benning's plan (fig. 5) describes this building, at the south-western corner of the Quadrangle, as "The Devil Tower ... late made use of by the Maids of Honour", in other words the ladies in attendance on the Royal Family.

Although the buildings of the Black Rod were frequently drawn and painted by Paul Sandby, the subject does not feature among his exhibited works. Sir Joseph Banks's collection included four views of the Castle from the Black Rod, only one of which (lot 28, 10.1) was acquired for the Royal Collection. Lots 22 and 34 in the 1876 sale are probably to be identified with the pictures now in Melbourne and at Anglesey Abbey (9.2 and 10.2). All three views are in bodycolour. Lots 43 and 47 have not been

located, but the appearance of one may be recorded in the outline drawing at Greiz (E 472) inscribed "The Round Tower and part of the Castle of Windsor taken from the Black Rod" and dated 1768. The format of the Greiz drawing is similar to that of the broad panoramic views such as 8. An outline etching (7.2), showing a view from the Black Rod ditch towards the Henry III Tower, was made in 1782, very shortly before the buildings were demolished.

This and the following watercolour belong to a second small group recording this area of the Castle included in the posthumous sale of the contents of Paul Sandby's studio in 1811. Another drawing from this group is the dramatic upright (Oppé 39) of the area shown in the right half of both 10.1 and 9. Although the date (1767) on the upright view may be a later addition, it is probably approximately correct. The looser handling and softer tonality of 9 and 10, both from the 1811 Sandby sale, argue for a later date. The warm glow in the sky at the right is similar to that found in the North Terrace views of *ca.* 1790 (*e.g.* 16 and 17).

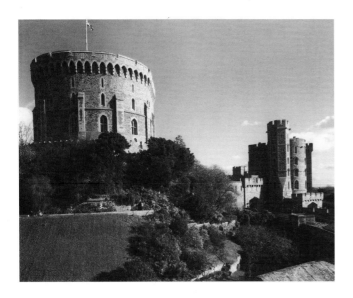

9.1 Photograph of the Round Tower and Edward III Tower (formerly the Devil's Tower), November 1994

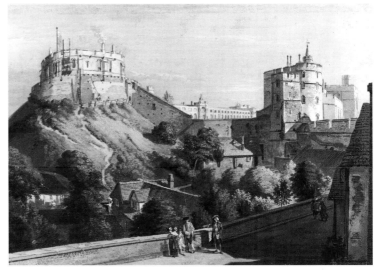

9.2 Paul Sandby, *The Round Tower and Devil's Tower from the Black Rod*, *ca.* 1767, bodycolour, 11¾" × 17¼" (297 × 437 mm), National Gallery of Victoria, Melbourne (Felton Bequest 1922, acc. no. 1260/3)

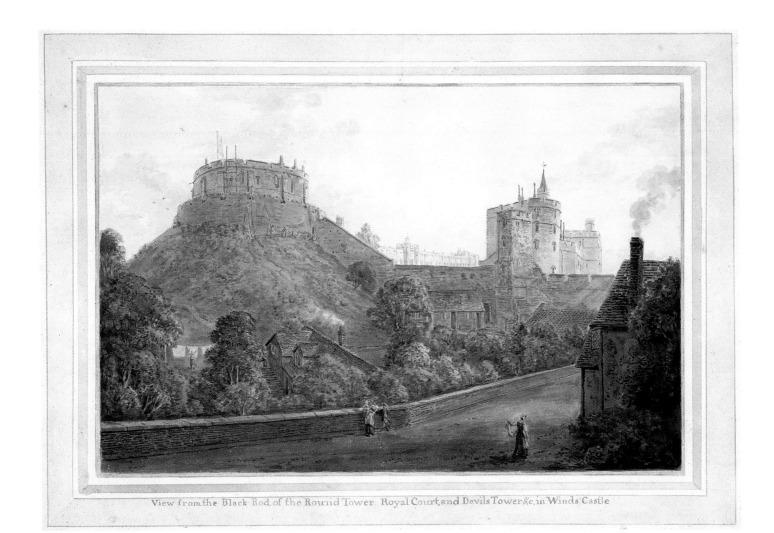

View from the Black Rod, of the Round Tower, Royal Court, and Devils Tower &c. in Winds Castle

10. PAUL SANDBY

The Round Tower, Winchester Tower and Henry III Tower from the Black Rod, ca. 1790

Watercolour and bodycolour with gum, with some pen and ink over graphite,
11" × 17⅛" (281 × 435 mm)
WATERMARK countermark
I VILLEDARY
MOUNT Type 1. Lettered in grey wash: *View of the Round, Winchester, and Store Towers in* WINDSOR CASTLE
PROVENANCE Paul Sandby (sale, Christie's, 2 May 1811, lot 93); purchased by Shepperd (£2. 5s.) for the Prince Regent (later King George IV); by descent
Oppé 43; RL 14566

This view is taken from a position slightly to the east of that employed in 9, but looking north rather than north-east. Since the time of Wyatville's changes in this part of the Castle there has been a roadway to the south, as to the north, of the Round Tower (9.1). This was not originally the case. The area in the foreground of 9 and 10 was not a road but an open space or platform between some of the Black Rod houses. For 10 (and 10.2) the artist appears to have placed himself on the steps descending from this platform (see fig. 5); the parapet to the left in both these views is the same as that in the foreground of 9 and 10.1.

The topography of the area is essentially the same in the Banks bodycolour (10.2) and in the later watercolour (10), although it is likely that the actual appearance of the area had changed considerably by this time, in order to accommodate improved access to the Queen's Lodge to the south. The same preparatory studies were evidently used.

Numbers 9 and 10 appear to have been painted as companion pieces and therefore belong to the large number of other paired views of the Castle produced by Sandby (see especially 16 and 17). They are lit from different directions, indicating that 10 is an evening view while 9 is a morning view.

10.1 Paul Sandby, *The Henry III Tower and the Round Tower from the Black Rod,* ca. 1765, watercolour and bodycolour over graphite, 11" × 17⅛" (280 × 435 mm), Royal Library (Oppé 41; RL 14563)

10.2 Paul Sandby, *The Round, Winchester and Store Towers from the Black Rod,* ca. 1767, watercolour and bodycolour, 11¾" × 20½" (298 × 520 mm), the Fairhaven Collection (The National Trust), Anglesey Abbey

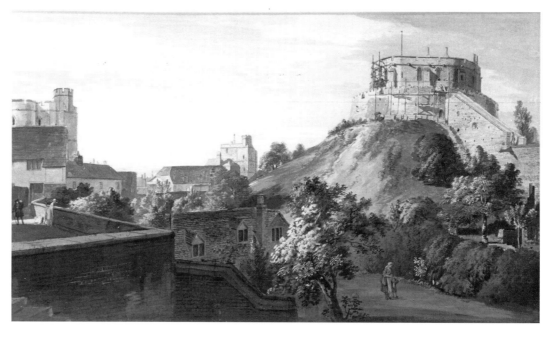

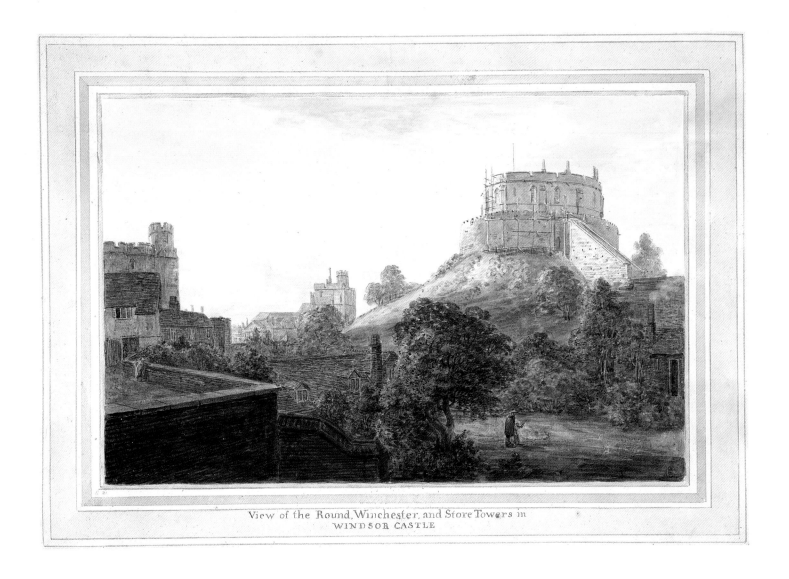

View of the Round, Winchester, and Store Towers in
WINDSOR CASTLE

51

11. PAUL SANDBY

The Norman Gateway from the gate to the North Terrace, ca. 1770

Watercolour and bodycolour with pen and ink over graphite, within black ink line and buff wash margin,
9¼" × 13½" (235 × 345 mm)
WATERMARK Strasburg Lily/LVG
MOUNT Type 2. Verso inscribed in graphite, by Paul Sandby (?): *West Entrance to the Great Court.* Mount watermark: monogram PvL
PROVENANCE Sir Joseph Banks; Sir Wyndham Knatchbull (sale, Christie's, 23 May 1876, lot 5); purchased (£2. 15s.) by Hogarth, probably for the Royal Collection; Royal Collection by 1892 (Sandby, p.215)
Oppé 12; RL 14534

The viewpoint in this watercolour is from the west, looking along the north side of the Middle Ward, towards the Norman Gateway. The Moat Garden is on the other side of the low wall to the right; the North Terrace is on the other side of the high wall to the left. The Magazine Tower, within the curtain wall, is immediately behind the stooped figure in the foreground. The tower was built to store ammunition but was converted into domestic accommodation in the nineteenth century.

The two towers of the Norman Gateway were far from uniform in Sandby's time. That on the left incorporated the west end of Queen Elizabeth's Gallery (now the Royal Library), with a magnificent window from which the Thames Valley to the north and east could be observed. The changes wrought by Wyatville in this area of the Castle are clearly and confidently shown in his presentation watercolours (RL 26485–86; see also 11.1).

Like 7, this watercolour was acquired from the Banks collection, but does not appear to be directly related to a more finished work. The view from further to the right is recorded both in a pencil drawing at Windsor (Oppé 11) and in an outline etching of 1777 (11.2). An unfinished watercolour with a wider format is in the British Museum (LB 136(2)).

11.1 Photograph of the Norman Gateway, November 1994

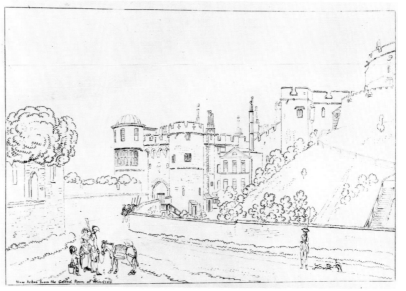

11.2 Paul Sandby, *View taken from the Guard Room at Windsor,* 1777, etching, platemark 6⅜" × 9¼" (161 × 236 mm), British Museum, London (189*.b.2)

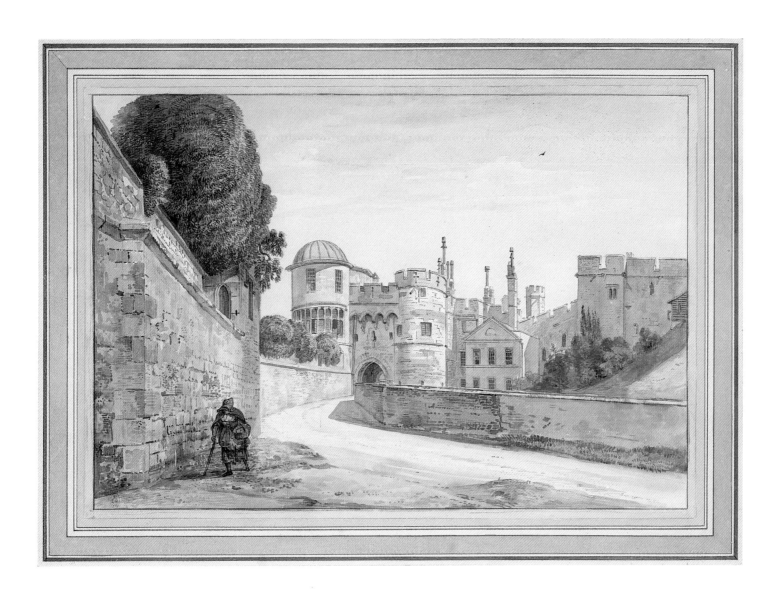

12. PAUL SANDBY

The Norman Gateway and the Moat Garden, ca. 1770

Watercolour and bodycolour with pen and ink over graphite, within broad black border, 14¾" × 20⅛" (374 × 510 mm)
WATERMARK Strasburg Lily/LVG
MOUNT Type 4
PROVENANCE Sir Joseph Banks; Sir Wyndham Knatchbull (sale, Christie's, 23 May 1876, lot 20); purchased (£4. 10s.) by Seabrook; Royal Collection by 1892 (Sandby, p.215; mount bears VR drystamp)
Oppé 13; RL 14535

The dry ditch surrounding the Round Tower provided, and still provides, a well sheltered area, ideal for a small garden. The northern ditch, adjoining the Norman Gateway, has long been used as a flower garden, while the slope and ditch to the south have a history of cultivation for fruit and vegetables (see fig.2): in 1836 Wyatville warned that if fruit trees continued to be planted in that area he could not be held responsible should the Round Tower and its boundary wall collapse.

The garden in the northern ditch adjoined the apartment at the foot of the Round Tower. This was successively the home of the Deputy Governor and the Castle Housekeeper; in the early twentieth century it became the residence of the Governor of the Castle. The occupant between 1764 and 1800 was Lady Mary Churchill, Horace Walpole's half-sister, in her position as Castle Housekeeper. The pedimented façade appears to have been an introduc-

tion of the mid-eighteenth century.

The Moat Garden has survived in somewhat altered form to that shown in 12. It has been excavated to a greater depth and is therefore narrower, particularly at this point nearer the domestic apartments. The present rock and water gardens were laid out by Sir Dighton Probyn, Keeper of the Privy Purse to King Edward VII, at the beginning of the twentieth century.

This watercolour was formerly in the Banks collection. A very similar, and probably slightly earlier, view in bodycolour was formerly in the Molyneux and Harewood collections and is now at New Haven (12.1). A pencil drawing at Greiz (E 469), inscribed "Part of Windsor Castle from the House Keeper's Garden", records the view from the slope further to the right. A watercolour taken from a similar viewpoint was acquired for the Royal Collection in 1954 (RL 17757).

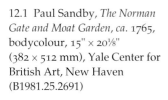

12.1 Paul Sandby, *The Norman Gate and Moat Garden, ca. 1765*, bodycolour, 15" × 20⅛" (382 × 512 mm), Yale Center for British Art, New Haven (B1981.25.2691)

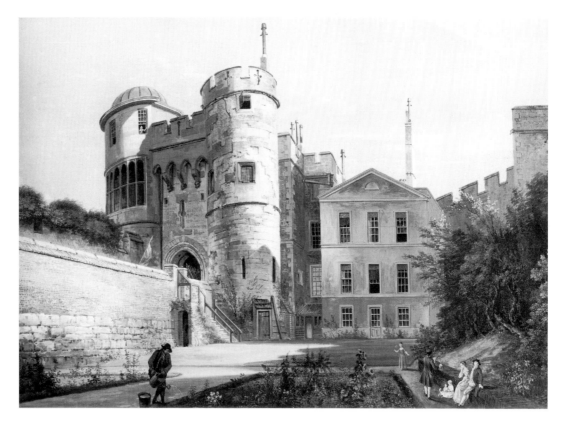

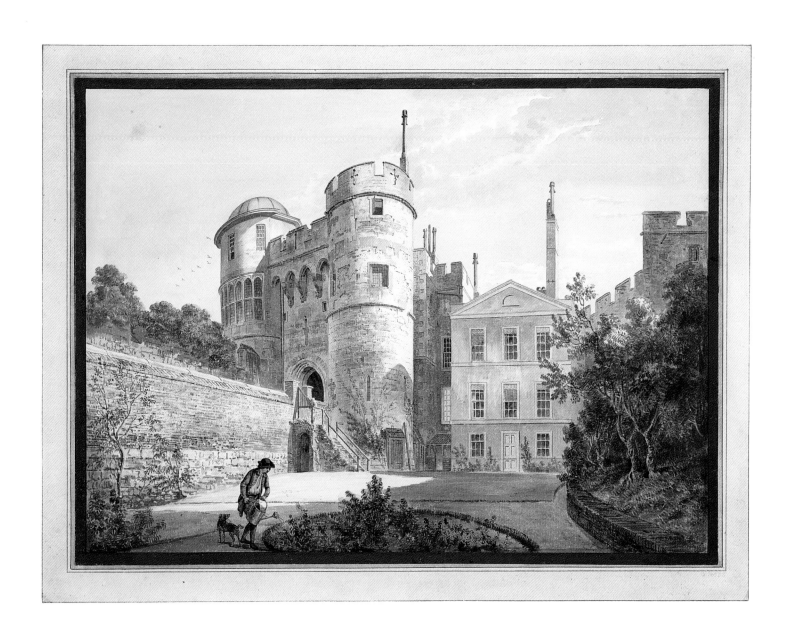

55

13. PAUL SANDBY

View through the Norman Gateway, looking west towards the Winchester Tower, ca. 1770

Watercolour with pen and ink over graphite, 6⅞" × 9¼" (175 × 234 mm)
WATERMARK countermark small crown/GR
MOUNT Type 4. Partially erased inscription: *By Thos Sandby.* Verso inscribed once in graphite, once in pen and ink: *Gateway under the Library, Windsor / P. Sandby*
PROVENANCE Messrs. Leggatt; purchased 1910 (£18, with 29)
Oppé 14; RL 14536

This watercolour is the reverse of 11, and shows the view to the west through the Norman Gateway, with the Magazine Tower and the Winchester Tower behind, seen in the distance through the archway.

The finished bodycolour version of this view, now at Yale (13.1), is inscribed with the date 1767, which suggests that it may have been painted as part of a group to which 1.1 and 2.1 (identically dated) also belonged. Another watercolour version

of this view is at Leicester (Faigan, p.18). The same view (entitled *Under Queen Elizabeth's Picture Gallery*) was included among the outline etchings issued in 1780; a fixed outline drawing at Greiz (E 473) may have served as a model for the etching.

The New Haven view (13.1) includes a group of soldiers marching towards the gate; a similar group (or groups) of soldiers was indicated behind the wall of the New Haven bodycolour of the Moat Garden (12.1).

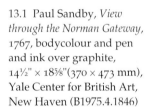

13.1 Paul Sandby, *View through the Norman Gateway,* 1767, bodycolour and pen and ink over graphite, 14½" × 18⅝"(370 × 473 mm), Yale Center for British Art, New Haven (B1975.4.1846)

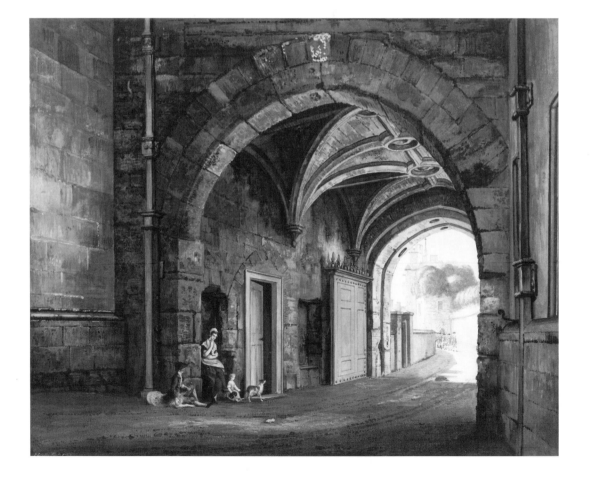

14. PAUL SANDBY

The ascent to the Round Tower, ca. 1770

Watercolour and bodycolour with pen and ink over graphite, 14⅜" × 17⅛" (365 × 436 mm)
VERSO faint graphite outline of north front of Windsor Castle with the Winchester Tower and the north slopes from the Home Park
WATERMARK countermark J VILLEDARY
MOUNT Type 2, in sheet measuring 18" × 24¾" (480 × 630 mm). Verso (now detached) inscribed in graphite, by Paul Sandby (?): *Windsor / View of the Ascent to the Round Tower*. Mount watermark: countermark BLAUW. Banks label inscribed in pen and ink: *Windsor / View of the Ascent to the Round Tower*. Drawing inlaid into wash border during conservation, 1992
PROVENANCE Sir Joseph Banks; Sir Wyndham Knatchbull (sale, Christie's, 23 May 1876, lot 25); purchased (4 gns.) by Gaskell; purchased 1959 (sale, Christie's, 7 July 1959, lot 157)
RL 17876

The long flights of stone steps to the Governor's apartments in the Round Tower were evidently frequented in the eighteenth century by many people other than those in the immediate entourage of the Castle Governor. Sandby has used the steps as the setting for three main groups of figures and three single figures, all shown in a typically characterful manner. The bold perspective construction is gently interrupted rather than assisted by the ladder hanging on the wall at the right. The Round Tower now houses the Royal Archives and is closed to the public. The steps have changed very little since Sandby's time.

No finished version of this view is known. The mount demonstrates that 14 can be securely associated with lot 25 in the Banks sale; it was acquired for the Royal Collection in 1959. The inscriptions on the verso of the old backing sheet are reproduced below (p. 137, Provenance, fig. 1).

14.1 Photograph of the steps to the Round Tower, November 1994

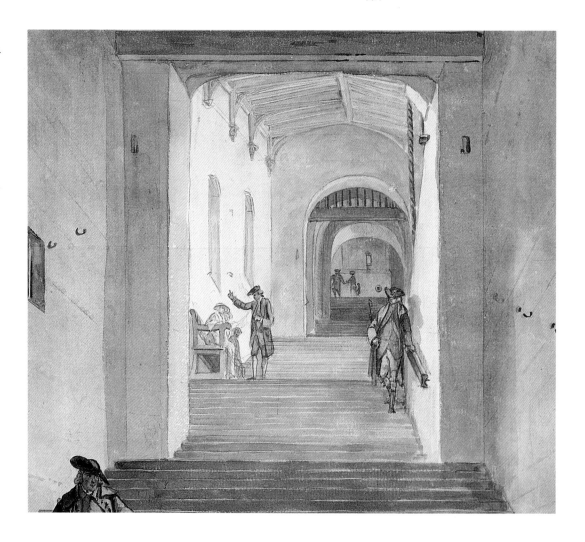

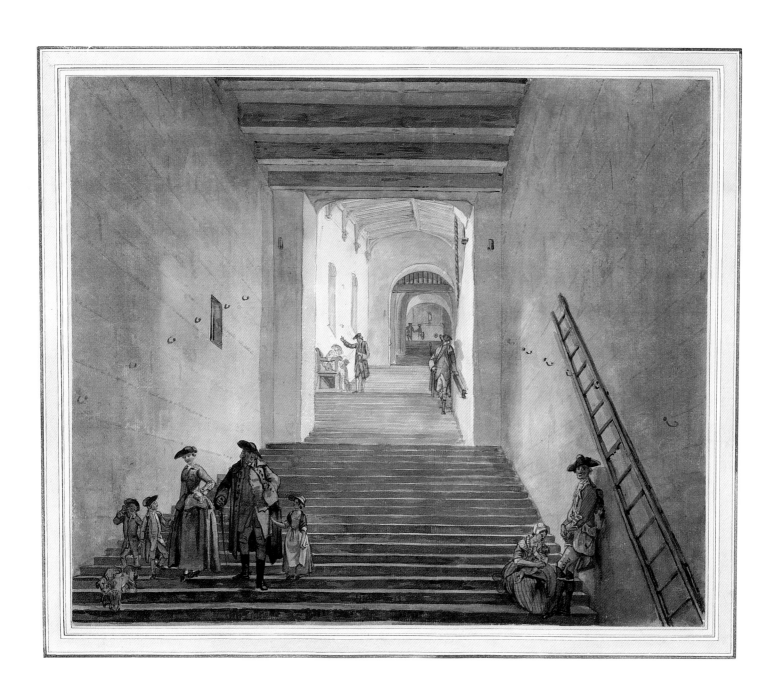

59

III The Upper Ward and North Terrace

The upper Court or Ward, is a spacious regular Square, and contains on the North Side, the Royal Apartments, and the Chapel and Hall of St. George [...]; on the East and South Sides are the several Apartments of his Royal Highness the Prince of Wales, the Royal Family, and the great Officers of the Crown. In the Area or middle of this Court is erected by a faithful and grateful Subject, a noble equestrian Statue in Copper of his Majesty King Charles II. in the Habit of a Roman Caesar, on a Statuary Marble Pedestal, curiously carved in Basso Relievo
(Pote's *Delices de Windsore*, 1755, p.4)

Until some time after the return of the Royal Family to Windsor in the late 1770s, the south and east ranges of the Quadrangle and King John's Tower were divided into separate apartments which were allocated by the Sovereign to individuals as Grace-and-Favour accommodation. Among many others, the Walsingham family had apartments on the south side (until 1783) while the Egertons occupied the tower on the north-east corner of the Castle (until 1804).

The entrance to the State Apartments was *via* the State Entrance, through the archway below the clock in the northern range. Benning's plan and its key (fig. 5) indicate the name of each room. Although the line of the outer walls in this area has remained approximately as it was in Sandby's day, the internal arrangements were considerably adjusted by James Wyatt from 1800 and by Wyatville from 1823. In particular, Brick Court and Horn Court were filled in and the Royal Chapel and St George's Hall were thrown into a single space to form the present St George's Hall.

There were Terraces – or open areas, for promenading – along the outer walls of the north, east and south ranges of the Upper Ward. The North Terrace was the first to be laid down, in the 1530s; the other two were introductions of the late seventeenth century. They were open to the public, in varying degrees. In 1725 Daniel Defoe described the North Terrace as "This noble Walk" and observed that "neither at Versailles, nor at any of the Royal Palaces in France, or at Rome, or Naples, have I seen anything like it" (Defoe, II, p.77). The *Windsor Guide* of 1768 described it as "the noblest walk in Europe". Sandby's many views of the North Terrace themselves provide ample records of the variety of people who enjoyed the use of this area; the number of versions and variants is also testimony to the popularity of the subject well into the nineteenth century.

Detail of 17

Detail of 15

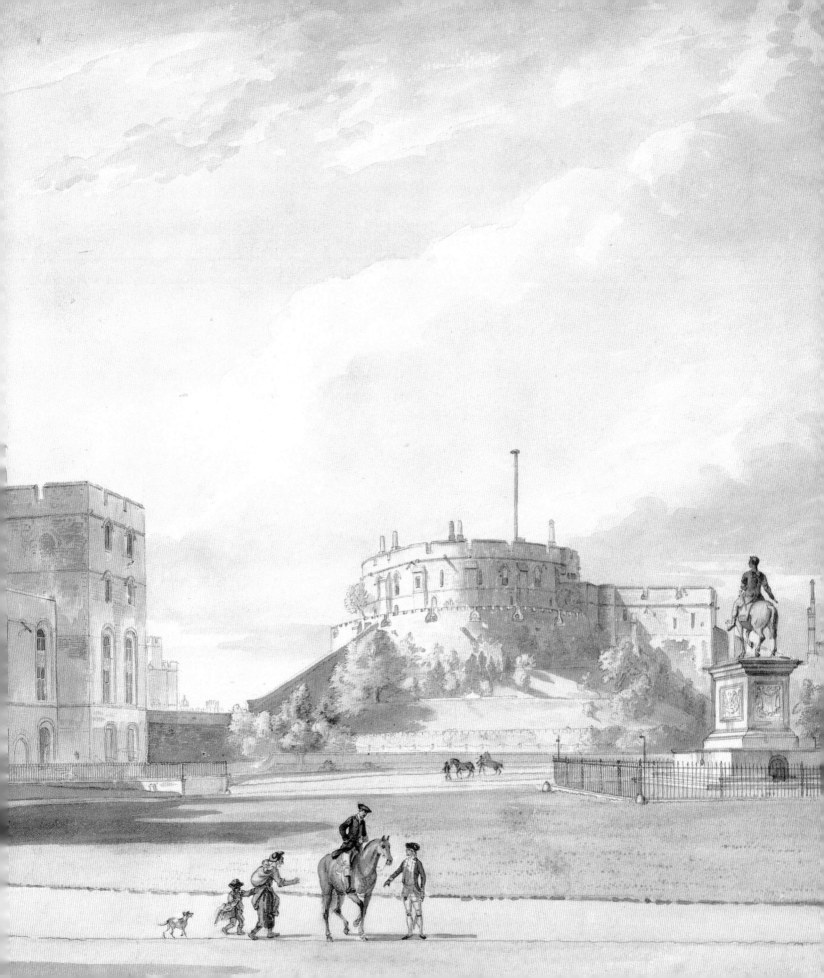

15. PAUL SANDBY

The Quadrangle looking west, ca. 1765

Watercolour and bodycolour with pen and ink over graphite, within black ink line, 12" × 20½" (305 × 522 mm)
WATERMARK Strasburg Lily/VDL
MOUNT Type 2; figures 1–15 inscribed within left and lower buff borders. Verso inscribed in graphite, by Paul Sandby (?): *Windsor / View of the Royal Court.* Mount watermark: Strasburg Lily with countermark IHS/I VILLEDARY. Banks label inscribed in pen and ink: *Windsor / View of the Royal Court*
PROVENANCE Sir Joseph Banks; Sir Wyndham Knatchbull (sale, Christie's, 23 May 1876, lot 49); purchased (16 gns.) by Lord Stair; purchased (with 32) 1936 (sale, Christie's, 19 June 1936, lot 76)
Oppé 38; RL 14560

The Quadrangle is the name given to the space between the buildings of the Upper Ward; the western side of the Quadrangle is occupied by the Round Tower. Wyatville's new apartments for the Royal Family were situated on the southern and eastern sides of the Quadrangle and since the reign of George IV this space has therefore not been open to the public. Wyatville's changes also involved the raising of the Round Tower and the addition of a flag turret (*ca.* 1830); in the southern range the Rubbish Gate (the arch of which is just visible at a low level below the little tower at the left) was closed and the George IV Gate was introduced. In addition, the equestrian figure of Charles II by Josias Ibach (1679), on a base with panels carved by Grinling Gibbons, was turned through 180° and was placed at the west end of the Quadrangle, with

its back to the Round Tower (see 15.2).

This fine watercolour, with figures nearly as minute and delicate as those in the Lower Ward view (8), must be one of the earlier views of the Castle from Banks's collection. With 32 it was purchased at the 1876 sale by Lord Stair and was acquired for the Royal Collection at auction in 1936. In both cases there has been some fading owing to exposure to light. No related works are known, apart from a pencil drawing of the central area in the album at Greiz (15.1). *A view from the east side of the Royal Court at Windsor Castle* by Paul Sandby was lot 102 on the second day of the Sandby sale in 1817.

The significance of the figures 1–15 in the inner border of the old mount (along the left and lower edges) of 15 has not been explained.

15.1 Paul Sandby, *Windsor Castle Court Yard, Upper Court*, ca. 1770, graphite, 7⅝" × 10⅝" (193 × 270 mm), Staatliche Museen Greiz (E474)

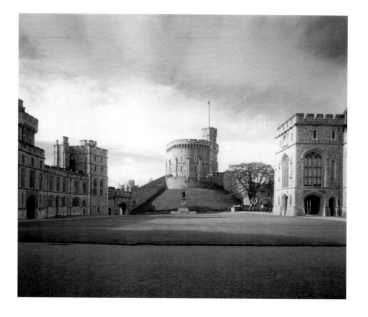

15.2 Photograph of the Round Tower from the Quadrangle, November 1994

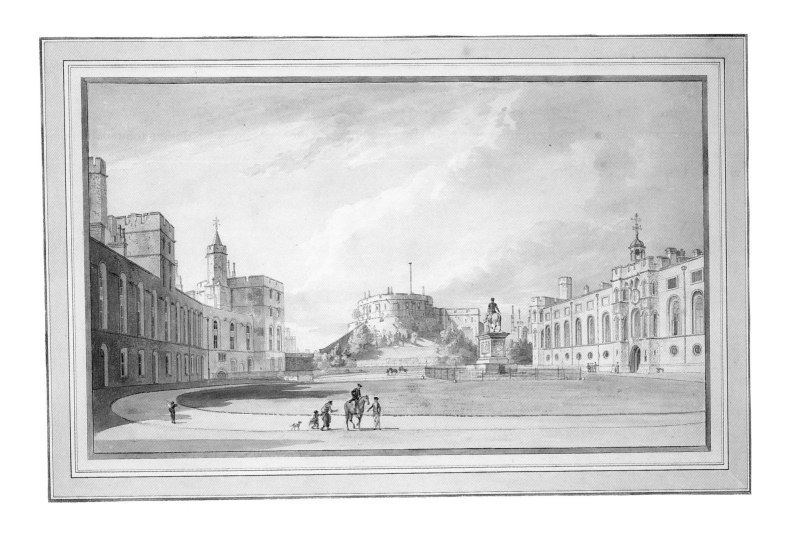

16. PAUL SANDBY

The North Terrace looking west, with a seated mother and children in the foreground, ca. 1790

Watercolour with pen and ink over graphite, 12¼" × 16⅞" (311 × 430 mm)
WATERMARK countermark IV
MOUNT Type 1. Mount watermark: Strasburg Lily/GR with countermark IV
PROVENANCE [Paul Sandby: see mount type;] Royal Collection by 1910 (bears Edward VII mark)
Oppé 2; RL 14524

16.1 Photograph of the North Terrace looking west, November 1994

16.2 Paul Sandby, *The North Terrace looking west*, ca. 1768, bodycolour, 15" × 19" (380 × 480 mm), collection of HM Queen Elizabeth The Queen Mother

The North Terrace was the most popular subject painted by Paul Sandby and remains little changed to this day (16.1). He produced quantities of views of the Terrace, looking east or looking west, from the 1760s until his death fifty years later. These exist in a variety of media – oil, bodycolour, watercolour, pencil, aquatint and etched outline – in collections throughout the world (see the summary in Dorment, pp.357–62). The first exhibited views of the Terrace were *A view on the North side of the Terrace at Windsor* (Society of Artists, 1766) and two views, looking east and west, at the Royal Academy in 1774. There were no obvious pairs of North Terrace subjects among the three relevant items (lots 1, 12 and 46) of the Banks sale in 1876; none of these was acquired for the Royal Collection, which remains surprisingly devoid of early North Terrace views. However, there is a fine bodycolour, looking east (RL 23138; acquired in 1980), and a pair of pencil views inscribed with the date 1777 (Oppé 1 and 7).

Of the surviving North Terrace views in other collections, the earliest and finest are the pair of bodycolours now at Yale (17.1 and 17.2), one of which may be related to Sandby's 1766 exhibit. There are two pairs of North Terrace views, both in bodycolour, which concentrate on the dramatic light effects at sunrise (view to the east) and sunset (view to the west). One pair is at Eton College; the other is divided between the National Trust at Anglesey Abbey and the Victoria and Albert Museum, London (Herrmann, p.89). These may be related to the series of views exhibited by Paul Sandby at the Royal Academy in 1770, entitled *Morn, Noon, Evening, Night in water-colours*. The set

of aquatint views of Windsor published in 1776 included a pair of North Terrace subjects rather more extensively populated than the earlier bodycolours. The oil in Philadelphia may be associated with one of the 1774 Royal Academy exhibits; its pendant could be the painting in the Royal Collection (Millar 1055) described by Dorment as a later copy but probably identifiable with an oil by Sandby purchased by Seguier (presumably for the Prince Regent) in the 1817 Paul Sandby sale. Dorment associated the two rather taller North Terrace views from the Drumlanrig series with the 1774 exhibits, but they may be a little later, *ca.* 1780. No Castle views were exhibited by Sandby in the 1780s or 1790s. The final Terrace exhibit was at the Royal Academy in 1802. There is a view to the west dated 1800 in the Victoria and Albert Museum, and two views to the east dated 1803, respectively in the Royal Collection (Oppé 10) and at Christie's in 1988; all three are in bodycolour.

The viewpoint of 16 is rather further to the west than that normally employed; it therefore omits the lobed parapet of the wider area of the North Terrace in front of the Star Building. The archway in the left foreground leads to the stone steps which issue into Engine Court (opposite the foot of the entrance to the Round Tower). There are several early prototypes for this view, including the fine bodycolour in the collection of Queen Elizabeth The Queen Mother (16.2), which has been identified with lot 12 of the 1876 sale of Banks's collection; the view was also the subject of one of Sandby's 1777 outline etchings. For a detail of the sky in 16, see below, Media, fig. 1.

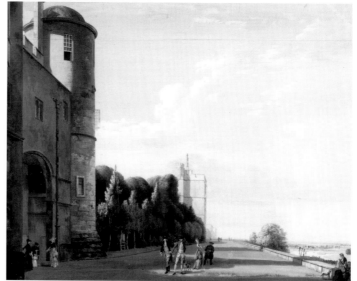

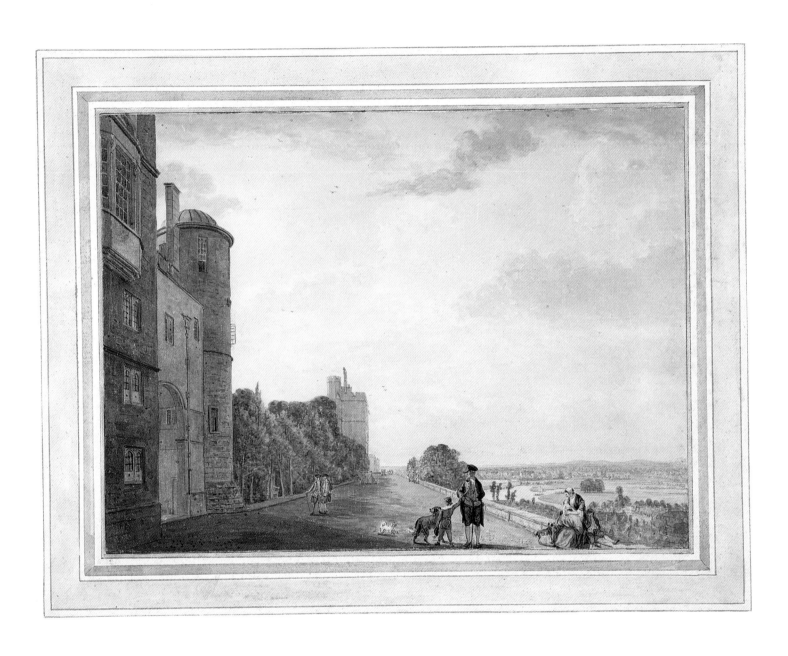

17. PAUL SANDBY

The North Terrace looking west, with a seated man in the foreground, ca. 1790

Watercolour and bodycolour with pen and ink over graphite, 13⅝" × 21" (345 × 532 mm)
WATERMARK countermark IHS/I VILLEDARY
MOUNT Type 1. Mount watermark: A STACE. Verso inscribed in graphite: *View on the Terrace of Windsor Castle / looking Westward*
PROVENANCE Paul Sandby (sale, Christie's, 2 May 1811, lot 88 or lot 96); both purchased (£2. 15s. and 3 gns. respectively) by Shepperd for the Prince Regent (later King George IV); by descent
Oppé 4; RL 14525

Both 16 and 17 are watercolour versions of views of the North Terrace looking west, painted frequently by Sandby in oil, bodycolour and watercolour from the 1760s (see 16). Cat. 17 is painted from virtually the same viewpoint as most of the other views to the west (including 17.2) – within the wider platform opposite the Star Building.

The tonality in 16 and 17 is naturally more subdued and the colouring less varied than in Sandby's earlier works. The yellow glow (to indicate late afternoon sun) in both drawings is a typical feature of Sandby's watercolours of the 1780s onwards. There are several unobtrusive instances of pen and ink underdrawing in both watercolours; the depiction of the village of Clewer (in the distance on the right) is particularly delicate. Oppé pointed out that the Windsor Uniform worn by one of the figures in the foreground of 16 indicates a date after 1778. It is likely that both 16 and 17 (like 9 and 10) date from ca. 1790.

The album at Greiz contains a number of general North Terrace views (E 470–71, E 475–78 and E 487), and pencil studies of architectural details in this area (E 491, E 509 and E 510) which were doubtless made in preparation for this great series. These include a detailed study of the oriel window of Queen Anne's Closet (17.1) which was probably used both in 17.2 and in 17.

17.1 Paul Sandby, *Windows overlooking the North Terrace*, ca. 1760, graphite, 12⅝" × 9¼" (319 × 236 mm), Staatliche Museen Greiz (E 491)

17.2 Paul Sandby, *The North Terrace looking west*, ca. 1765, bodycolour, 15" × 21½" (379 × 545 mm), Yale Center for British Art, New Haven (B1981.25.2693)

17.3 Paul Sandby, *The North Terrace looking east*, ca. 1765, bodycolour, 15" × 21¼" (380 × 540 mm), Yale Center for British Art, New Haven (B1981.25.2689)

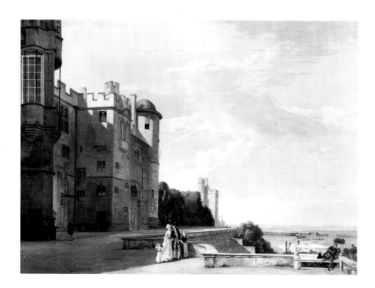

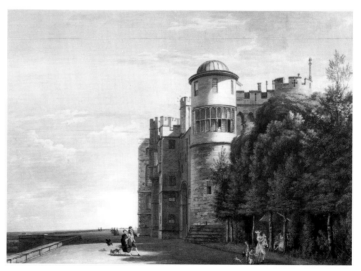

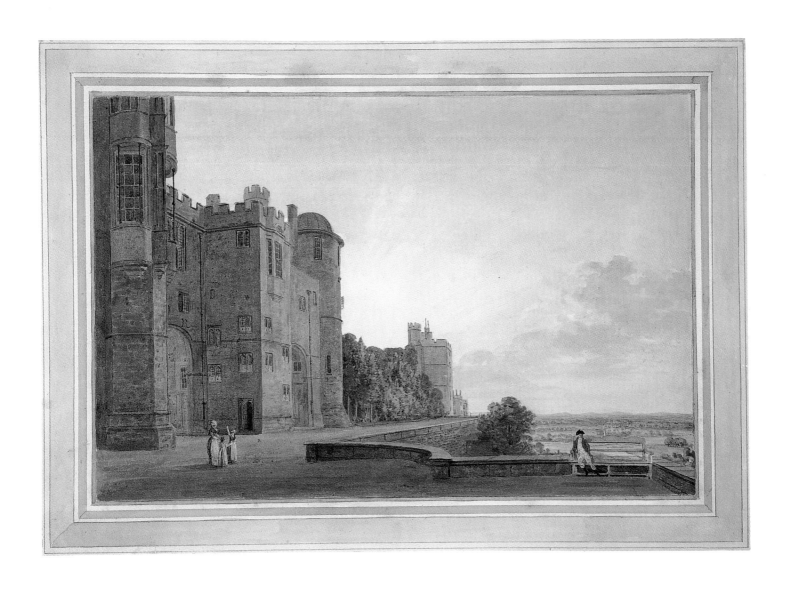

18. PAUL SANDBY

The meteor of 1783 seen from the east end of the North Terrace, ca. 1783

Watercolour over graphite, 11⅛" × 19⅜" (282 × 493 mm)
WATERMARK Strasburg Lily/GR and countermark I TAYLOR
MOUNT Type 4. Inscribed in pen: *WE* (in monogram: Lugt 2617) and *P Sandby*, and in graphite: *Vide the back.* Verso inscribed in pen: *EIE* (in rectangle), and *WE* (in monogram) *P93 The representation of a fiery meteor which pass'd over London ab⁺ 9 O clock in the evening of 18ᵗʰ August 1783. / Taken from Windsor terrace. P Sandby.*
PROVENANCE William Esdaile (not recognisable in the catalogue of his sale, June 1840); Royal Collection by 1910 (bears Edward VII mark)
Oppé 53; RL 14577

As is clearly indicated by the inscription on the back of the mount, the event shown in this watercolour is the passing of a meteor on the evening of 18 August 1783, seen from the eastern end of the North Terrace. The subject was reproduced in an aquatint published by Paul Sandby in October 1783 and dedicated to Joseph Banks by both the Sandby brothers (18.1). According to the account of Dr Tiberius Cavallo (1749–1809) included in the *Philosophical Transactions* for the following year: "Being upon the Castle Terrace at Windsor, in company with my friend Dr James Lind, Dr Lockman, Mr T. Sandby and a few other persons, we observed a very extraordinary meteor in the sky. Mr Sandby's watch was seventeen minutes past nine nearest; it does not

mark seconds." Dr Lind (1736–1812) was physician to the Royal Household; Dr Lockman (1722–1807) was a Canon of St George's (see 6). The inscription below the aquatint (18.4) explains the serial depiction of the meteor, from left to right : first "A. its appearance soon after it emerged from a cloud in the NW by W where it was first discovered. B. its further Progress, when it grew more strong. C. When it divided & formed a long train of small luminous bodies each having a trail: in this form it continued till it disappeared from the interposition of a Cloud in E by S." A recent study of the depiction of comets has remarked on the "surreal quality" of observation in these views, and "the artist's strange depiction of the meteor travelling across the sky three times, as it

18.1 Paul Sandby or Thomas Sandby, *The comet of 1783 as seen from the east angle of the North Terrace*, 1783, watercolour, 12⅝" × 20⅛" (320 × 511 mm), British Museum, London (LB TS 27(20))

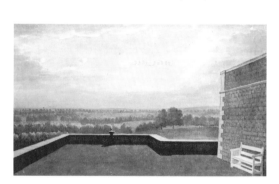

18.2 Thomas Sandby or Paul Sandby, *The comet of 1783 as seen from the east angle of the North Terrace*, 1783, watercolour, 11⅛" × 18⅛" (284 × 460 mm), British Museum, London (LB TS 27(19))

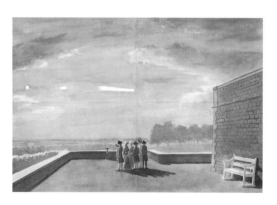

18.3 Paul Sandby, *The comet of 1783 as seen from the east angle of the North Terrace*, 1783, watercolour over pen and ink, 12½" × 19" (318 × 483 mm), Yale Center for British Art, New Haven (7-25-94)

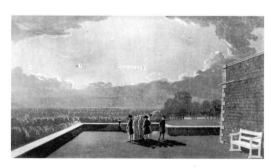

18.4 Paul Sandby after Thomas Sandby, *The comet of 1783*, 1783, aquatint, image 10¾" × 19½" (274 × 494 mm), British Museum, London (Case 21, Imp. Unm. Box)

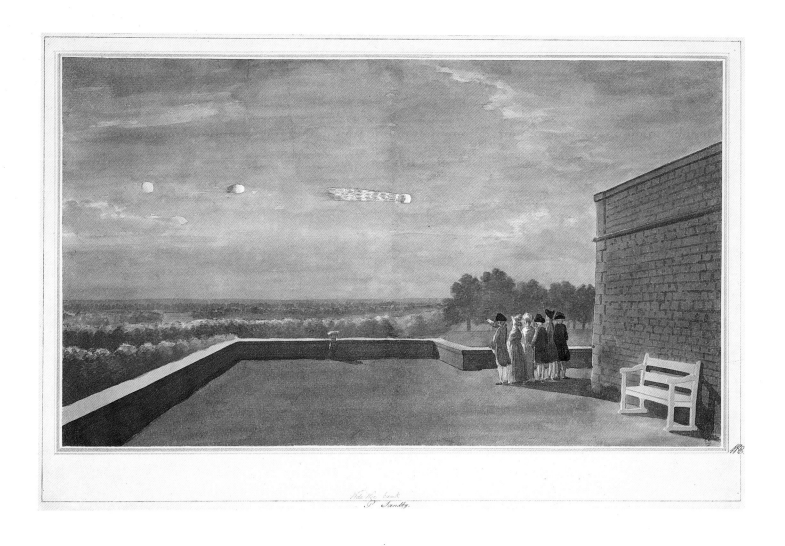

develops a tail. The effect is that of three superimposed still photographs" (Roberta M. Olson, *Fire and Ice*, New York 1985, p.71).

In view of Thomas Sandby's close association with the sighting of the meteor, this watercolour could be one of the few firm anchors for the attribution of drawings to Thomas as opposed to Paul Sandby. However, the existence of a number of variants of this view, together with Esdaile's attribution of 18 to Paul, means that after all it is not. Thomas's known weakness in figure drawing, coupled with the fact that he could not easily have drawn a group of figures to which he himself belonged, might sug-

gest that the version of the view from which figures are excluded (18.2) may be his (sole) record of the event; as such it would be a rare instance of a datable landscape by Thomas at this stage of his life. The other watercolour versions of the scene (18.1 and 18.3), which include both the meteor and the group of figures in varying positions, would thus be the work of Paul. However, against this is the fact that the old mounts of 18.1 and 18.2 are inscribed in an early hand "by Thos. Sandby" and "by Paul Sandby".

For details of the watermarks, see below, Media, figs.4, 5.

IV The Castle exterior: the northern approach

This section contains some of Sandby's views recording the appearance of the Castle as the traveller approaches Windsor from the north, having crossed the River Thames at Datchet. At that point, a pedestrian could proceed into the Little Park, to approach the Castle from the south-east. But all other travellers had to turn right or left on the Windsor bank and proceed by the road between the late seventeenth-century park walls and the river. Collier's map (fig. 4) shows the narrow strip occupied by this road; in several places it was at risk of being eroded by the flow of the river and repairs were frequently required. The usual route to Windsor involved a right turn after the river crossing, before proceeding first north then west and south. Alternatively the town and Castle could be reached from the south by turning left towards Old Windsor after crossing the river, before branching right past Frogmore and proceeding to Windsor along Park Street.

The more frequently used river crossing-point was the bridge between Eton and Windsor, further upstream, leading immediately into Windsor town opposite the north front of the Castle. But the Datchet route was also used by numerous travellers, and incidentally presented Sandby with a wide range of attractive subjects.

Until the beginning of the eighteenth century the river was crossed at Datchet by ferry. A wooden bridge on stone piers was erected in 1706 to improve the crossing. By 1793 the bridge needed considerable repairs; two years later it was closed and the ferry was brought back into service while discussions concerning alternative designs, construction and location proliferated. With the major changes in access to Windsor in the 1840s and 1850s, a river crossing-point at Datchet was abandoned in favour of one further upstream, whence a new road proceeded due east towards Windsor. A large area of the Home Park in the curve of the river to the north of this road became the Home Park Public, intended for recreational use. At the same time, the road past Frogmore was closed and the route between Old Windsor and Windsor was moved further south, beyond the southern edge of the Frogmore estate. A second bridge was built as part of the new road between Datchet and Old Windsor.

Although Paul Sandby frequently recorded the Castle from the east and north, many of these views were taken from within the Little Park and are therefore included in a later section (see 34–36). Because of the narrow area between the high park wall and the river, the Castle was excluded from the traveller's view until beyond the north-western corner of the Park, close to the northern end of Romney Island. The full extent of the Castle's northern façade could be seen to best advantage from within the Little Park or from the Eton side of the river. Sandby also painted a number of fine views of Eton, several of which were once owned by Banks.

Detail of 19

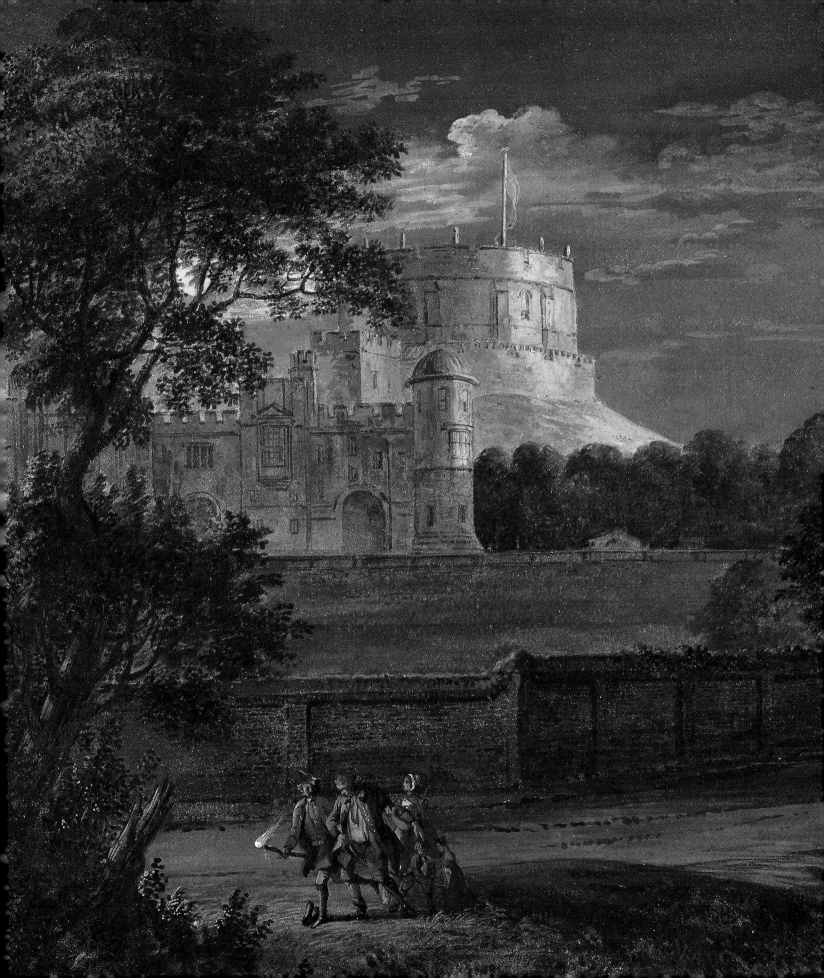

19. PAUL SANDBY

The Castle from Datchet Lane on a rejoicing night, 1768

Watercolour and bodycolour, including gold paint, within black line, 12⅛" × 18⅛" (307 × 459 mm). Signed and dated in gold, bottom left: *P Sandby 1768*
WATERMARK countermark IHS/I VILLEDARY
PROVENANCE Royal Collection by 1910 (bears Edward VII mark)
Oppé 60; RL 14584

For this view Sandby has adjusted the relative scale of the buildings, thus suggesting that we are closer to the north front of the Castle than we actually are. The viewpoint for 19 is immediately to the north of the bridge leading to Lower Romney Island, which is itself to the north of the Engine House (seen at right in 19), the viewpoint for 20. The two small bridges at this point are noted in Collier's plan (fig. 4); they are around half a mile from the north front of the Castle.

In 1768 Paul Sandby exhibited a *View of Windsor on a Rejoicing Night* at the Society of Artists. The Banks sale included a *View of the Castle, taken on a rejoicing night from the King's Engine House* (lot 9; purchased by Seabrook, £1. 10s.). The subject exists in several versions, including three of the 1760s, all of which are in the Royal Collection, each employing a slightly different viewpoint. Of these 19, which is dated 1768, is the finest, and is taken from the most distant viewpoint. The smallest is 19.2, which has a wider format, making the Castle appear more distant. The largest is 19.1, from slightly closer to the Castle: the view is indeed taken from the same point as 20 (and 20.1). Fig. 19.1 (which was presented by Lord Fairhaven to Princess Elizabeth, now Her Majesty The Queen, in 1947) may be the picture exhibited in 1768. A Banks provenance for 19 is suggested both by its former mount and by its exceptional quality. However, there are strong reasons

for associating lot 9 in the 1876 sale with 19.2, which leaves 19 unidentified therein.

The cause of rejoicing in these views is far from certain. The thick foliage on the trees indicates that it cannot be Guy Fawkes night (5 November), although the celebrations in the Castle on that night were the subject of one of Sandby's later aquatints (I.1). As the Society of Artists exhibition opened in late April it is likely that Sandby's exhibit in 1768 referred to an event of the previous year, while the date on 19 suggests that it may refer to an event in the inscribed year, 1768. The celebrations appear to have involved a bonfire in the same position as that for 5 November.

The dramatic effect is created by the use of deep-toned bodycolour and watercolour highlighted by touches of paint of brighter hues. Particularly notable is the gold paint used to suggest the fireworks, to show the light glistening in the windows of the Winchester Tower and on the buttons of the retreating group of merry-makers, and also for the artist's signature.

The King's Engine House, which pumped water up to the Castle, was designed by Vanbrugh in 1718 and survives to this day, beside the Southern Region railway line. A small watercolour by Paul Sandby of the Engine House looking north is also in the Royal Collection (RL 17758; purchased 1954).

19.2 Paul Sandby, *Windsor Castle from Datchet Lane on a rejoicing night*, ca. 1770, watercolour and bodycolour, 9⅜" × 13" (238 × 353 mm), Royal Library (Oppé 61; RL 14585)

19.1 Paul Sandby, *Windsor Castle from Datchet Lane on a rejoicing night, ca.* 1768, watercolour and bodycolour, 18¼" × 28½" (465 × 725 mm), Royal Library (RL 17598)

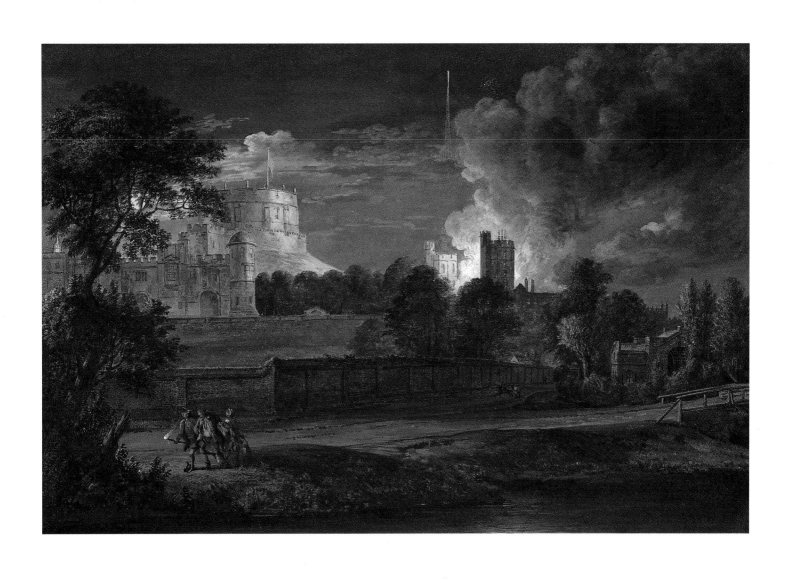

20. PAUL SANDBY

The north front of the Castle from Datchet Lane near Romney Island,
ca. 1785

Watercolour and bodycolour over graphite, 12" × 18"
(305 × 456 mm)
WATERMARK Strasburg Lily/LVG
MOUNT Type 1. Inscribed in graphite: *WINDSOR from DATCHET ROAD.* Mount watermark: Strasburg Lily/GR with countermark I TAYLOR
PROVENANCE Paul Sandby (sale, Christie's, 2 May 1811, lot 94); purchased (£2. 4s.) by Shepperd for the Prince Regent (later King George IV); by descent
Oppé 69; RL 14593

This view is taken from beside the bridge over the stream between Lower Romney Island and the Windsor bank, adjacent to the King's Engine House (seen in 19).

A view of the Castle from the King's Engine House was included in Banks's collection (1876 sale, lot 21; purchased by Sandby – presumably William Sandby – for £7. 15s.). This may be identifiable with the fine bodycolour painting in a private collection (20.1). A very similar image was included in the small series of etched Windsor views of 1780, based on a design of 1769. With what Oppé described as "its massive foliage and picturesque trees, atmospheric feeling and disproportionate figures", 20 may be a rather later version of this view.

A very similar view in bodycolour, probably of around the same date as 20, was recently sold in Paris (Etude Couturier Nicolay, 17 June 1994, lot 32). Typically, the placing and scale of the figures varies from view to view, but the *dramatis personae* remain similar.

The stretches of water around Romney Island were a favourite haunt for fishermen in Sandby's time. The fine watercolour view of the Castle from Romney Meadows (20.2) shows the track parallel to the river on Romney Island along which the Thames bargemen would lead their boats upstream; it was acquired for the Royal Collection in 1955 and is identifiable with lot 32 in the Banks sale.

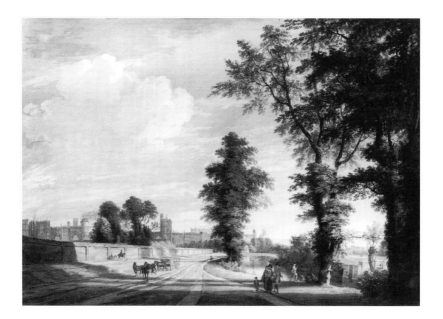

20.1 Paul Sandby, *Windsor Castle from Datchet Lane,* *ca.* 1769, bodycolour, 15" × 21½" (380 × 545 mm), private collection

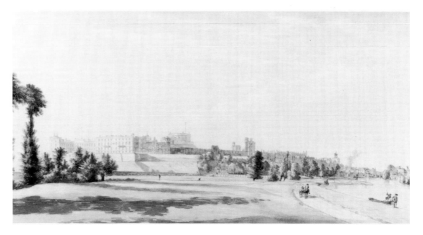

20.2 Paul Sandby, *Windsor Castle from Romney Island,* *ca.* 1765, watercolour over graphite, 10⅜" × 20½" (262 × 520 mm), Royal Library (RL 17807)

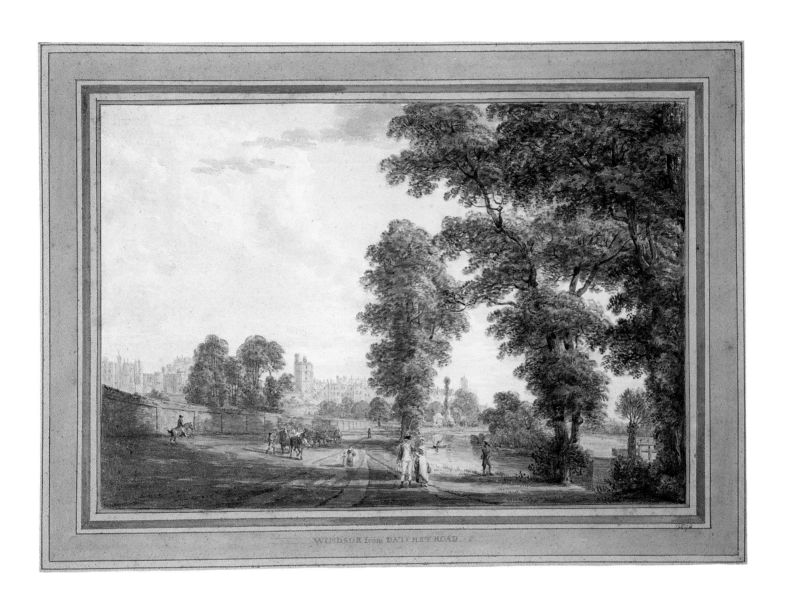

WINDSOR from DATCHET ROAD.

21. PAUL SANDBY

The Castle from a point east of the Isherwood Brewery, with the houses of Datchet Lane to the right, ca. 1790

Watercolour with pen and ink, over graphite, 8½" × 17⅛" (218 × 436 mm)
WATERMARK countermark
I VILLEDARY
MOUNT Type 1. Inscribed in graphite (Oppé considered the inscription "recent or ... rehandled"): *Part of Windsor from Datchet Lane 1770*. Mount watermark: 1798
PROVENANCE [Paul Sandby: see mount type;] Royal Collection possibly by 1892 (Sandby, p.215), certainly by 1910 (bears Edward VII mark)
Oppé 70; RL 14594

After proceeding due south towards the Castle, Datchet Lane turned sharply to the west before passing along the northern edge of the land below the north front of the Lower Ward of the Castle. On the inside corner was a large house which was acquired (with adjoining land) by the Crown in 1755 from Richard Crowle, in exchange for lands in Yorkshire. The house is shown on the right of 21; it can be clearly seen on one of the plans of Crowle's estate made at the time of the exchange (21.1). The north façade of the house was shown by Canaletto in his painting of Windsor Castle dated 1747 (21.2). The old label on the frame of Canaletto's painting states that it was painted "from the window of the small Cottage at the end of the Enclosure next Mr. Crowle's Garden", that is, at the northern end of Pearman's Close (see fig.4).

The smoke rising through the centre of this view may originate from the brewhouse that is the subject of 22. Oppé noted that "the minute but rather mechanical penwork in the architecture and trees conflicts with the summary atmosphere colouring which is especially happy in the houses on the right". The warm sunglow at right may suggest a date *ca.* 1790.

This subject cannot be identified either in the Banks sale or among Sandby's early exhibits. However, the etched outline recording the same view is inscribed "drawn 1769, Etch'd 1780"; there is a fixed pencil drawing of the view at Greiz (E 503).

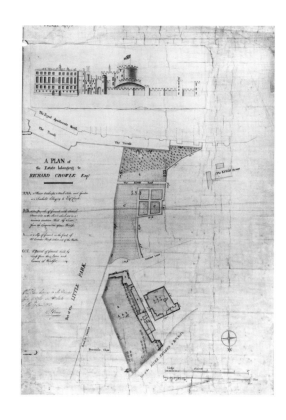

21.1 *A plan of the Estate belonging to Richard Crowle Esqr, ca.* 1755, Public Record Office, London (Work 34/175)

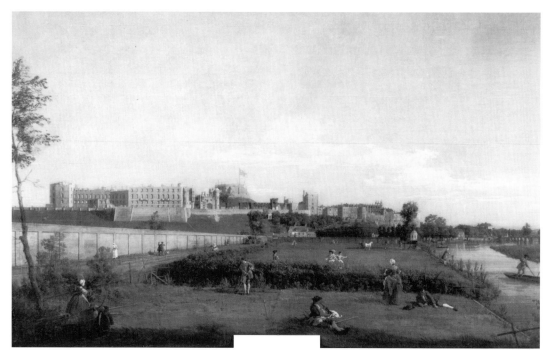

21.2 Antonio Canal, called Canaletto, *Windsor Castle from the north*, 1747, oil on canvas, 32½" × 53½" (82.6 × 136 cm), collection of the Duke of Northumberland

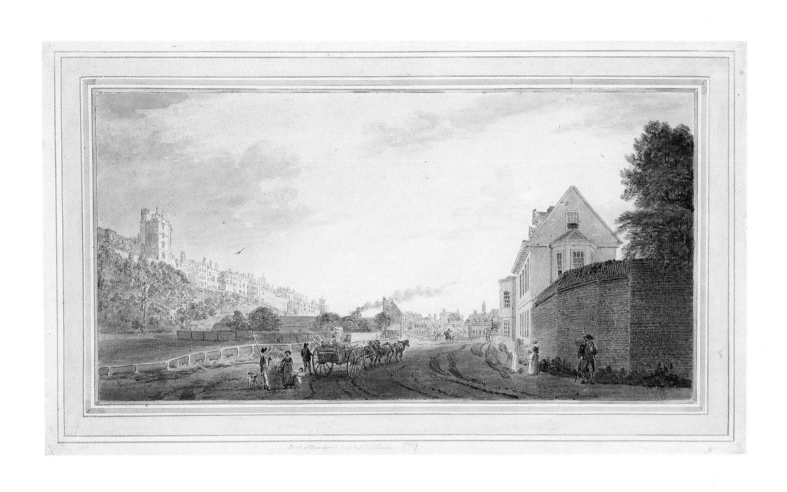

22. PAUL SANDBY

The north front of the Castle from Isherwood's Brewery in Datchet Lane, ca. 1765

Watercolour and bodycolour with pen and ink,
14⅞" × 21¼" (378 × 540 mm)
WATERMARK countermark
IHS/I VILLEDARY
MOUNT Type 4, in sheet measuring 19" × 25"
(482 × 635 mm). Verso (laid down) inscribed in graphite, by Paul Sandby (?): *View of the Castle from the Gateway of the Brewer's Yard in Datchet Lane*
PROVENANCE [Sir Joseph Banks; Sir Wyndham Knatchbull (sale, Christie's, 23 May 1876, lot 24); purchased (£4. 15s.) by Seabrook;] family of William Seabrook; purchased 1925 (6 May, locally)
Oppé 72; RL 14596

This view is taken from the brewhouse in Datchet Lane which was owned for much of the late eighteenth century by the Isherwood family. The brewhouse appears to have occupied a site close to the Thames Street junction with Datchet Lane and to have been distinct from the larger and older brewhouse or inn called The Crown, which is also documented on the south side of Datchet Lane from the mid-sixteenth century. The Crown Inn estate was reduced on two occasions in the eighteenth century: first in 1743 when the Steward's Plot and College Garden were leased out separately (to Richard Crowle), secondly in 1782 when the stables and coach houses were removed for use as the Canons' Mews. These stable buildings are seen in some of Sandby's views of the Hundred Steps (*e.g.* 23.2). In 1799 another part of the Crown Inn estate was set aside for the construction of accommodation for seven Poor (Naval) Knights of Windsor (of Travers' Foundation). The new building, known as Travers' College, was completed in 1803; the buildings are now used by St George's School, where the choristers of St George's Chapel are educated.

The father of Henry Isherwood (1743–1797), who died in 1772, was apparently the founder of the smaller brewing enterprise to the west of the Crown Inn but also in Datchet Lane. Isherwood Senior and his partner William Reddington, both brewers,

leased a house in Thames Side in 1749. Land abutting the Crown Inn estate was occupied by Isherwood by 1754. Isherwood Junior became an important landowner in Windsor and in 1786 bought the lease of the Rectorial Manor of Old Windsor. In 1796, the year before his death, he was elected Member of Parliament for the Borough. He is shown by Sandby among a group of figures on the North Terrace (Oppé 243); his sisters were the subject of another figure study (Oppé 300). The site occupied by Isherwood's Brewery was still in use as a brewery earlier this century.

The size and high degree of finish of 22 suggest that it could be identified with either or both of the following views: that exhibited at the Society of Artists in 1765, and that included as lot 24 in the 1876 Banks sale. A pencil drawing of the subject is at Greiz (E 505). In 1780 Paul Sandby published an etching of the same view entitled *Windsor from Isherwood's Brew-house in Datchet Lane*. A number of later variants are preserved in the Royal Collection (Oppé 71 and 73) and elsewhere (including one recently at Agnew's). In 22 there is a subtle change of atmosphere from the dark, sordid, almost steaming foreground to the bright sky and Castle behind; this transition becomes degraded in the later versions. The pinks, brick reds and apple greens are particularly remarkable in 22.

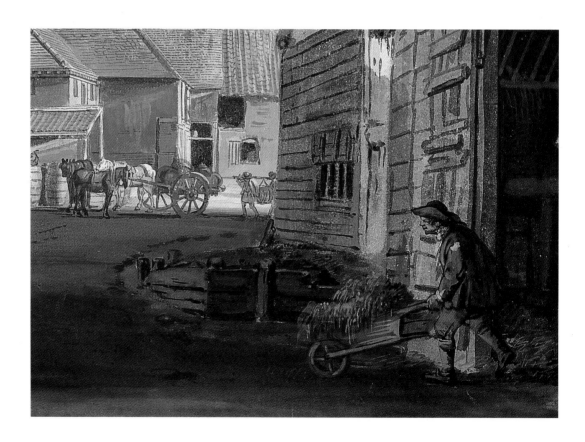

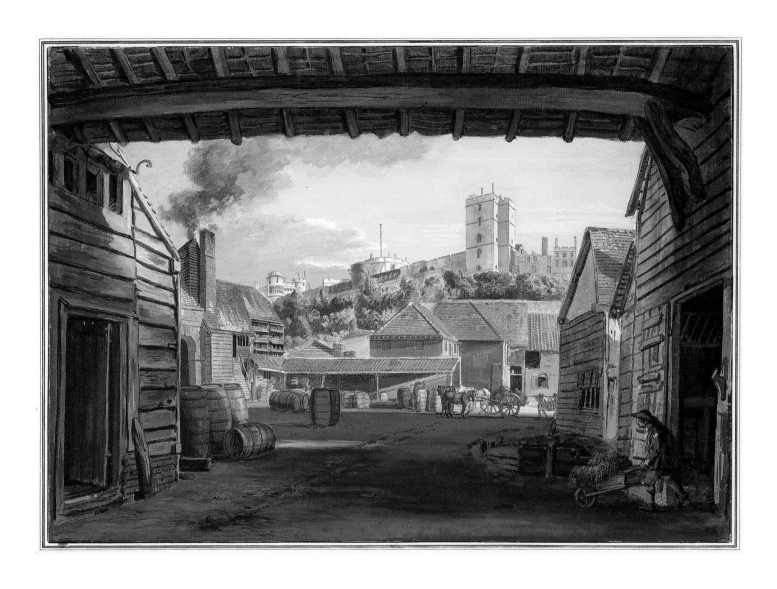

23. PAUL SANDBY

The Hundred Steps,
ca. 1760

Watercolour with pen and ink over graphite, within line (grey) and wash (grey) border, 6¼" × 8⅜" (159 × 212 mm) MOUNT Type 4. Inscribed on verso in graphite, by Paul Sandby (?): *Windsor. View of Winchester Tower & part of the Hundred Steps*
PROVENANCE Sir Joseph Banks; Sir Wyndham Knatchbull (sale, Christie's, 23 May 1876, lot 2); purchased (2 gns.) by Hogarth, probably for the Royal Collection; Royal Collection by 1892 (Sandby, p.215)
Oppé 50; RL 14574

There has been pedestrian access to the north side of the Lower Ward, *via* a steep flight of steps, since the Middle Ages. The entrance to the steps is through a gated entrance at the point where Thames Street turns west at the foot of the Castle slopes; the steps finally issue into the Canons' Cloister. They were rebuilt in the nineteenth century and are no longer open to the public.

The Hundred Steps provided Sandby with two distinct subjects: one concentrating on the uppermost flight, the other showing the full extent of the steps, from the foot. It is likely that the former was evolved first, to produce 23 and the fine bodycolour now in Nottingham (23.2). The larger view is known in several versions: the watercolour in Dublin (23.1) is close to a drawing at Windsor (Oppé 47) dated 1777 and to the outline etching of the same year; there is a variant pencil drawing in Greiz dated 1775 (E 482). Two later bodycolours, both acquired by the Prince Regent at Sandby's

1811 sale, are also in the Royal Collection (Oppé 48 and 49). Two views of the Hundred Steps were included in the Banks sale in 1876: lot 2 was purchased for 2 gns., probably for the Royal Collection, and is identifiable with 23; lot 48 remained unsold at £5. 15s. 6d. but appears to have been bought by W.A. Sandby, through whose bequest the Dublin watercolour reached its destination.

Unusually, the figures in 23 are not obviously associated with those in any of the other versions of this composition. Oppé commented on the "highly conscious virtuosity in the composition and the elongated figures ... posed in twisted, somewhat affected attitudes such as are common in Sandby's early studies, but are less often found in the landscapes. They may show the influence of Gainsborough, or a common, momentary fashion." The romantic foliage on the left contrasts with the much looser treatment on the right.

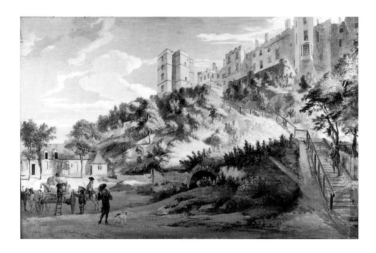

23.1 Paul Sandby, *The Hundred Steps with the Winchester Tower, Windsor Castle, ca.* 1765, bodycolour, 15⅛" × 23¾" (385 × 604 mm), National Gallery of Ireland, Dublin (2577)

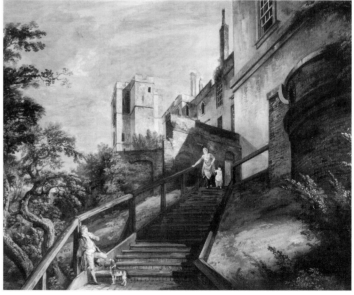

23.2 Paul Sandby, *Part of the Hundred Steps with the Winchester Tower, Windsor Castle, ca.* 1765, bodycolour, 19" × 22⅝" (482 × 575 mm), Castle Museum, Nottingham

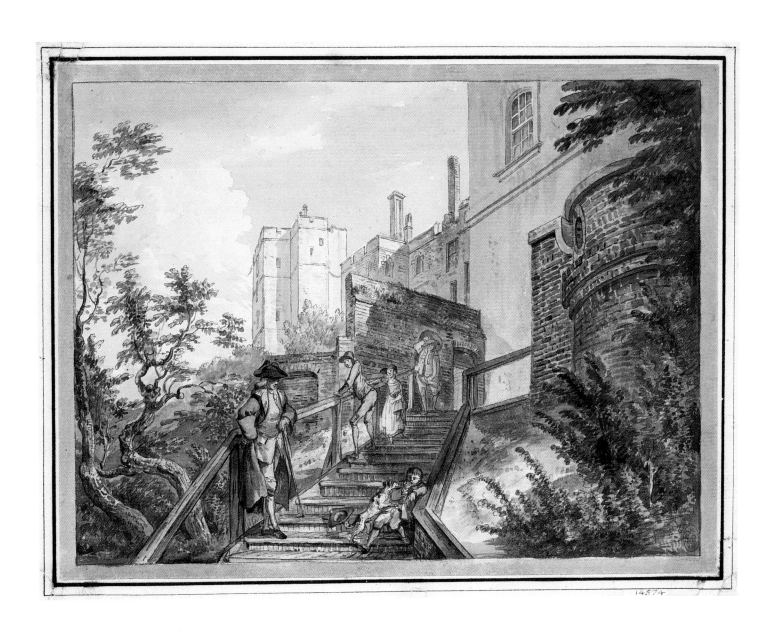

14574

81

V The Castle exterior: the south side

In medieval times the south, west and east sides of the Castle were surrounded by a dry ditch. Along the exterior walls of the Lower Ward numerous houses occupied the ditch. Those to the west are shown in detail in plans such as V.2; they are also indicated in Collier's plan (fig.4). Although to our late twentieth-century eyes the buildings to the left of the Henry VIII Gateway in 24 have considerable charm, the ditch behind them harboured filth and disease. In 1864 Charles Knight, who had spent his childhood in Windsor, described the appearance of Thames Street at around the turn of the century as "crowded with houses. Some of the meanest character, and with the most disreputable occupiers, were the property of no one, but were tenanted under what was termed 'key-hold'." The houses around the northern and western sides of the Lower Ward were only finally swept away as part of the Windsor Improvements of 1850.

The route along the southern side of the Castle (see fig.4) was a particularly busy one until the start of George IV's reign. This roadway not only served the many houses on the south side of Castle Hill, but also led to the royal apartments in the Queen's Garden House (also known as the Queen's or Upper Lodge), to the Rubbish Gate opposite, and on into the Home Park beyond (see V.3). From there the pathway divided: one branch headed due south across the Park (towards the Ranger's Lodge) while the other veered south-east towards Datchet Bridge.

All five watercolours in this section were purchased at the Banks sale and date from before the return of the Royal Family to Windsor. An additional Sandby subject records part of Castle Hill between 25 and 26. The Banks version of this subject is now in the collection of Her Majesty Queen Elizabeth The Queen Mother (26.1); there are also pencil (Oppé 21) and etched outlines of this subject, which was repeated later in watercolour (*e.g.* Oppé 22). As the King's first Windsor base was the Queen's Lodge, his visitors would inevitably have taken this southern route rather than reaching the private royal apartments through the different Castle wards. For this reason the houses in the Castle ditch to the east of the Henry VIII Gateway – visible both in Kip's view of *ca.* 1708 (fig.3) and in Sandby's views of over fifty years later, *e.g.* 26 – were demolished, and the ditch along the southern and eastern sides of the Castle was filled in, *ca.* 1780.

V.1 Sands after T. Allom, *Windsor Castle*, engraving, 8" × 16" (203 × 405 mm), Royal Library (headpiece from *The Stationer's Almanac*, 1837)

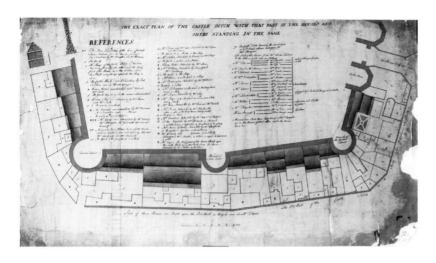

V.2 *Plan of the eastern Castle ditch, ca.* 1800,
Public Record Office, London (Work 34/182)

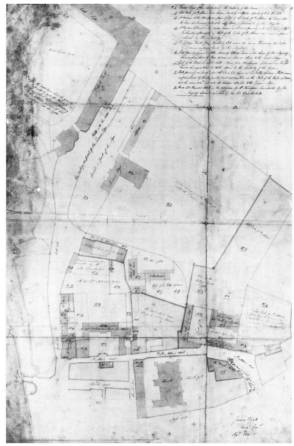

V.3 James Wyatt, *Plan of Castle Hill* (detail), 1810 (with north
to the left), Public Record Office, London (Work 34/179)

At the same time, several properties to the south, immediately to the west of the Queen's Lodge, were purchased for the crown. But the houses on the southern side of the road up Castle Hill further to the west remained in private occupation until early in the nineteenth century. They are shown in the plan by the Surveyor General James Wyatt dated September 1810 (V.3). Charles Knight's reminiscences are also useful in describing this part of Windsor: "I can again ramble in the upper park. Castle Street, in which I live, has a continuation of houses up to the Queen's Lodge, in which the King dwells at his Castle foot. There is nothing to separate the Castle Hill from the town but a small gateway, which bears the inscription 'Elizabethae Reginae, xiii, 1572'. Beyond the gate are substantial houses, inhabited by good families. In one of those near the Lodge once dwelt Mrs Delany", the close friend of the Royal Family and inventor of botanical paper cut-outs.

The houses on Castle Hill had been demolished by the beginning of Queen Victoria's reign, thus rendering the full extent of the southern façade of the Castle – and in particular Wyatville's rearrangement of the eastern end – visible from the Henry VIII Gateway (see V.1). In 1839 work began on the Royal Mews, to the south of the Castle, between St Alban's Street and the Home Park; building work on the Mews was completed in 1842. Within less than ten years another major change had taken place. With the Windsor Improvement Act public access to the Home Park from both Castle Hill and Park Street ceased, and the public road to the south of the Castle was diverted several hundred yards further south, to its present position. Castle Hill now serves as a car park for the use of those on official business in the Castle, and strategic planting has ensured that the south front of the Upper Ward can (once again) only be seen from the Long Walk to the south.

24. PAUL SANDBY

The Henry VIII Gateway from Castle Hill, ca. 1760

Watercolour and bodycolour with pen and ink over graphite, within narrow black ink line, 12" × 15¾" (305 × 401 mm)
MOUNT Type 2. Verso inscribed in graphite, by Paul Sandby (?): *Windsor / View of the Town Gate.* Mount watermark: monogram PvL. Banks label recorded by Oppé.
PROVENANCE Sir Joseph Banks; Sir Wyndham Knatchbull (sale, Christie's, 23 May 1876, lot 26); purchased (10 gns.) by Holmes, the Royal Librarian
Oppé 25; RL 14547

This view is taken from opposite the Henry VIII Gateway, but the artist has also focussed on the buildings which at the time occupied the Castle ditch. Houses were shown in this position in seventeenth-century views of the Castle. They were swept away in the years around 1850, as part of a general town improvement scheme. Shortly before that date, the Salisbury Tower (to the left of the Gateway) was refaced to the designs of Edward Blore, and an additional storey was added in place of the pitched roof (see 24.1).

Although all the topographical detail in 24 is depicted in different shades of watercolour, bodycolour is employed for the figures in the foreground and for the brick wall on the left. The perspective of details (particularly of the receding line of houses on the left) is very expertly handled, but the perspective of the view as a whole is somewhat defective: see, for example, the squat proportions of the Castle, and the diminishing height of the wall between the Henry VIII Gateway and the shops. These factors would suggest an early date for this watercolour.

The Greiz album contains both Sandby's outline drawing (E 457) and a tracing (E 453), probably by Princess Elizabeth, of this subject.

24.1 Photograph of the Henry VIII Gateway, summer 1993

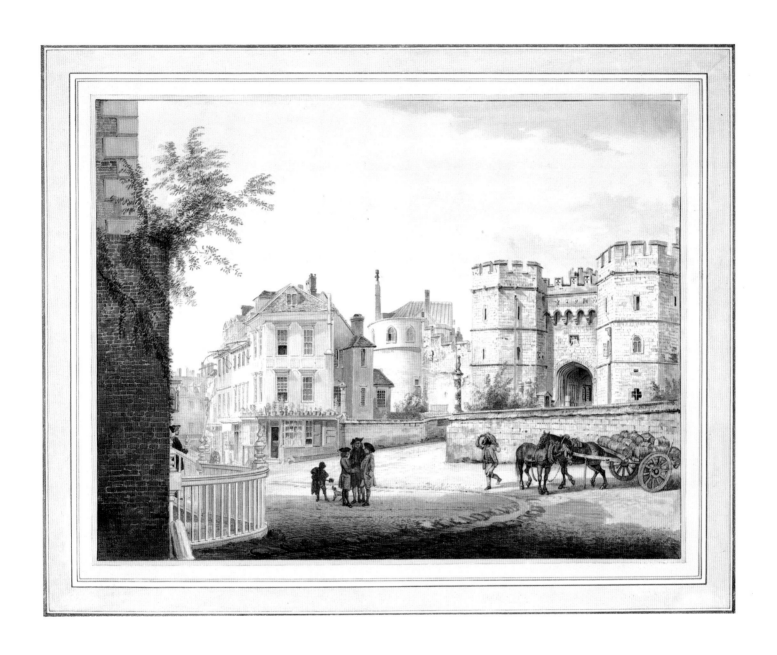

25. PAUL SANDBY

The Town Gate looking westwards down Castle Hill, ca. 1765

Watercolour with pen and ink over graphite, within grey line and buff wash border,
12⅜" × 18¼" (315 × 465 mm)
WATERMARK Strasburg Lily/LVG
MOUNT Type 2. Verso inscribed in graphite, by Paul Sandby (?): *Windsor / View of the Town through the Gate-way from the Castle Hill.* Mount watermark: monogram PvL. Banks label recorded by Oppé.
PROVENANCE Sir Joseph Banks; Sir Wyndham Knatchbull (sale, Christie's, 23 May 1876, lot 23); purchased (14 gns.) by Holmes, the Royal Librarian
Oppé 24; RL 14546

The Town Gate of Windsor Castle was adjacent, but at right angles, to the Henry VIII Gateway, and was built in the reign of Queen Elizabeth I. There were a number of houses on Castle Hill above the gateway.

The view through the gateway reveals a variety of activities involving the loading or unloading of luggage to the right, the manœuvring of beer barrels in connection with one of the many inns on Castle Hill (note the hanging inn signs, suspended from the buildings on the left seen through the arch), and the general passage of horse-drawn and pedestrian traffic. Unlike the shops in the Castle ditch, the house on the left has retained hinged and leaded casement windows. Sash windows were gradually introduced in most town buildings from the beginning of the eighteenth century.

The horse and gig on the right have just passed through the Town Gate. In the eighteenth century the main pedestrian route from Windsor to Datchet was along this road, which passed close to the walls of the Lower and Middle Wards, and then entered the Little Park through the King's Gate (see 28 and 30), to continue through the Park to Datchet Bridge.

This view is recorded in two pencil outline drawings by Paul Sandby, at Greiz (E 458) and at Windsor (Oppé 23). Both the Windsor drawing and

the outline etching (one of the 1777 series) omit the area at the extreme left – which explains the object of the young soldier's interest – together with the old lady witnessing the scene from the first floor window. The detail seen through the gateway (rightly described by Oppé as "of the utmost delicacy") is the subject of a further study at Greiz (25.2).

The passengers in the elegant two-wheeled vehicle include a baby boy clutching the coral handle of a rattle. The group is recorded in two independent studies: a graphite drawing at Windsor (25.1) shows the group stationary; a graphite and wash drawing (formerly with Agnew) shows the group in reverse, moving to the left, more actively than in 25 but not at the speed suggested in Oppé 23 and the related etching. Note how Sandby has 'folded' the shadow of the horse in 25 up the Castle wall.

25.1 Paul Sandby, *Horse and cart with passengers*, 1768, graphite, 5" × 6½" (125 × 165 mm) Royal Library (Oppé 406; RL 14545)

25.2 Paul Sandby, *Town Gate of the Castle, ca.* 1760, graphite, 8½" × 7⅛" (216 × 180 mm), Staatliche Museen Greiz (E 455)

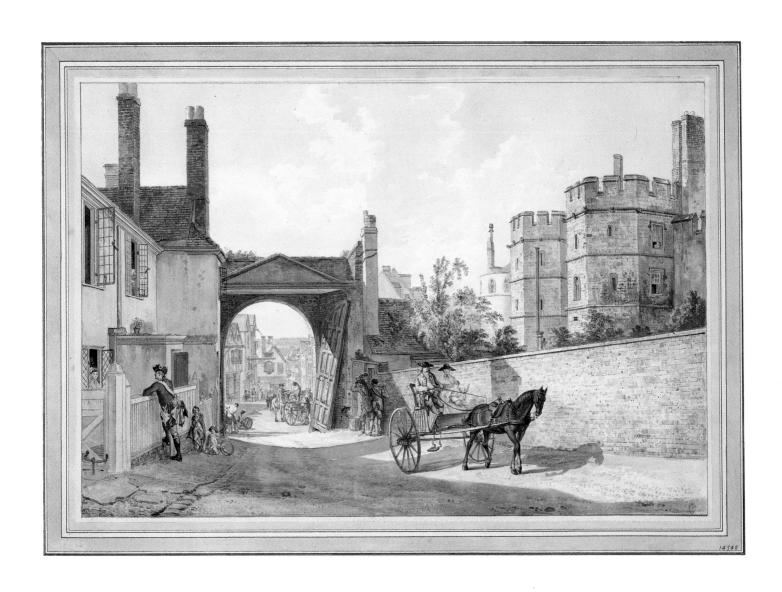

14546

87

26. PAUL SANDBY

Castle Hill with the Henry III Tower and the Mary Tudor Tower seen from the south, ca. 1765

Watercolour and bodycolour with pen and ink over traces of graphite, within line (black) and wash (buff) border, 8¾" × 14¼" (222 × 361 mm)
WATERMARK countermark IV
MOUNT Type 2. Mount watermark: monogram PvL
PROVENANCE Sir Joseph Banks; Sir Wyndham Knatchbull (sale, Christie's, 23 May 1876, lot 6); purchased (£4) by Holmes, the Royal Librarian
Oppé 19; RL 14541

For this view the artist has proceeded further up Castle Hill, along the route shown in 26.1, passing the large brick house in the Castle ditch – shown here to the left, immediately under the Mary Tudor Tower – before veering to the south. The viewpoint is to the south of the Henry III Tower (then called the Store Tower). The gable of one of the houses overlooking the Black Rod is just visible over the curtain wall at right.

Oppé considered this "one of the most delicately drawn and tinted of the Banks series, the figures fresher and less *découpées* than is frequently the case". The architecture (omitting a strip at the left-hand side) is the subject of another watercolour now in the Royal Collection (RL 17760); it is inscribed "Mr Mundens picture 4f. 7½ by 2. 5¼", suggesting a painting of vast proportions. The view of the Henry III Tower shown here is also recorded in an upright pencil drawing at Windsor (Oppé 18).

The figures in the foreground of 26 include a water-carrier and a chair-mender. The latter in particular recalls Sandby's *London Cries*, issued *ca.* 1760. In the upright study of the Henry III Tower (Oppé 18) carpets are being beaten against the low wall in the foreground.

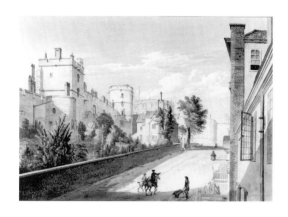

26.1 Paul Sandby, *Castle Hill from the south*, *ca.* 1765, watercolour and bodycolour, 11⅞" × 17" (301 × 430 mm), collection of HM Queen Elizabeth The Queen Mother

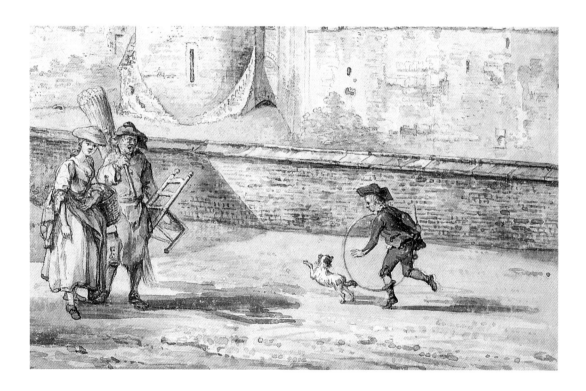

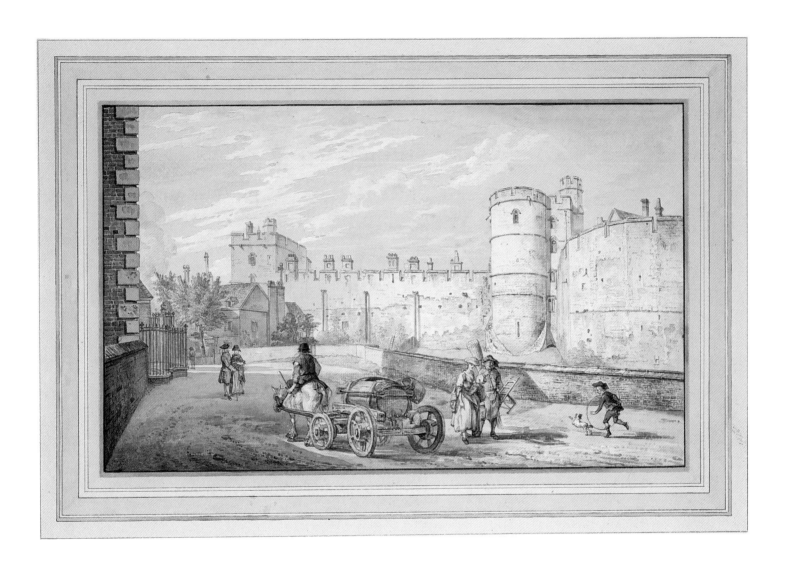

27. PAUL SANDBY

Castle Hill looking towards the Devil's Tower,
ca. 1765

Watercolour and bodycolour
with pen and ink over traces of
graphite, within narrow black
ink line, 10¼" × 13⅞"
(260 × 354 mm)
WATERMARK countermark IV
MOUNT later reproduction of
type 1; wash line trials on recto
(under watercolour). Mount
watermark: countermark J
WHATMAN
PROVENANCE Sir Joseph
Banks; Sir Wyndham
Knatchbull (sale, Christie's, 23
May 1876, lot 16); purchased
(£5) by Holmes, the Royal
Librarian
Oppé 20; RL 14568

For this watercolour the artist proceeded further up
the hill, with the eastern part of the high curved wall
of the Middle Ward (part of which was shown at
right in 26) terminating at the Devil's Tower to the
right of centre. The Devil's Tower is seen from in-
side the Castle in 9.

The houses to the right were among those pur-
chased for the Crown in 1779 to make way for the
enlargement of the Queen's Garden House (see 28).
The whole area of Castle Hill was later re-planned
by Wyatville (see 27.1).

A further Sandby subject (not included here) re-
lating to this part of the Castle employs a viewpoint
further to the east, immediately to the south-west of
the Devil's Tower and the bridge to the Rubbish
Gate (seen from the other side in 28). The studies of
that subject include a wide view in Greiz (27.2),
showing more of the house (later the Queen's
Lodge) on the right, and Oppé 17, repeated in an
outline etching of 1777. At Greiz there are other
views of the south front taken from slightly further
to the east (E 454) and from immediately to the
south of the Rubbish Gate (E 460).

The passengers in the coach in the foreground are
apparently engaged in negotiations with the stand-
ing cloaked lady holding a basket. The coach is sim-
ilar to that shown in Oppé 392. The soldier at the

27.1 Photograph of Castle Hill, summer 1993

right is close to the figure drawn in Oppé 378. There
is a marked difference between the care taken with
the main part of 27 and the handling of the tree at
the right, suggesting that 27 (like 35, also included in
the Banks sale) is in part unfinished.

27.2 Paul Sandby, *Entrance to*
the Castle and the Kings Garden
House, ca. 1770, graphite,
12⅝" × 18" (321 × 457 mm),
Staatliche Museen Greiz (E 459)

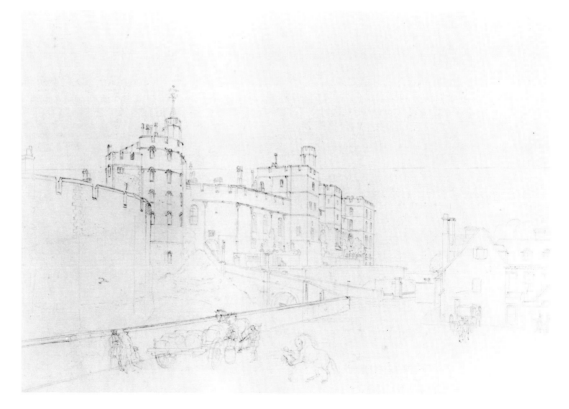

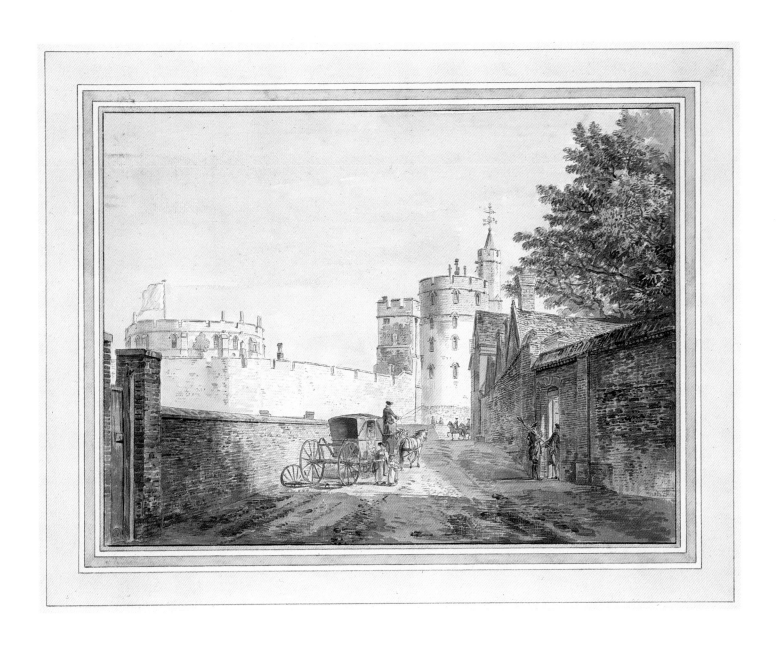

91

28. PAUL SANDBY

The moat bridge, the King's Gate and the entrance to the South Terrace, ca. 1765

Watercolour with pen and ink over graphite, within black line and gold paint border, 7⅝" × 10½" (195 × 268 mm)
MOUNT Type 2. Verso inscribed in graphite, by Paul Sandby (?): *Windsor. View of the King's Gate and Entrance to the South Terrace.* Mount watermark: Strasburg Lily/GR; also countermark IHS/I VILLEDARY
PROVENANCE Sir Joseph Banks; Sir Wyndham Knatchbull (sale, Christie's, 23 May 1876, lot 10); purchased (£4. 15s.) by Holmes, the Royal Librarian
Oppé 16; RL 14538

In this watercolour Sandby records the view from between the Garden House (later the Queen's Lodge) and the south front of the Castle, looking westwards. The centre of the composition is occupied by the arch of the bridge over the Castle ditch, leading from Castle Hill *via* the Rubbish Gate into the Quadrangle. The King's Gate (at the left) was the inner of the two gates marking the entrance to the Castle from the Little Park. Along the southern wall of the Castle (at the right) was the South Terrace, approached through another gateway; to the right of the gateway is the upper part of the arch of the Rubbish Gate.

After the return of the Royal Family to Windsor this area was considerably altered. In October 1779 the *Reading Mercury* reported: "Orders are given for a large platform to be made fronting the royal apartments at Windsor, which is to be considerably enlarged; several houses have already been purchased for this purpose, which are to be taken down, and more are likely to be purchased, and the whole is to be completed by next spring." During the succeeding years the ditch was filled in, the bridge was buried and the King's Gate was demolished. In addition, the high curtain wall (in the middle distance in 28) was taken down to improve the view from the Lodge, but the South Terrace remained largely unchanged. The area was transformed yet again during Wyatville's remodelling and is now within the Home Park (see fig.7 and 28.1). The Rubbish Gate was filled in and replaced by two new and infinitely grander entrances to its west and east: St George's Gate at the foot of the Round Tower and the George IV Gate in the centre of the south front, on axis with the Long Walk to its south. The South Terrace disappeared as a result of these changes. The Queen's Lodge was itself demolished in the autumn of 1823.

Sandby has concentrated his figures in a small area in the lower left corner. A well-built cleric makes a disdainful gesture at a disabled beggar while a young boy addresses a mother and child seated on the ground. The brick house in the Castle ditch is shown in the distance beyond.

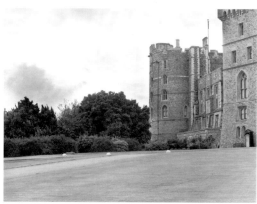

28.1 Photograph of the south front of Windsor Castle from the Home Park looking west, summer 1993

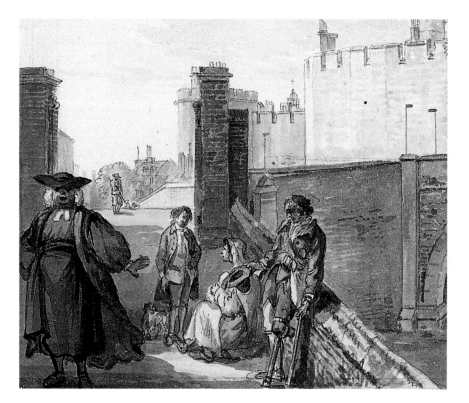

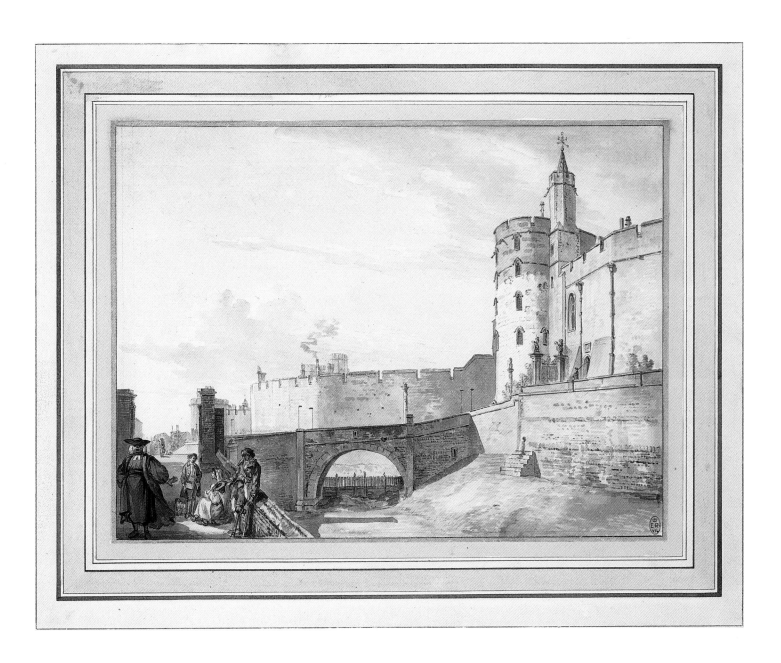

VI The Little Park and the Long Walk

The Little Park is the area of parkland immediately surrounding the Castle. Until the acquisition of considerable amounts of land to the south in the mid-nineteenth century, the Little Park (which was then renamed the Home Park) was a completely separate entity from the Great Park to its south. With the planting of the Long Walk from 1680 some connection between the area around the Castle and the Great Park was established, but the Long Walk was never part of the Little Park.

Collier's plan of 1742 (fig.4) records the Little Park as it existed in Sandby's time; in the mid-eighteenth century it covered an area of around five hundred acres (200 ha.). Initially a very small area around the Castle, in 1439 the Park was enlarged by the addition of two hundred acres (80 ha.) to the east and south-east. During Charles II's reign further additions were made to the south-east and a new Ranger's Lodge was built on or close to the newly acquired land. In the last years of the seventeenth century the Park was considerably extended to the north and east by the addition of 258 acres (104 ha.) between the old Park boundaries and the river, and thus gained a river frontage for the first time. This addition was made to accommodate King William III's ambitious plans for an elaborate formal garden (the Maestricht Garden, see 36) that was intended to occupy the whole of the vast area between the Castle and the Thames to the north. The need to provide a public roadway

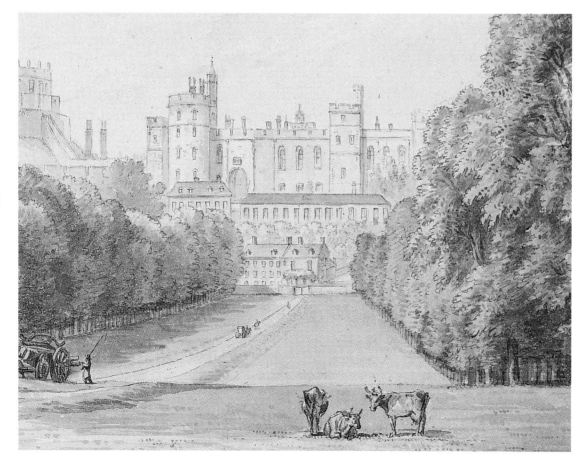

Detail of 28

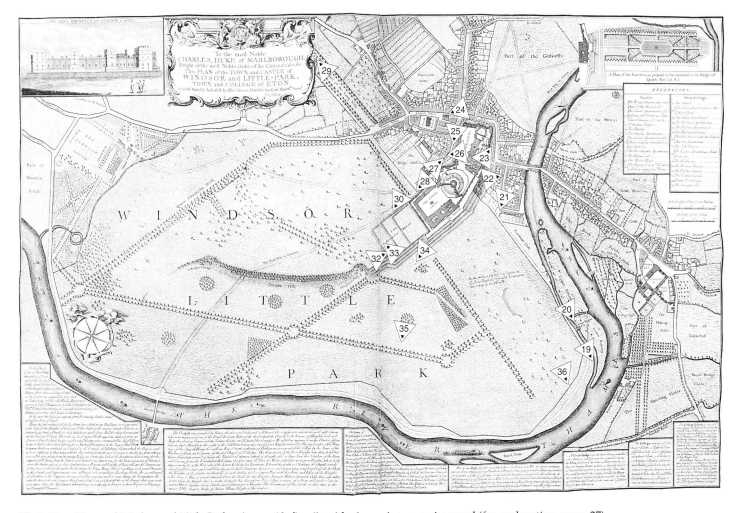

W. Collier, *Plan ... of Windsor and Little-Park ...* (see p. 13, fig. 4), with viewpoints superimposed (for explanation, see p. 27)

between Windsor and the river crossing at Datchet meant that Datchet Lane had to be resited parallel to the line of the river. A brick wall was built on the land side of the road to protect the privacy of the Park. The wall alongside Datchet Lane can be clearly seen in 19 and 20. The inside of the same wall is shown from within the Park at the far right in 34 and 36.

The northern area of the Little Park was the subject of considerable changes as a result of the introduction of the railways to Windsor in the 1840s and the passing of the Windsor Improvement Act in 1848. One of the two lines serving Windsor now proceeds for part of its route along Datchet Lane, while the main (public) road between Windsor and Datchet now crosses the site of the Maestricht Garden; around seventy acres (28 ha.) to the north of the

road are now separated from the Home Park and set aside for the recreational use of the people of Windsor with the designation Home Park Public (see 36.1).

Meanwhile the southern boundary of the Park was revised to include the Duke of St Albans's House (used by King George III as the Lower Lodge) and its gardens (see V.3), the Frogmore and Shaw estates, and part of the Keppel estate, purchased in 1843. The old public road between Windsor and Old Windsor, which formerly passed immediately to the north of the Frogmore estate, was moved further to the south *ca*. 1850. Frogmore was not recorded by Sandby; it was divided into two small estates, both of which were privately occupied before being acquired for Queen Charlotte in the early 1790s.

29. PAUL SANDBY

The Castle from the Long Walk, ca. 1765

Watercolour with pen and ink over graphite, within black line, 6" × 8" (154 × 205 mm)
WATERMARK L V GERREVINK
MOUNT Type 4. Partially erased inscription in pen: *By Paul Sandby.* Verso inscribed in graphite: *P. Sandby* and in ink: *Windsor* and *pt/t/- the pair*
PROVENANCE Messrs. Leggatt; purchased 1910 (£18, with 13)
Oppé 82; RL 14606

The Long Walk, laid out and planted by King Charles II from 1680, is a wide double avenue which stretches around two and a half miles (4 km) due south from the Little Park to Snow Hill in the Great Park. King George IV erected an equestrian memorial (the Copper Horse) to his father George III at the southern end of the Long Walk in the late 1820s.

Sandby's view shows how in the eighteenth century two rows of buildings lay between the northern end of the Long Walk and the Castle. Only when these buildings were removed could the full impact of Charles II's avenue be enjoyed. The low houses to the south fronted the public road (Park or Pound Street) between Windsor and Old Windsor. The long building immediately below the Castle was the "Green House" attached to the Queen's Garden House (later converted into the Queen's Lodge).

No view of or from the Long Walk was included in the Banks sale. However, there is a pencil drawing dated 1776 of this composition, with extensions to left and right, at Greiz (E 445). The miniature delicacy in the treatment of the figures and animals in 29 recalls similar features in Banks views such as 8; 29 is probably therefore to be dated to around the same period.

A very similar viewpoint was used in the oil painting by Sawrey Gilpin and William Marlow of *The Duke of Cumberland visiting his stud* (29.1), which is probably identifiable with the picture exhibited at the Society of Artists in 1771. The composition appears to have originated in a watercolour by Thomas Sandby painted shortly before the Duke's death in 1765. The watercolour is probably identifiable as the *Portrait of His Royal Highness William Duke of Cumberland inspecting the Mares and Foals in his Royal Highness's racing stud, at Windsor Great Park – animals by Gilpin* included in the Paul Sandby sale in 1817 (third day, lot 6) among the "Drawings Framed and Glazed". This was purchased by Seguier for £8. 5s., probably for the Prince Regent although the picture is not recorded in the Prince's collection.

The depiction of the Castle in the background of the painting differs in several ways from that shown in 29: for instance, the turret of the Devil's Tower is shown considerably higher than the Round Tower; in addition, the painting is lit from the east while 29 is lit from the south. A second watercolour of this subject was purchased for the Royal Collection in 1962 (RL 17890) and accords in most respects with the oil.

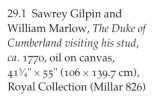

29.1 Sawrey Gilpin and William Marlow, *The Duke of Cumberland visiting his stud, ca.* 1770, oil on canvas, 41¾" × 55" (106 × 139.7 cm), Royal Collection (Millar 826)

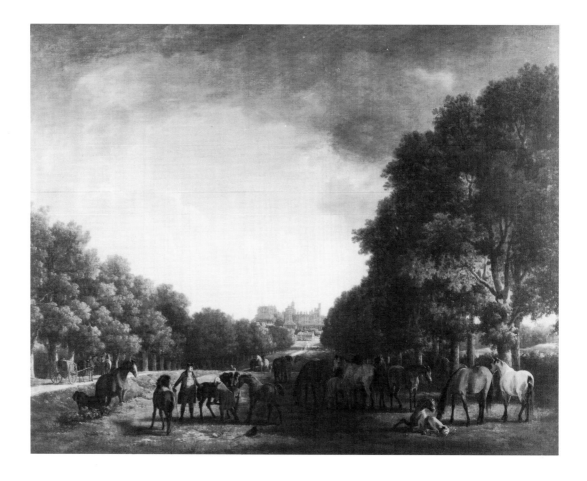

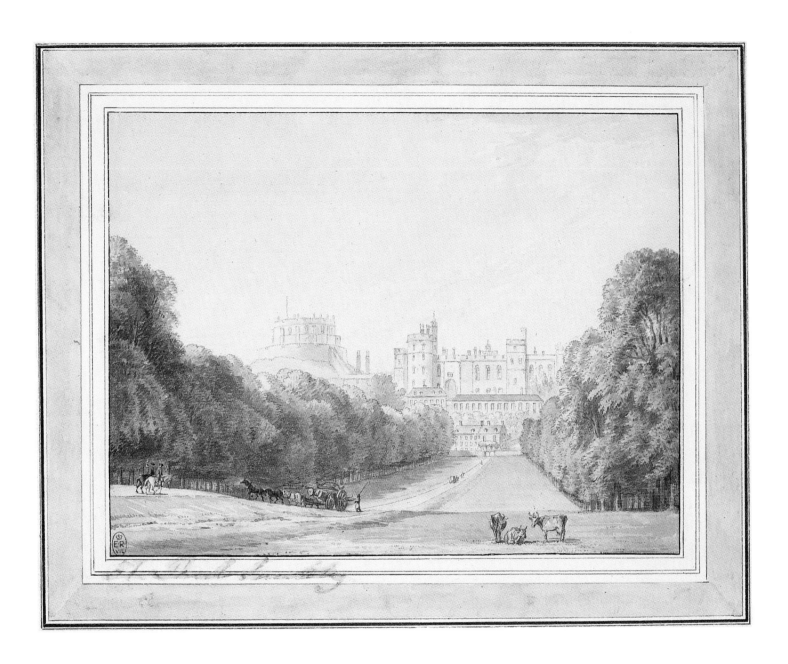

30. PAUL SANDBY

The south-east corner of the Castle and the Tennis Court, from the Little Park (watercolour version), *ca.* 1765

Watercolour with pen and ink over graphite, within narrow grey line, 6⅜" × 8⅞"
(162 × 226 mm)
WATERMARK Posthorn
MOUNT Type 4 (later reproduction of that on 29).
Verso inscribed in graphite, in a late hand: *S.E. corner with the Secretary of State's Tower / and the tennis court, from the Home Park*
PROVENANCE Sir Joseph Banks; Sir Wyndham Knatchbull (sale, Christie's, 23 May 1876, lot 3); purchased (18s.) by Hogarth, probably for the Royal Collection; Royal Collection by 1892 (Sandby, p.215)
Oppé 54; RL 14578

31. PAUL SANDBY

The south-east corner of the Castle and the Tennis Court, from the Little Park (bodycolour version), *ca.* 1765

Bodycolour, within line (black), gold and wash (brown) border 12 mm wide, 15¾" × 19¾"
(400 × 503 mm)
VERSO inscribed in graphite: *S.E. Corner of Windsor Castle, 1772*
MOUNT Type 4. Mount watermark: monogram PvL
PROVENANCE Royal Collection by 1892 (Sandby, p.215)
Oppé 55; RL 14579

This pair record the view to the south-west from a point in the Little Park immediately to the east of the south-east corner of the Castle. In 30 figures are shown walking along the East Terrace, which was linked to both the North and the South Terraces. Immediately to the left of the corner of the Terrace are the gates of the outer entrance leading to the King's Gate seen in 28. Behind these are the buildings of the Green House and the Queen's Garden House; the Tennis Court, with open walls below the high roof, is shown beyond. The Duke of St Albans's House (later Lower Lodge and Burford House) is included in 30 but is omitted from 31, although the gate leading from the Duke of St Albans's garden into the Little Park is shown to the right of the trees. As in the case of 19, where the distances were deliberately distorted, the reason for this omission was doubtless artistic.

On the hillside to the left of the Tennis Court two tiny houses are indicated; these are (to the right) St Leonard's Hill, home of Maria Walpole, the young widow of the Earl Waldegrave, between *ca.* 1766 and 1781 and (to the left) the adjoining estate called Sophia Farm after its purchase by the Duke of Gloucester and the birth of his daughter Princess Sophia in 1773. St Leonard's Hill was purchased by Maria at around the time of her clandestine second marriage to the Duke of Gloucester in 1766. According to a Windsor guide issued in 1768 the house was still being improved to the designs of Thomas Sandby, but by 1771 it was complete.

In both views figures are shown proceeding along the footpath crossing the Park from the King's Gate to the river-crossing to Datchet. As the Park was open to pedestrians only, the horseman was presumably one of the Park Keepers, as in 35. It is clear from other views of this part of the Park (*e.g.* fig.14)

that the figures on the right are standing close to, if not actually in, the remains of the eastern Castle ditch. This was levelled by George III *ca.* 1780 and was transformed by King George IV into the East Terrace Garden; at the same time the footpath was closed to the public. Later in the nineteenth century the south-east tower was renamed the Victoria Tower; it is now called the Queen's Tower.

A comparison between 30 and 31 demonstrates the differences of handling and effect in the two distinct media, watercolour and bodycolour. Whereas areas of 30, particularly the grass and foliage, are only summarily sketched in, they are completed with great delicacy and care (even if somewhat drily, as Oppé observed) in 31. Although the figures are comparable in the two views, the scale is smaller (and more correct) in the bodycolour version. As in other early bodycolours, the dramatic effect of the lighting is explored, using a silvery-white tonality quite distinct from the golden glow of the later watercolours. Cat.30 appears to be a watercolour replica of 31, made for Sir Joseph Banks. The early history of 31 is not known.

Sandby recorded the Castle from further to the south and south-east on several occasions. The fine bodycolour acquired for the Royal Collection in 1978 (30/31.1) may be the picture exhibited at the Society of Artists in 1767; the direction of the view is now to the north-west. The watercolour version (identical in size to 30/31.1) in the collection of the Earl of Stair was acquired at the Banks sale in 1876. The outline drawing at Greiz (E 486) and the engraved view (fig.12) record the Castle from further to the south. Other variants are in the Royal Collection (RL 17756) and in the collection of the Duke of Buccleuch. The second view from the south-east in the Banks sale (lot 55) is untraced.

30/31.1 Paul Sandby, *The south and east fronts of the Castle from the Little Park, ca.* 1765, bodycolour on prepared panel, 15⅛" × 22"
(384 × 558 mm), Royal Library (RL 18986)

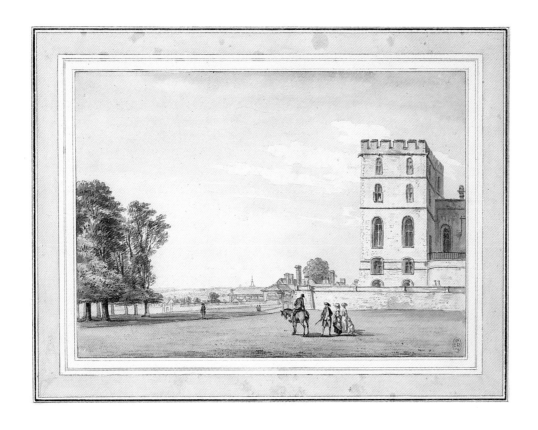

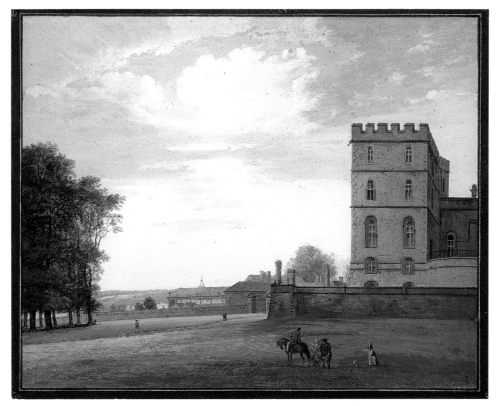

32. PAUL AND THOMAS SANDBY

View to the east over the Little Park, ca. 1765

Watercolour with pen and ink and graphite, in double ruled black ink border,
11¼" × 22⅝" (286 × 575 mm)
(two sheets of paper)
WATERMARK Strasburg Lily/LVG
MOUNT formerly Type 3 (see Oppé). Banks label inscribed in pen and ink: *Windsor / View from the end of the North terrace looking towards / London*
PROVENANCE Sir Joseph Banks; Sir Wyndham Knatchbull (sale, Christie's, 23 May 1876, lot 54); purchased (12 gns.) by Lord Stair; purchased (with 15) 1936 (sale, Christie's, 19 June 1936, lot 76)
Oppé 52; RL 14576

The subject of this entirely rural view is recorded on Banks's label: "View from the end of the North Terrace looking towards London". It is thus the landscape over which the meteor is shown in 18.

To the east of the Castle is a plateau of high ground which extends to the south-east. A chalk escarpment separates the plateau from the lower area of the Park below. The great avenues shown in Collier's plan (fig.4) criss-crossing the area between the escarpment and the river are visible to the left in this watercolour. The spire of Datchet church is just discernible towards the left edge of the sheet.

The precise viewpoint of 32 is probably somewhat to the east of the North and East Terraces, at the foot of the bowling greens shown in Collier's plan. In around 1780 this area was levelled. The resulting earth and stone were moved to the north slopes, which were to be transformed into pleasant walks by the planting of trees and shrubs, a process which continued for the next hundred years. Deer were

kept in the Little Park until the beginning of the nineteenth century. On the left they descend the chalky escarpment.

Oppé commented that although 32 "is now somewhat browned by exposure, it retains the same effective combination of great breadth in the distance and exquisiteness of detail. The touch in the foliage is miniature, some figures in the middle distance are so small as to be all but invisible, and the herd of deer on the edge of the slope have been left in pencil and barely touched with colour. In these drawings Paul Sandby set out to surpass his brother precisely in those technical methods that he, perhaps, learnt from him." However, as Oppé was also well aware (Oppé, p.13), it is arguable that watercolours such as 32 and 33 are the work of Thomas rather than Paul Sandby. The variant from the late 1770s in the collection of the Duke of Buccleuch (32.1) includes three figures in the foreground, more typical of a composition by Paul than by Thomas Sandby.

32.1 Paul Sandby, *View to the east over the Little Park*, ca. 1780, watercolour, 17½" × 33¼" (445 × 845 mm), collection of the Duke of Buccleuch and Queensberry KT, Drumlanrig

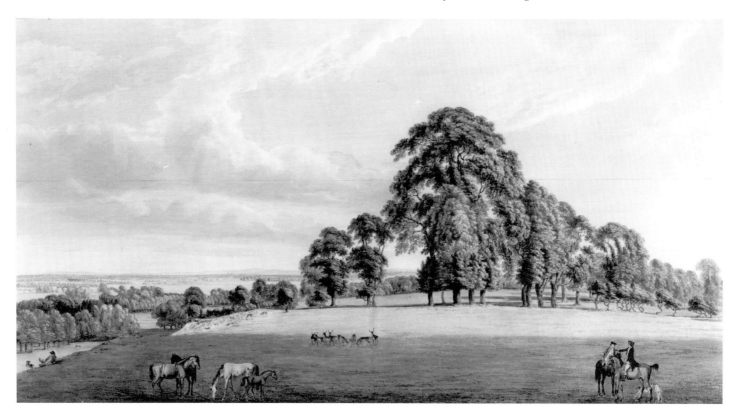

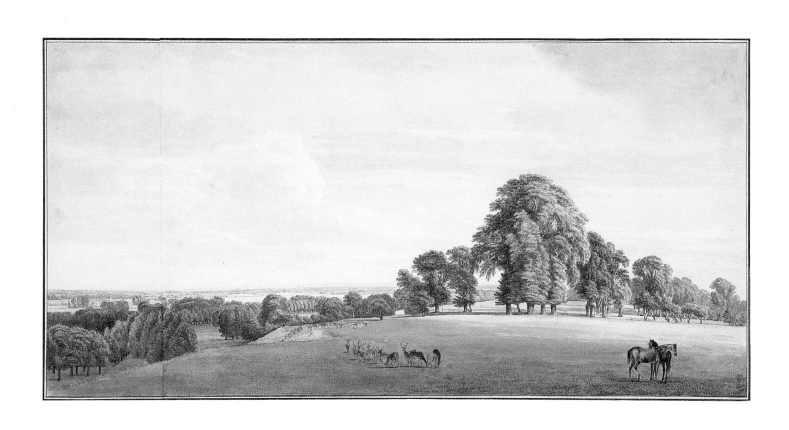

33. PAUL AND THOMAS SANDBY

The seat near the Terrace with a view of the adjacent country to the north-east, ca. 1765

Watercolour and bodycolour over graphite, within line (black) border,
10⅞" × 22⅜" (276 × 568 mm)
MOUNT Type 3. Verso inscribed in graphite, by Paul Sandby (?): *Windsor / View of the Seat near the Terrace and a view of the adjacent Country.*
Mount watermark: monogram PvL
PROVENANCE Sir Joseph Banks; Sir Wyndham Knatchbull (sale, Christie's, 23 May 1876, lot 56); purchased (6 gns.) by Holmes, the Royal Librarian
Oppé 51; RL 14575

The viewpoints of 32 and 33 must be almost identical, at the north-east corner of the bowling greens to the east of the Castle; but whereas 32 shows the view to the east, in 33 the view is to the north-east. In both watercolours an extraordinary, almost cartographic, attention to detail is employed. Moving from left to right, in 33 Sandby shows the King's Engine House over the park wall of Datchet Lane (see 19), the flooded Maestricht Pond (see 36), and – in several clearings in the trees – a thin pale blue line signifying the River Thames, proceeding on its eastward course. Between the river and the foreground of this watercolour the long avenues included in Collier's plan (fig. 4) can be clearly distinguished.

Beyond the river a number of houses have been carefully and minutely depicted, but the appearance of the landscape around Slough has changed so much that precise identification is difficult. The 1763 edition of Pote's guidebook to Windsor mentions the following houses as being visible from the North Terrace: Ditton Park, Langley Park with its Banquetting House, Percy Lodge (north of Colnbrook) and Stoke House. It is likely that Baylies House (Slough), Stoke House and Wexham are included within this view.

The wooden structure at right was probably approximately triangular in ground-plan, offering

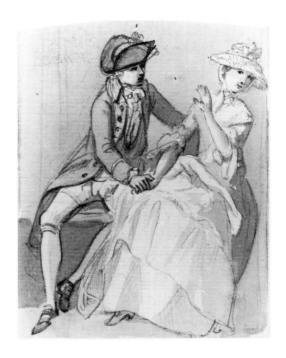

33.1 Paul Sandby, *Figure group*, ca. 1765, graphite and brown wash, 4¼" × 3½" (107 × 88 mm), private collection

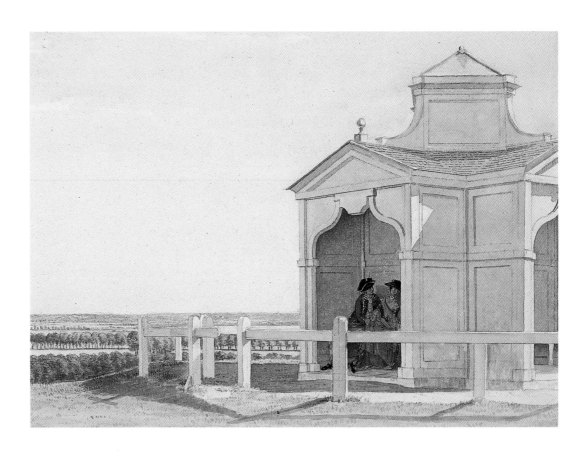

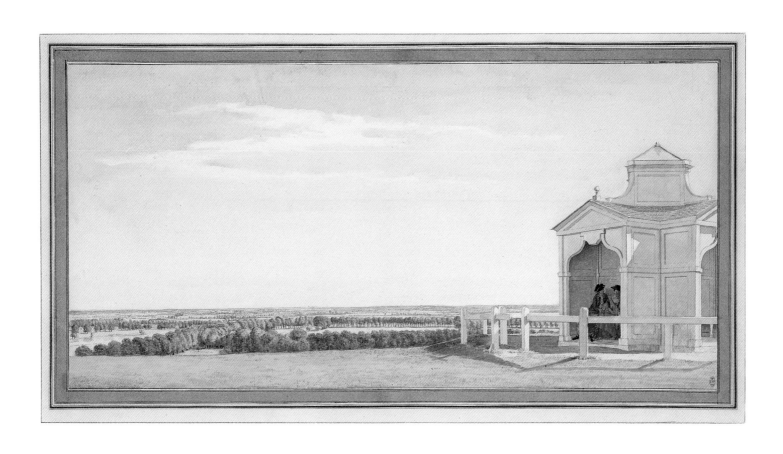

views from – and shelter in – each of its three sides. The simple rows of wooden fencing surrounding the seat ensured that it was not accessible to the deer in the Park. The seat is seen again, and its relationship to the Castle is clarified, in 35 and at the far right of Sandby's south-east view of the Castle (30/31.1). In 33 it has the appearance of being a very recent addition; it would probably not have survived the levelling work in this area *ca.* 1780. The presence of the bold architectural form of the seat is crucial to the composition of 33. The effect is yet further enhanced by the presence of the courting couple within one of the covered niches: the red jacket worn by the soldier acts as something of a focal point in the broad sweep of the panorama, even though it is muted by being cast into shadow. The final composition was arrived at only after much care. Note how some of the white posts were first drawn to project above the horizon, but were then reduced in height to ensure that the broad sweep of the landscape was not interrupted.

There may be an indirect connection between the composition of 33 and Stubbs's oil painting of *Gimcrack on Newmarket Heath* (Fitzwilliam Museum, Cambridge) in which the Rubbing Down House at Newmarket occupies a similar position to Sandby's seat. The painting was engraved in mezzotint in 1766 and was probably painted *ca.* 1765.

The same figure group was used in several other Sandby subjects. With greater insistence from the soldier the couple is seen in one of the North Terrace bodycolours now at New Haven (17.2), and with less passion in one of the North Terrace aquatints (fig. 11). The group is recorded in a number of independent studies: a small watercolour from the collection of Iolo Williams (published by Oppé in the *Burlington Magazine*, November 1944, p.276, fig. A) includes the line of the horizontal rail, but in a position somewhat higher than that finally chosen, and without the vertical element; the pencil and wash study (33.1) shows the figures precisely as in the Williams drawing but on a larger scale and without the fence; a late study in the British Museum (LB 138(103)) has the figures in approximately the same scale as 33, but with their positions reversed.

As in the case of 8, the colours of 33 appear to retain their original balance and clarity. "This drawing exhibits the breadth, the clear lighting, and the subtle gradations of distance and detail which Sandby could achieve by his delicacy of pencil work and carefully chosen flat washes. The usual interest of architectural variety is here replaced by a pretty incident and the simplest of structural forms" (Oppé).

34. PAUL SANDBY

The north-east corner of the Castle seen from below, with lightning, ca. 1765

Bodycolour with pen and ink, 15" × 19⅛" (380 × 485 mm) (the drawn sheet continues on the left and upper edges to become part of the border, with black and gold lines applied)
MOUNT Type 4. Inscribed (according to Oppé): *N. Side of Windsor Castle from the Home Park*
PROVENANCE Paul Sandby (sale, Christie's, 2 May 1811, lot 91); purchased (£2. 7s.) by Shepperd for the Prince Regent (later King George IV); by descent
Oppé 57; RL 14581

Whereas in 31 the stark south-east corner of the Castle is silhouetted against a bright evening sky, in 34 the whole of the north-east corner of the Castle, seen from below in steep perspective, is similarly treated, with an extraordinarily liquid continuous white line (signifying lightning) zigzagging across the composition. The viewpoint is in the lower area of the Little Park, immediately below the north slopes. At the top of the escarpment at the left is the Bowling Green; further to the left again (out of the picture) is the seat shown in 33. The east end of the North Terrace (seen from the opposite direction in 18) is just to the left of centre. Through the trees at right is the brightly lit area known as Maestricht, with the houses of Datchet Lane beyond.

The lightning flash is directly aimed at the terrified horse in the lower left corner. The strip of leather hanging below the horse's head suggests that it has broken loose. The horse's back is modelled by the silvery moonlight. The subject of a frightened horse was particularly associated with George Stubbs in the 1760s. The exhibition at the Society of Artists in 1763 included two paintings by Stubbs on the 'lion and horse' theme. Lightning was shown in association with the horses pulling Phaeton's chariot in the mezzotint published *ca.* 1765–66 which may relate to one of Stubbs's paintings of *Phaeton*, shown at the Society of Artists in both 1762 and 1764. The composition is recorded in a pencil outline at Greiz (E 488).

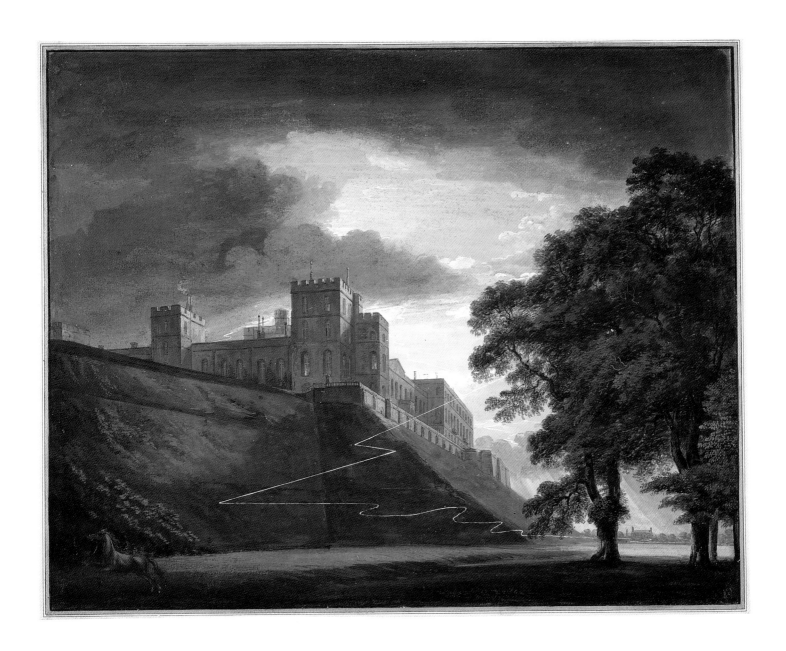

35. PAUL SANDBY

A north-east view of the Castle from the Little Park, ca. 1765

Watercolour with pen and ink over graphite, 12¼" × 27⅝" (310 × 702 mm) (two sheets of paper)
WATERMARK Strasburg Lily/LVG
MOUNT Type 3. Verso inscribed in graphite, by Paul Sandby (?): *Windsor | North East view of the Castle from the Lower Park,* and in graphite: *Drawn for Sir Joseph Banks.* Mount watermark: monogram PvL. Banks label inscribed in pen and ink: *Windsor | North East View of the Castle from the Home Park* (the last two words added later, to replace a line trimmed off the bottom of the sheet)
PROVENANCE Sir Joseph Banks; Sir Wyndham Knatchbull (sale, Christie's, 23 May 1876, lot 52); purchased (5 gns.) by Blane; H.N. Veitch; purchased (18 gns.) 1920 (sale, Christie's, 22 December 1920, lot 9)
Oppé 59; RL 14583

The similar wide formats of 35 and 36, which are almost identical in size, suggest that they may have been conceived as a pair. Both were included in the Banks sale, but they reached the Royal Collection by different routes.

The viewpoint for 35 is within the irregular trapezoid-shaped enclosure bounded by avenues to the north-east of the Castle. On the upper level, to the east of the castle, is the raised area, containing the bowling greens until *ca.* 1780, with the seat shown in 33. The Park Keeper in the foreground to the left of centre is looking towards the group of deer disappearing as effectively into the middle distance as did

those descending the escarpment in 32.

Although the figures and areas of foliage are treated with the degree of care that we expect in a watercolour from the Banks collection, elsewhere the drawing seems rushed and barely complete. The diagonal hatching in the row of trees in the middle distance is particularly jarring, as is the barely concealed join in the paper across which the figure of the horseman is drawn. The sky to left and right of the join is so little co-ordinated as to suggest that the two parts were conceived as two separate compositions.

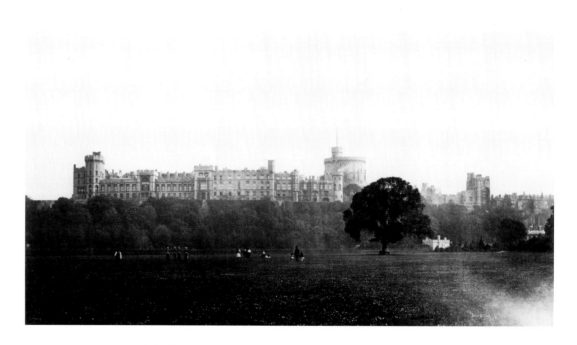

36.1 Photograph by Roger Fenton of the north front of the Castle from the Home Park Public, 1860

36. PAUL SANDBY

The north front of the Castle from the Maestricht Pond, ca. 1765

Watercolour over graphite, 12⅛" × 27⅝" (308 × 703 mm) (two sheets of paper)
MOUNT the original mount had disappeared before the drawing entered the Royal Collection. Banks label

The viewpoint for 36 was probably at the northernmost point of the Little Park, immediately to the south of the park wall and Datchet Lane. Most of the low land to the north of the Castle was enclosed into the Little Park only in the late 1690s, with the specific intention of laying out a massive formal garden, occupying the entire space between Castle and river. In 1674 the southern part of this space had been the setting for a re-enactment of the Siege of Maestricht. The whole area was called by this name until the mid-nineteenth century when it was divided by the new public road (see 36.1).

Work did not begin on the laying out of the

Maestricht Garden until the reign of Queen Anne. The shape of the planned garden is shown in the top right-hand corner of Collier's plan (fig.4). Aerial photographs of this area indicate that the garden plan was indeed laid out in its entirety but it was soon abandoned owing to a combination of the vast expense of its upkeep and repeated flooding. The pond in 36 is considerably larger and less regular than that shown in Collier's plan. The gravel excavated when the Maestricht Garden was first laid out was immediately used to make the new road skirting the river between Windsor and Old Windsor; the present view suggests that one reason for the

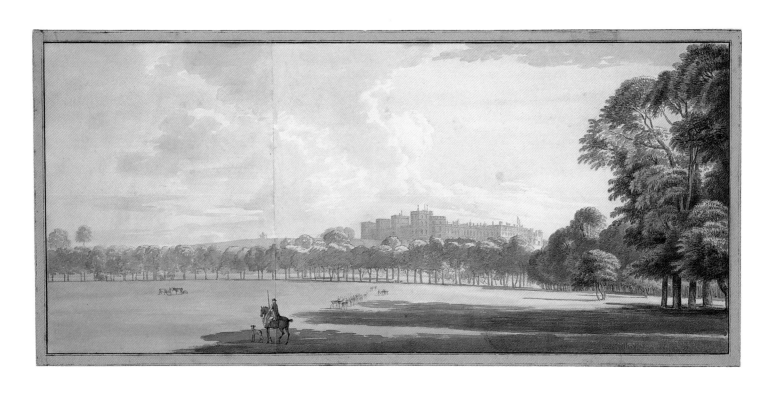

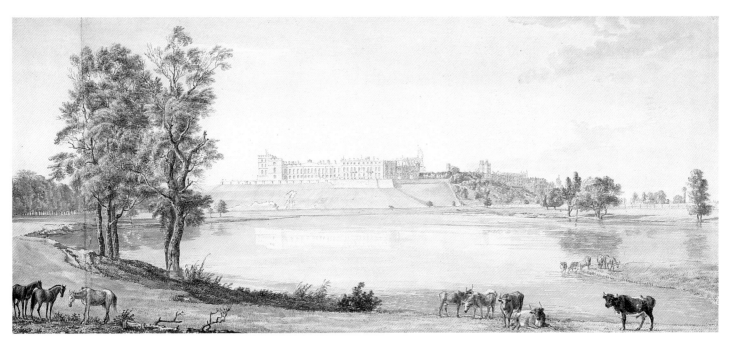

inscribed in pen and ink:
Windsor / View of the Castle from the Maestricht Pond / in the Little Park
PROVENANCE Sir Joseph Banks; Sir Wyndham Knatchbull (sale, Christie's, 23 May 1876, lot 51); purchased (8½ gns.) by Weston; Anderdon Weston (sale, Sotheby's, 16 February 1922, lot 118, and 27 June 1922, lot 48; £14. 10s.); purchased by HM Queen Mary; presented to the Royal Collection, 6 March 1930
Oppé 58; RL 14582

failure of the Maestricht Garden may even have been excessive gravel extraction.

The cattle and horses observing the viewer with such interest are familiar from other Sandby views. The ancient horse drawn across the join in the paper is shown in a view of Eton in the British Museum (LB 13). A pencil study of the same horse is inscribed "Portrait of a Mare ridden by Wm. Duke of Cumberland in his Campaigns in Flanders, afterwards turn'd out for life in Windsor Gt Park and paddocks" (36.2).

A larger variant of this view, probably painted around a decade later, is in the collection of the Duke of Buccleuch at Drumlanrig (36.3). In composition these views are close to Paul Sandby's north-western view of Wakefield Lodge at New Haven (Robertson 77), signed and dated 1767. The dimensions of that view are close to those of the Drumlanrig version.

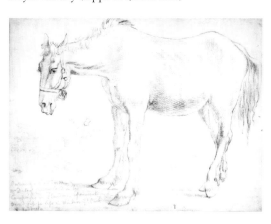

36.2 Paul Sandby, *The Duke of Cumberland's mare*, ca. 1755, graphite, 8⅜" × 11⅜" (213 × 288 mm), Royal Library (Oppé 384; RL 14354)

36.3 Paul Sandby, *The north front of the Castle from the Maestricht Pond*, ca. 1780, watercolour, 33½" × 17⅛" (850 × 435 mm), collection of the Duke of Buccleuch and Queensberry KT, Drumlanrig

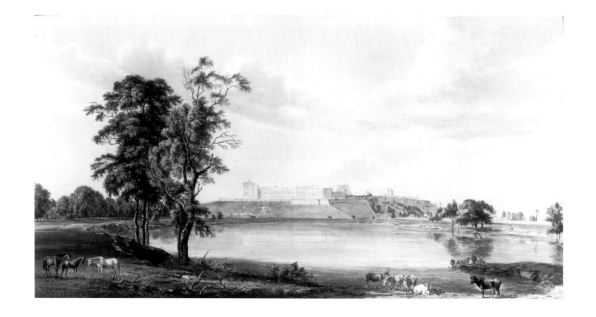

Detail of 36

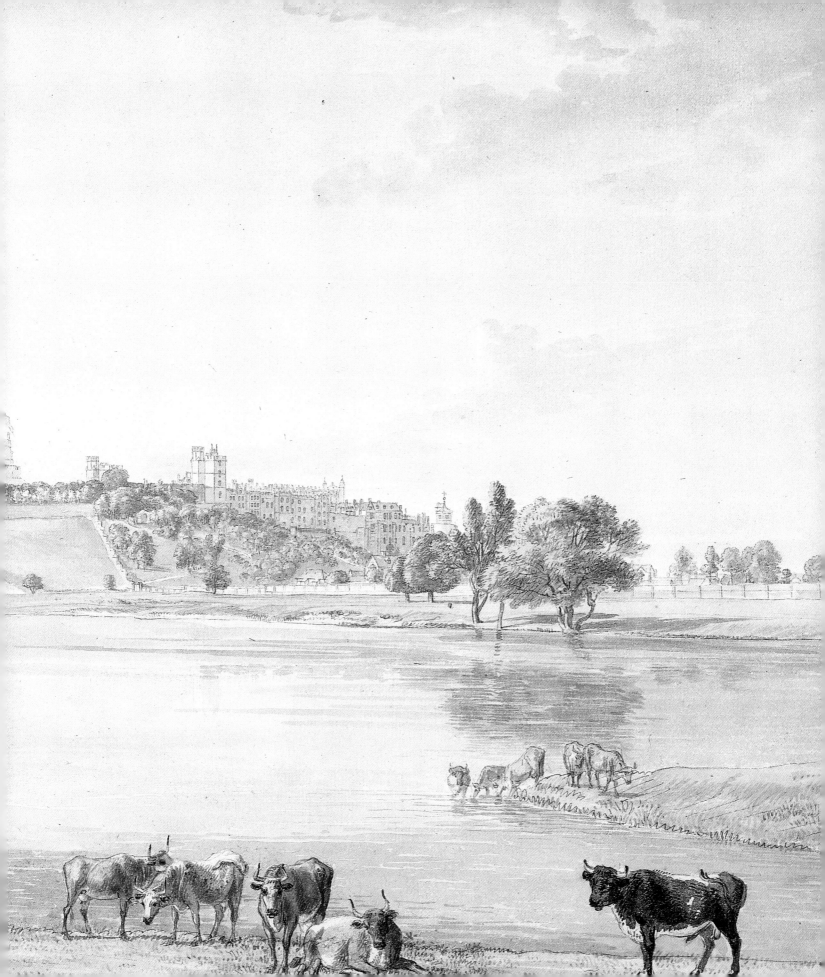

VII The Great Park and Ascot

As its name suggests, the Great Park is a large enclosed area of parkland to the south of Windsor, amounting to just under 5000 acres (2020 ha.); it is therefore ten times larger than the Little Park. Both the Great Park and the Little Park were originally enclosures within the vast expanse of Windsor Forest. The *raison d'être* of both the Parks and the Forest was the protection of the venison (the beasts of the chase, mainly deer) and the vert (the growing timber and undergrowth that provided food and shelter for the venison), principally for the sport of king and courtier but also for the royal larder. The Great Park evolved in the thirteenth and fourteenth centuries; by the early seventeenth century it contained over 3600 acres (1460 ha.), but it may already have approximated this size two hundred years earlier.

During the Commonwealth the deer were neglected and the Great Park, like the Little Park, was sold off piecemeal, or rather handed out in lieu of pay to officers who had led the Parliamentary forces during the Civil War. After the Restoration of the monarchy in 1660 the Park was gradually reinstated and deer were reintroduced to the area. Twenty years later work began on the planting of a great avenue two and a half miles (4 km) long, the Long Walk, which provided a link between the Castle and the Great Park for the first time. Under Queen Anne a whole series of subsidiary avenues were planted to protect the Queen in her drives around the Park and between Park and Forest. The park boundary is shown as an irregular black line in Rocque's plan of 1752 (VII.1).

The office of Ranger of the Great Park, with overall responsibility for the Park and its Keepers, was established in the seventeenth century. The Rangership was at first given to a series of senior courtiers but since 1746 it has been held by members of the Royal Family: the present Ranger is His Royal Highness The Prince Philip, Duke of Edinburgh. The Ranger between 1746 and his death in 1765 was Thomas Sandby's patron, William Augustus, Duke of Cumberland, second son of King George II and uncle to George III. Sandby became Steward to the Duke in 1764; this appointment was tantamount to that of Deputy Ranger. He continued to serve in this capacity throughout the Rangership of William Augustus's successor as Ranger, King George III's youngest (surviving) brother, Henry Frederick, Duke of Cumberland (1745–1790), and served the King as Deputy Ranger from 1790 to 1798.

The changes introduced within the Park during William Augustus's Rangership were extensive and crucial to the future development of the area. In addition to numerous changes at the Ranger's official home, the Great Lodge, the watercourses in the Park were manipulated to create a series of lakes; the largest of these was Virginia Water, which was over one and a half miles (2.5 km) from east to west. The new lakes provided the settings for other works – bridges, grottos, cascades and temples – erected by the Duke's architects in the vicinity but all, with the exception of Fort Belvedere, soon destroyed. The drawn and painted views of Thomas Sandby (*e.g.* 37, 38 and 44) are contemporary records of many of these features.

In 1751 William Augustus had assumed the additional offices of Warden of Windsor Forest and Keeper of Cranbourne Chase, with a residence at Cranbourne Lodge (see 42 and 43), situated outside the Great Park but within a mile of the Great Lodge.

George III had established himself and his family at Windsor by 1780 and soon began to take an active interest in the Windsor Parks. In 1768 Duke William Augustus's pondhead at Virginia Water had been swept away by torrential rain. In August 1781 it was announced that the King had ordered that "the water in the Great Park and Windsor should be restored with considerable Improvements" (PRO T25/1, p.217). Throughout the 1780s and 1790s work proceeded around Virginia Water, and the new cascade was inaugurated in April 1797. At the same time, areas of the Park were transformed for agricultural purposes, under the direction of Nathaniel Kent.

Thomas Sandby's house (39 and 40) was later converted

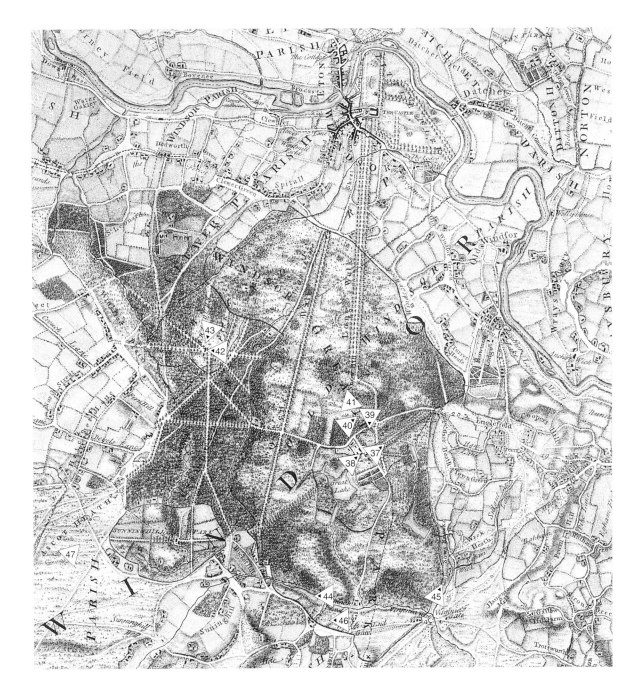

V11.1 John Rocque, *Actual Survey of Berkshire*, 1752, engraving (detail), with viewpoints superimposed (for explanation see p. 27)

for the use of the King's son, who ruled as Prince Regent from 1811 to 1820 and as King George IV from 1820 to 1830. The Prince Regent took increasing delight in visits to his "cottage" in the Park (now Royal Lodge) and made a number of picturesque additions in the southern area; of these the Chinese Fishing Temple on Virginia Water was the best known. The Park was once again the subject of sustained

agricultural improvement during the Rangership of Prince Albert (1840–61). Today it is divided into areas of parkland (stocked with deer), farmland and landscaped gardens (the Savill and Valley Gardens). It remains the property of the Sovereign in right of the Crown and is managed by the Crown Estate Commissioners.

37. THOMAS SANDBY

The east front of Cumberland Lodge, ca. 1754

Watercolour and bodycolour with pen and ink over graphite, 15¾" × 28¾" (400 × 731 mm)
WATERMARK Strasburg Lily/LVG, with countermark IHS/I VILLEDARY
MOUNT remains of narrow line and wash border (Type 1 (?))
PROVENANCE Paul Sandby (Lugt 2112; sale, Christie's, 2 May 1811, lot 73); purchased (3 gns.) by Shepperd for the Prince Regent (later King George IV); by descent
Oppé 100; RL 14627

37.1 Thomas Sandby, *The new north face of the Great Lodge*, ca. 1765, watercolour, graphite and pen and ink, Royal Library (Oppé 102; RL 14628) (detail)

37.2 James Mason after Thomas Sandby, *The Lodge & Stables*, 1754/55, engraving and etching, sheet size 13⅛" × 21⅞" (332 × 556 mm), Royal Library

The house now known as Cumberland Lodge was built by a Parliamentary army officer named James Byfield in the 1650s after the former Park had been divided up and disposed of by Cromwell's orders to private individuals (see Hudson, pp. 1–12). The site was in the very centre of the Park, to the south of Snow Hill (the end point of the Long Walk). After Charles II's decision to reimpark the area in 1670, Byfield's new house (which had cost around £5000 to build) became the official residence of the Ranger of Windsor Great Park and was therefore the home of the King's second son, Prince William Augustus, Duke of Cumberland, between 1746 and 1765. The stables to the north were extended before 1750 (the date on the turret clock), but no major additions were made to the main house until the late 1750s.

The architect responsible for the new works at the Lodge was almost certainly Thomas Sandby himself, who was described in 1759 as "Architect to HRH The Duke". He demolished the low buildings to the north-east and added a substantial new block (facing north) to the north end of the old house, thus effectively doubling the size of the Lodge. The new block is shown in the two unfinished watercolours by Thomas Sandby datable to the early 1760s (Oppé 101 and 37.1). In November 1869 this new wing was gutted and destroyed by fire. It was only partially rebuilt, to designs by Salvin, in the early 1870s.

This watercolour (37) is closely related to an unfinished monochrome drawing (Oppé 99) and to the engraved view which served as the title plate for Sandby's *Eight Views in Windsor Great Park* (37.2). It records the Great Lodge as built by Byfield, and the stables (to the right) as extended by William Augustus, whose rotund face is clearly recognisable in the carriage to the right of centre. There is no sign of Sandby's new wing, built in the late 1750s to replace the low buildings shown here immediately

behind the Duke's carriage. In the area between the fence and the Lodge and among the deer in the foreground, a number of exotic birds are shown, as described by Dr Richard Pococke in August 1754: "The Duke has wild beasts here, and I saw an ostrich walking in the lawn near the house. It is incredible how fine a place this is made, from being the most disagreeable and uncultivated, and the whole country round it is in a state of great improvement" (*Pococke Travels*, p. 60).

Cat. 37 was included in the Paul Sandby sale in 1811, described as the work of Thomas Sandby and dated 1768. Although it was possibly made as a repetition of the engraved subject rather than as a preparatory study for the print, it seems unlikely that Sandby would have repeated the earlier composition at a time when the Lodge looked very different and when – on the evidence of 38 – he was working in another, much looser, manner. A fine finished watercolour (National Trust, Anglesey Abbey) related closely to one of the *Eight Views* is dated 1752, which suggests that the other finished watercolours relating to the engravings, including 37, may be dated before 1754. Three *Views of Windsor* by Thomas Sandby were listed in the Duke's Bedroom at the Great Lodge in the posthumous inventory of 1765 (WRA CP 1/19) but have not been traced in other Royal Collection inventories. Among the framed and glazed drawings and watercolours included in the sale of Thomas Sandby's collection in 1799 were *Eight Views in Windsor Great Park* (lot 35), which may have been either preparatory studies or replicas of the engraved subjects. As both designer and publisher of the *Eight Views*, Thomas Sandby would naturally have retained much of the preparatory material involved in the project although the text of the subscription plate (fig. 13) specifies that the original views belonged to Cumberland.

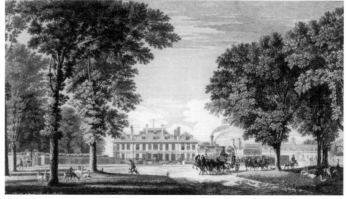

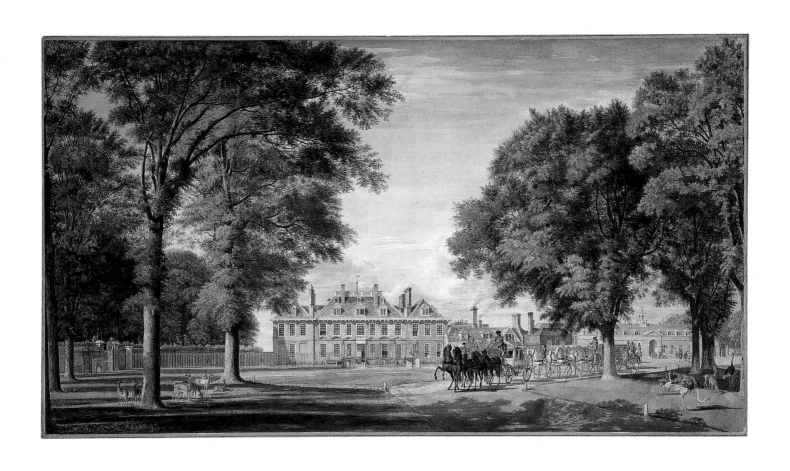

38. THOMAS AND PAUL SANDBY

The Chapel at Cumberland Lodge during building works in 1765, ca. 1770

Watercolour with pen and ink over graphite,
20⅞" × 30⅛" (530 × 766 mm)
VERSO inscribed in graphite:
TSandby fecit
WATERMARK ... HATMAN
PROVENANCE Thomas Sandby
(sale, Leigh & Sotheby's,
18 July 1799, lot 46, with Oppé
163); Colnaghi; purchased
(4 gns.) by the Prince Regent
(later King George IV),
13 July 1812; by descent
Oppé 190; RL 14704

Oppé was the first to associate "this puzzling drawing" with the title of Thomas Sandby's exhibit at the Royal Academy in 1773: *A perspective view of the back-part of the Chapel at Windsor Great Lodge, as it appeared when building in the year 1765.* Although the existence of (or even the proposal for) a chapel as part of the building programme at the Lodge before 1765 is undocumented, the title of the Royal Academy exhibit alone proves that one existed. That its design was the responsibility of Thomas Sandby may also be inferred: as Professor of Architecture at the Royal Academy, Thomas is unlikely to have publicized the work of another practitioner. A further reference to the Chapel occurs in 1807 in connection with the fate of the Holbein Gate (see 46), stones from which had been used in the Chapel building (Smith, p.22).

The Chapel was situated to the east of the new northern wing at the Lodge; on its western side it faced Great Meadow Pond, which can just be glimpsed through the open door in 38. By 1780 it had been converted into a Doric temple (38.1), but was not properly maintained and in 1814 the building was demolished.

The view of the Chapel (38) and its companion piece, a view of Somerset House (Oppé 163), which had been exhibited at the Royal Academy in 1772, were sold, framed, in a single lot in the posthumous sale of Thomas Sandby's collection in 1799; in 1812 both were purchased from Colnaghi by the Prince Regent. The artist could have been justifiably proud of the complex perspective construction of the unfinished tower and its scaffolding which is the true subject of 38. The small figure group at the left, which was also used in the Somerset House view, depends on an earlier pattern (see 38.2) often used by Paul Sandby in his Windsor views (*e.g.* 1.1). The group is shown to the same scale in 38.2 as in 38. Oppé considered that Paul "may have had a part in the final colouring generally [of 38], since it is rather warmer, and the washes are more varied, than is usual with Thomas. The shadows of the bricks, etc., in front of the lodge door are in the opposite direction from the others, which also points to a difference of hands."

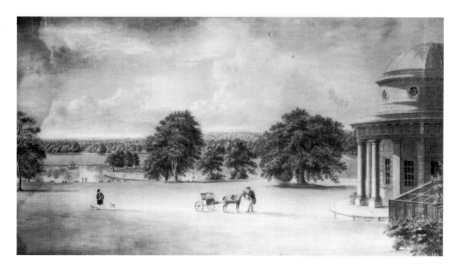

38.1 James Luttrell, *Great Meadow Pond and the Temple from Cumberland Lodge*, 1780, watercolour, 18½" × 33½" (470 × 850 mm), Royal Library (RL 21421)

38.2 Paul Sandby, *A man encountering a lady with two children*, ca. 1767, pen and ink and wash over graphite, 3⅛" × 3¾" (78 × 95 mm), Royal Library (Oppé 312; RL 14456)

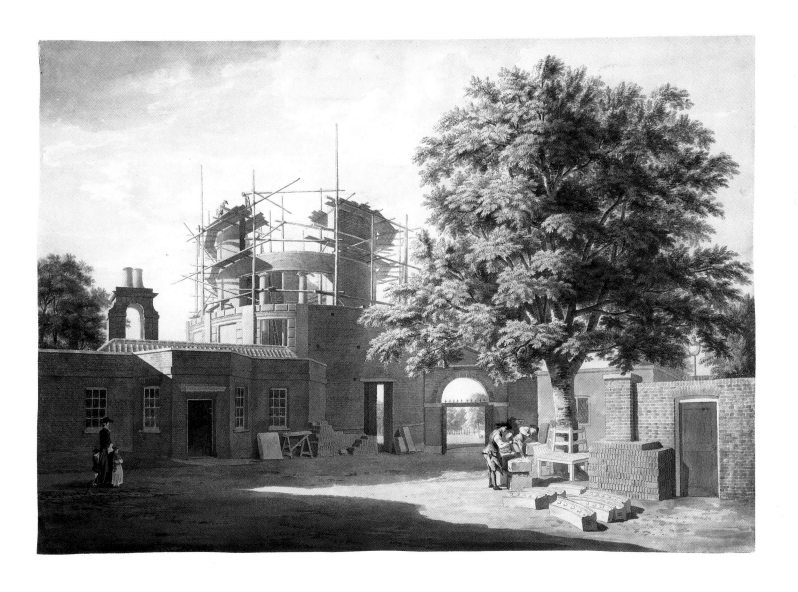

39. PAUL SANDBY

The Deputy Ranger's House, Windsor Great Park, ca. 1795

Watercolour and bodycolour, within line (black) and wash (brown) border,
16¼" × 23⅜" (413 × 594 mm); image 13⅝" × 20⅞" (347 × 530 mm)
WATERMARK Strasburg Lily/LVG, and countermark IV. Watermark of backing paper: monogram PvL
PROVENANCE Princess Helena Victoria and Princess Marie Louise (sale, Schomberg House, Robinson & Foster Ltd., 24–25 March 1947, lot 274, with 40); Messrs. Sabin; purchased 1948
Oppé 428; RL 17597

The building which was later occupied by Thomas Sandby as Deputy Ranger of Windsor Great Park may date, like Cumberland Lodge nearby, from the mid-seventeenth century. There was a house on the site by 1662; in 1750 it was in use as the dairy. Thomas Sandby took up residence there ca. 1770; his two watercolour views (Oppé 109 and 39.1) record the house from the south at around this time: 39.1 is inscribed on the verso "The Dairy at the Lodge, Windsor Great Park". The building was situated immediately to the north-west of the junction of the road between Windsor and the Long Walk to the north and Virginia Water and the remainder of the Great Park to the south, and the road crossing the Park from Sandpit Gate in the west to Bishopsgate in the east. The Great (or Cumberland) Lodge was less than half a mile to the south. By 1792 (the date inscribed on a variant of 39 in Manchester City Art Gallery) the house had been enlarged considerably by the addition of the south-facing block in the centre of 39. The addition was presumably built to Thomas's designs.

Following Thomas Sandby's death the house was occupied by Joseph Frost, the Park Bailiff. But in 1815 the Prince Regent himself moved into the Lodge, now renamed the Prince Regent's Cottage, following some rapid alterations and additions by his architect John Nash (see Morshead). Late in 1823 Jeffry Wyatt (later called Wyatville) took over from Nash as architect, and the house assumed its present name, Royal Lodge. Wyatville's additions were still being worked on at the time of George IV's death in June 1830. The new King, William IV, demolished everything except the conservatory, the new dining room and the adjacent chapel: no part of Sandby's house escaped demolition. The modest remnant of George IV's "Cottage" was converted to serve again as a residence in 1840. Just under a hundred years later it was granted by King George V to his second son, the Duke of York, as a country home. Between 1931 and 1936 the Duke and Duchess made substantial additions to the house. Royal Lodge remains the Windsor residence of Her Majesty Queen Elizabeth The Queen Mother.

The Deputy Ranger's Lodge was a popular subject for Paul Sandby in his later years and was doubtless repeated even after Thomas's death, when the Sandbys no longer had links with the Great Park. The view shown in 39 is recorded in a pencil outline at Greiz (E 442) and in a very summary later watercolour in the British Museum (LB 4(a)), as well as in the Manchester view dated 1792.

Two other Sandby views, one oblong and one upright, record this house; both are taken from closer to the building and from rather further to the left. The upright view is linked to 42 by the details of the planting in the immediate vicinity of the house that it contains. The different figures included in the two known versions of the upright view (39.2 and at Christie's, 15 June 1971, lot 93), can doubtless all be associated with members of Paul and Thomas's large and interwoven families.

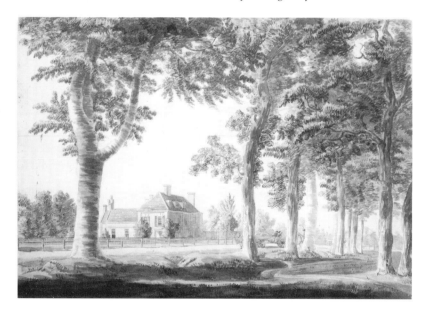

39.1 Thomas Sandby, *The Deputy Ranger's Lodge*, ca. 1770, watercolour and pen and ink over graphite, 14¾" × 21½" (375 × 547 mm), Royal Library (Oppé 451; RL17864)

39.2 Paul Sandby, *The Deputy Ranger's Lodge*, 1798, watercolour and bodycolour, 19⅞" × 15¾" (505 × 400 mm), collection of HM Queen Elizabeth The Queen Mother

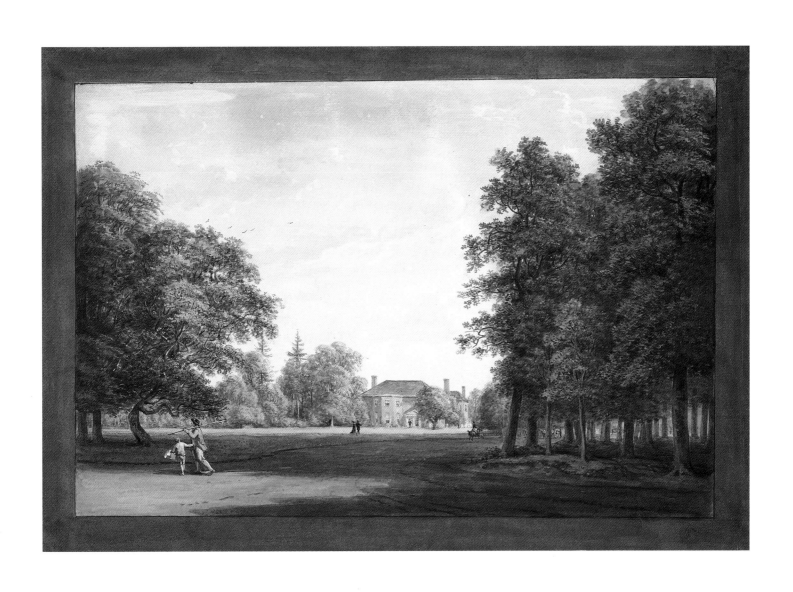

40. PAUL SANDBY

The garden of the Deputy Ranger's House, ca. 1798

Bodycolour, within line (black) and wash (olive-green) border, 15¾" × 23¼" (399 × 592 mm); image 13½" × 20¾" (343 × 526 mm)
PROVENANCE Princess Helena Victoria and Princess Marie Louise (sale, Schomberg House, Robinson & Foster Ltd., 24–25 March 1947, lot 274, with 39); Messrs. Sabin; purchased 1948
Oppé 429; RL 17596

This finished watercolour records the gardens immediately adjoining the south front of Thomas Sandby's house. The path in the left foreground has passed by the front door before winding to south and west. The figures are doubtless all members of the Sandby family and household. The fact that some appear to be wearing mourning has suggested that 40 may have been painted immediately after Thomas's death in June 1798. George Taylor Seton, an infant son of Thomas's son Thomas Paul and of Harriot Sandby, was baptized at Windsor on 15 June 1799; the address was given as "Great Lodge" (Berks RO, Old Windsor Baptisms).

The cohabitation of so many members of the Sandby family in the Deputy Ranger's Lodge resulted indirectly from the death in 1782 of Thomas's second wife, Elizabeth Venables, and the marriage in 1786 of Paul's second son, Thomas Paul, to his first cousin, Thomas's second daughter Harriot. Harriot and Thomas Paul, with their large family, cared for Thomas at Windsor during the last ten years of his life.

What may be a preliminary study for 40, in watercolour but omitting the figures, is in the British Museum (40.1). Other garden views by Paul Sandby include 12, various views of the garden at Nuneham (created by 2nd Earl Harcourt) made in 1777, and the late views of the garden of the Sandby house at Englefield Green.

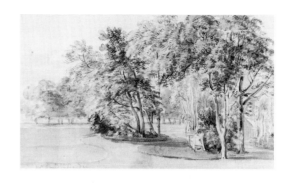

40.1 Paul Sandby, *The garden of the Deputy Ranger's House, ca.* 1798, watercolour over traces of graphite, 4⅜" × 7½" (112 × 190 mm), British Museum, London (LB 4(b))

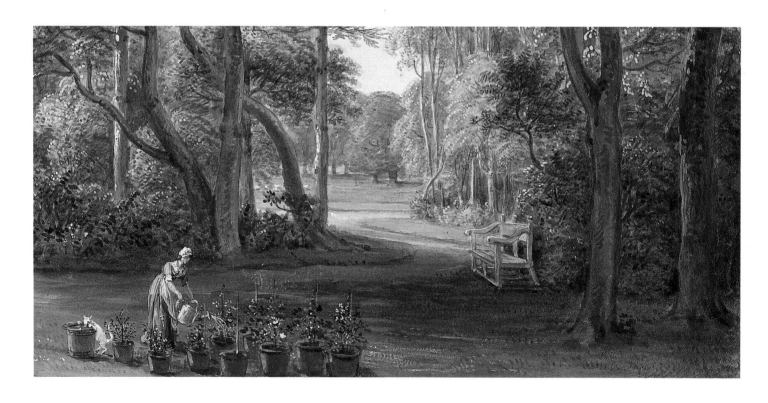

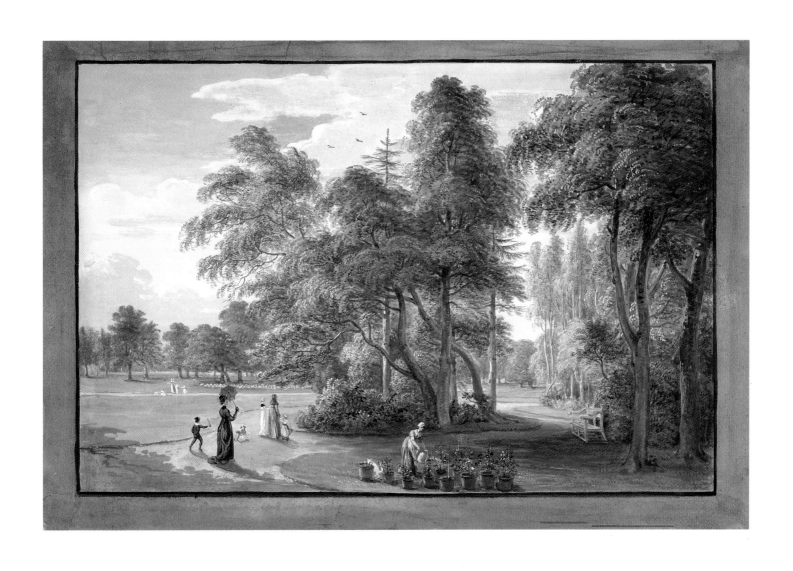

41. PAUL SANDBY

The wheelwright's shop in Windsor Great Park, 1792

Watercolour over graphite,
10⅞" × 16¾" (277 × 427 mm)
Signed and dated at bottom,
on log to right of centre: *PS / 1792*, and inscribed on plank,
lower centre: *Wood Yard W.P*
WATERMARK Strasburg
Lily/GR
MOUNT Type 4. Inscribed in
graphite: *The Wheelwrights shop
in Windsor G. Park 1792*, and *2 - 13/2*. Mount watermark:
Strasburg Lily/GR
PROVENANCE Paul Sandby
(sale, Christie's, 3 May 1811,
lot 13, one of a pair);
purchased (£2. 12s. 6d.) by
Shepperd for the Prince
Regent (later King George IV);
by descent
Oppé 92; RL 14618

The wheelwright's shop occupied an area of the Woodyard in the Great Park. The location of the Woodyard or Carpenter's Yard was noted on Vardy's map of 1750 as immediately to the west of the dairy. It was thus closely adjacent to Thomas Sandby's house, the Deputy Ranger's Lodge (39). In some of Sandby's views of the Woodyard (for instance, 41.1), the chimneys of the Ranger's Lodge and the tops of the fir trees in the garden can be seen over the roofs of the sheds. The Woodyard was moved to the west, to an area later developed as the Prince Consort's Workshops, when the Deputy Ranger's Lodge was converted into the Prince Regent's Cottage, from about 1813. A group of three views of the Old Woodyard were offered for sale by Thomas Paul Sandby in 1827, with a note in the catalogue that this was "now the scite [*sic*] of His Majesty's Royal Cottage and Garden".

As in any well run estate, the Park was expected to produce more than enough timber for building works, fencing and farm machinery. In 1791 it was noted that "All the Waggons Carts & Wheelbarrows [at Windsor] are made in the Woodyard belonging to the Park" (WRA Add. Geo 15/361). Among the farm equipment shown in 41 is a roller, a covered

waggon and several wheels.

Cat. 41 is one of a large group of watercolours by Paul Sandby of the Woodyard, most of which are dated 1792. It is one of five Woodyard views in the Royal Collection (with Oppé 91, 94, 96 and 41.1) which can be identified with lots purchased for the Prince Regent in Sandby's 1811 sale. There are further Woodyard subjects at Windsor (Oppé 95), the British Museum (LB 6, 7), Leicestershire Museum and Art Gallery (7a.1904), New Haven (Robertson 126), Reading Museum, and formerly Christie's (15 June 1982, lot 123 and 21 March 1989, lot 69). A canvas painted in oil, bodycolour and gum in the City of Hamilton Art Gallery, Victoria, Australia, is an elaboration of one of the British Museum drawings (LB 6).

It has been suggested by Bruce Robertson that this series was the product of a period of convalescence spent by Paul Sandby with his brother, son and daughter-in-law at Windsor. The Woodyard subjects show the artist returning to the challenge of depicting a complex (if unimposing) area from a multiplicity of viewpoints, as with the Castle views of around thirty years earlier.

41.1 Paul Sandby, *The Woodyard*, 1792, watercolour and bodycolour over graphite, 7⅛" x 11¾" (180 × 297 mm), Royal Library (Oppé 93; RL 14619)

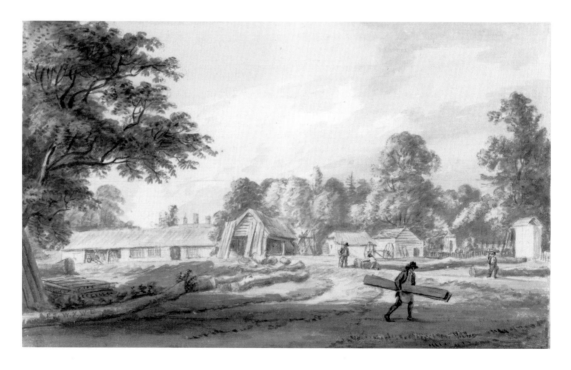

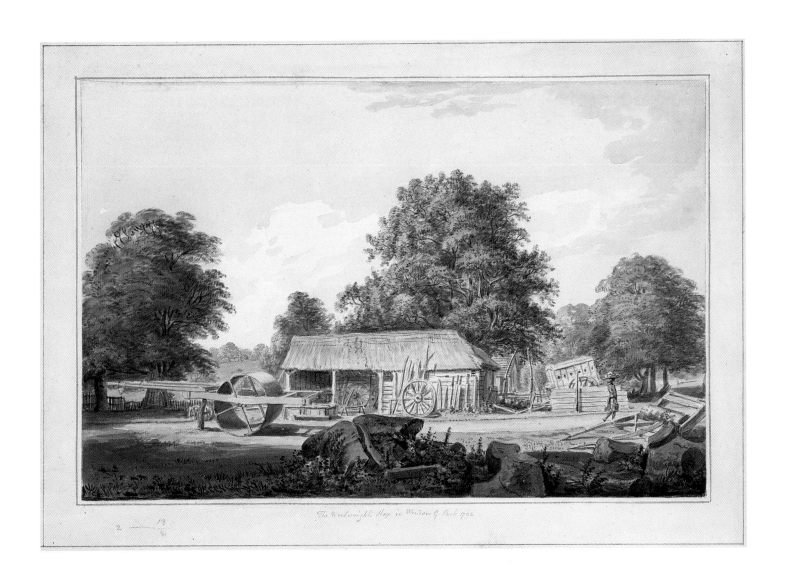

The Woodwrights Shop in Windsor G. Park 1792

121

42. THOMAS AND PAUL SANDBY

The walk and terrace at Cranbourne Lodge, 1752

Watercolour and bodycolour with pen and ink over graphite, 17¼" × 46½" (440 × 1180 mm) (two sheets of paper). Signed and dated in pen, lower right: *T. Sandby delin. Septemr 19. 1752*
PROVENANCE William Augustus, Duke of Cumberland; King George III; by descent
Oppé 111; RL 14636

The subject of this watercolour is explained by reference to a mid-eighteenth-century map of the area (42.1). The right-hand half of the view is occupied by the tree-lined walk which extended due east from Cranbourne Lodge; parallel to this on the left is the terrace which crossed the north front of the Lodge, situated behind the viewer. The viewpoint for 42 is thus at the north-east corner of the house, looking east-north-east.

Cranbourne occupies the northern tip of an elevated area of land to the south-west of Windsor, within the division of Windsor Forest known as Cranbourne Chase. The Keeper of Cranbourne Chase had his residence at the Lodge in the small enclosure called Cranbourne Rails. The house was rebuilt after the Restoration; it was probably little changed by the time of Thomas Sandby's view (42.5). Between 1699 and 1712 it was used by the Earl of Ranelagh as his country seat. Ranelagh spent vast sums of money at Cranbourne and appears to have laid out, with Henry Wise, the terraces and avenues shown radiating from the house and through the park enclosure in plans such as 42.1. In 1731 the Lodge reverted to its ancient rôle as home of the Keeper of Cranbourne Chase, an office which was combined between 1734 and 1765 with that of the Warden of Windsor Forest: for much of the eighteenth century it was the Warden's official residence, and from July 1751 it was one of the homes of William Augustus, Duke of Cumberland. Although

42.2 Paul Sandby, *Figure studies*, *ca.* 1752 (?), watercolour and pen and ink over graphite, 3⅜" × 4" (86 × 102 mm), Royal Library (Oppé 231; RL 14502)

42.3 Paul Sandby, *Figure studies*, *ca.* 1752, pen and ink and wash, 3⅜" × 3⅛" (86 × 80 mm), British Museum, London (LB 137 (12a))

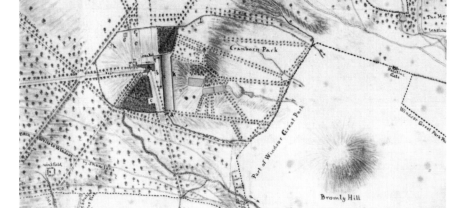

42.1 (left) *Plan of Cranbourne Chase* (detail), *ca.* 1755 (with north to the right), Royal Library

42.4 (on facing page) Thomas Sandby, *View to the north from Cranbourne*, 1752, watercolour with pen and ink over graphite, 16⅝" × 43⅛" (422 × 1095 mm), Royal Library (Oppé 114; RL 14639)

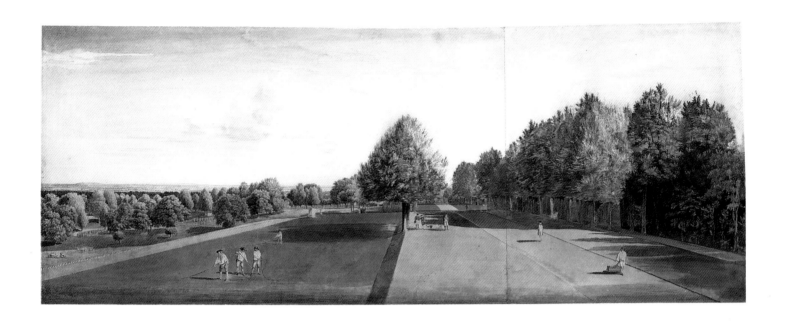

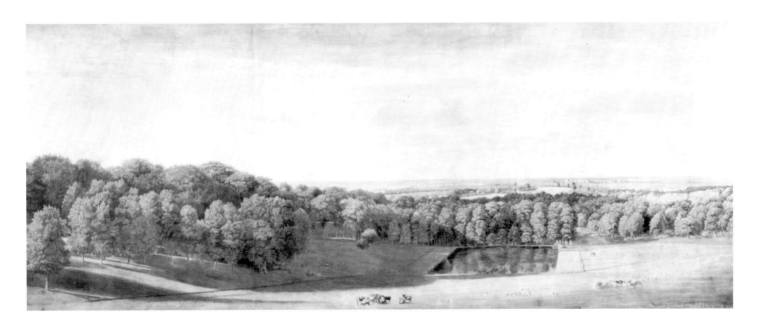

work was carried out in the gardens at Cranbourne between April and June 1752 (WRA CP 74/369), the basic layout remained unchanged. Cat. 42, dated 19 September 1752, must therefore record the walk and terrace first introduced by Ranelagh and Wise around fifty years earlier.

The position of the house was considerably more dramatic than that of the Great Lodge, which remained Cumberland's chief home. However, Cranbourne Lodge was used when building works were in progress at the Great Lodge and was also the site of Cumberland's stud and the birthplace in 1764 of the great racehorse Eclipse.

An estimate was made in February 1768 during the Wardenship of George III's brother, the Duke of Gloucester, for extensive building and repair works at Cranbourne totalling £5200. It included works in the Pleasure Ground ("To repair and paint the movable Garden Seat put a Kirb for the wheels to run on complete £6 12s") possibly relating to the seat at the far end of the terrace in 42. Between 1804 and 1808 further major building works were undertaken, to the designs of James Wyatt and at a total cost of over £20,000 (see PRO CRES 2/47B). Wyatt's house occupied the same position as the seventeenth-century house, with a north–south axis terminating in a lofty tower at its northern end and an entrance front facing west. It was the temporary home of Princess Charlotte of Wales between 1814 and 1816, but no use could be found for it thereafter. The house was demolished in 1830 by order of William IV and all that survives today is the octagonal tower, with a fine room on the ground floor dated 1808.

This watercolour belongs to a group of five of similar style and format, all early works of Thomas Sandby, which can be associated with the set of "Six Different Views of Cranbourne Lodge and Park" recorded in the Duke's Dressing Room at the Great Lodge in 1768, and almost certainly the same as the "Six different views in Water Colours" noted in the same room in 1765 (WRA CP 1/19). Two (42 and 42.4), dated September and August 1752, are clearly related to Cranbourne; three (Oppé 112, 113 and 115) record the landscape of the Great Park itself; the sixth view has not survived. Cat. 42 is the only one of the set to include figures. Three of those to the right of centre also appear on a sheet of studies by Paul Sandby (42.2); the figure of the gardener on the left is related to another early drawing by Paul (42.3). Oppé considered that both the execution and the invention of the figures in 42 were the responsibility of Paul Sandby.

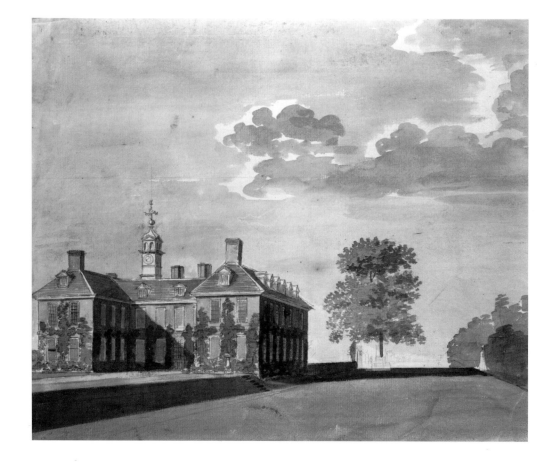

42.5 Thomas Sandby, *Cranbourne Lodge, ca.* 1765, watercolour and pen and ink over graphite, 12" × 15⅛" (305 × 383 mm), Royal Library (Oppé 110; RL 14635)

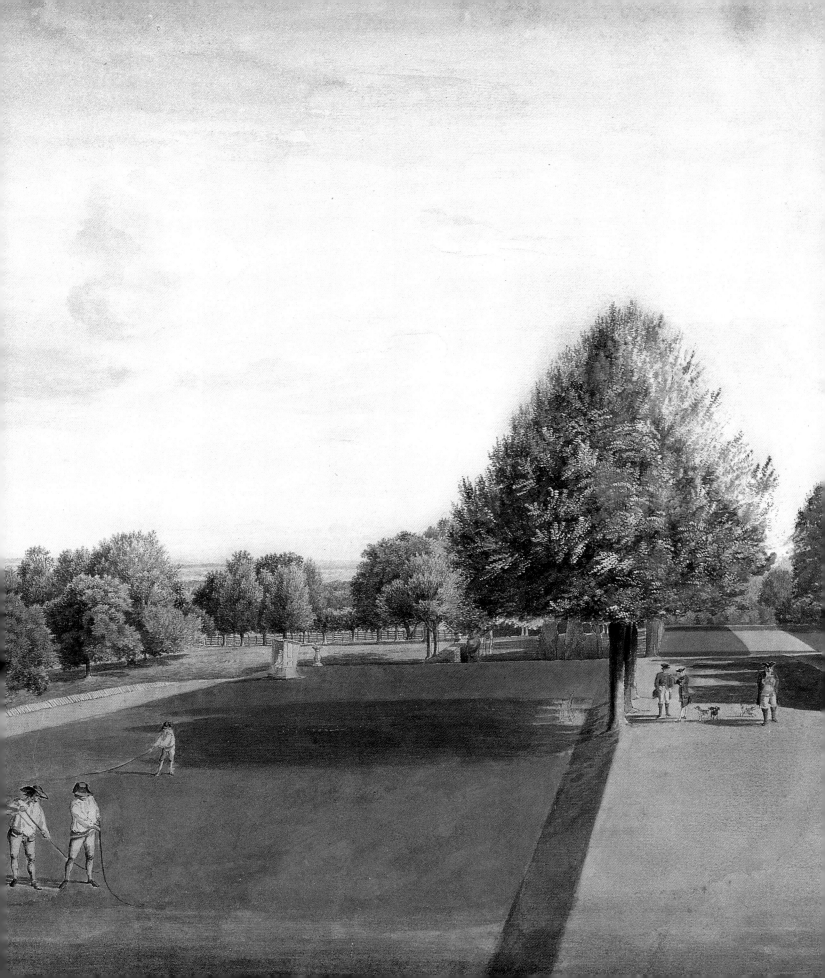

43. THOMAS SANDBY

Distant view of Windsor from the south-west, ca. 1760

Watercolour with pen and ink over graphite, irregular, max. 10½" × 19⅝" (267 × 500 mm)
VERSO inscribed in pen and ink: *Windsor from the Lodge grounds in the Great Park No. 1* and *£1-1--*
WATERMARK Strasburg Lily/GR, and J WHATMAN countermark
PROVENANCE the Earl of Derby (sale, Christie's, 19 October 1953, part of lot 137); F.T. Sabin; purchased for the Royal Collection
RL 17751

Since the early eighteenth century artists have painted distant views of Windsor Castle looking to the north from three principal vantage points in the Park: from Cranbourne in the south-west, from Snow Hill (the site of the Copper Horse at the end of the Long Walk) in the south, and from Bishopsgate in the south-east. In every case the view was taken from an elevated position, around three miles from the Castle.

The Sandbys recorded the Castle from all three viewpoints. The inscription on the verso of 43, "Windsor from the Lodge Grounds in the Great Park" indicates that the viewpoint was in the grounds of either Cumberland Lodge (from which no such view is possible) or Cranbourne Lodge. In 1752 Thomas recorded the view of Windsor from Cranbourne (42.4), and with the honesty of a military topographer he showed the true distance and the features such as Bromley Hill (which is not indi-

cated in 43) which partly interrupt the view from this angle. By contrast a watercolour by C.R. Stanley recording the view from Cranbourne in 1839 (RL 19751) shows how a nineteenth-century artist was prepared to manipulate the topography for artistic purposes. At a later date than 1752, Thomas Sandby may have done the same in 43.

The foreground of 43 shows an enclosed area, with trees on a slightly lower level. The upper ends of the paling, picked out in the sunshine, are shown running across the view from left to right. A watercolour in the Victoria and Albert Museum (43.1), also attributed to Thomas, may be a view from the same position, although the appearance of the Castle differs and figures (after models by Paul) have been introduced in the foreground. The touch of 43 is more delicate, and probably earlier, than that of the Victoria and Albert version. The bright green colouring in both versions is typical of Thomas.

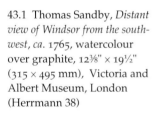

43.1 Thomas Sandby, *Distant view of Windsor from the south-west, ca.* 1765, watercolour over graphite, 12⅜" × 19½" (315 × 495 mm), Victoria and Albert Museum, London (Herrmann 38)

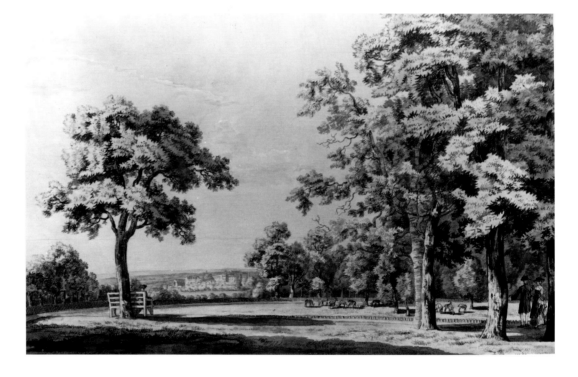

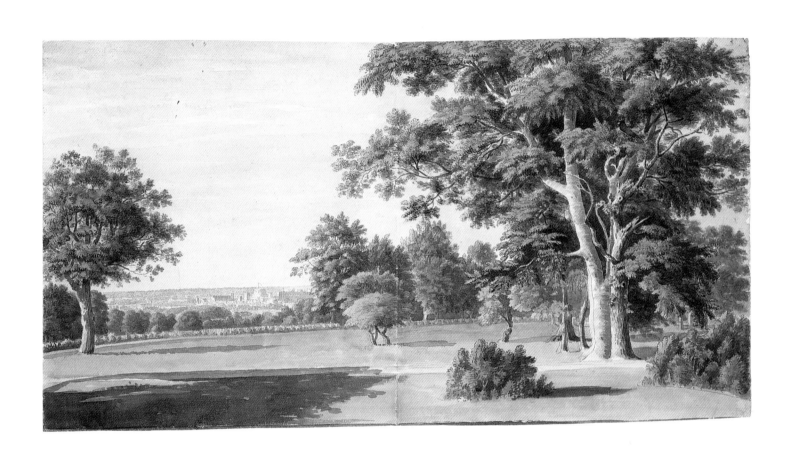

44. THOMAS AND PAUL SANDBY

The Great Bridge over Virginia Water, ca. 1754

Watercolour and bodycolour with pen and ink over graphite, 12⅜" × 22¾" (313 × 577 mm)
VERSO inscribed in graphite: *Windsor Great Park* WATERMARK Strasburg Lily/LVG, with countermark IHS/I VILLEDARY MOUNT (now detached) Type 1 (inner element only). Inscribed in graphite: *Bridge at Virginia Water*, and *The Late Duke of Cumberland*. Verso inscribed in pen and ink: *View of the great Wooden Bridge over the Virginia River in Windsor Great Park / built for his Royal Highness William Duke of Cumberland by Mr Fleetcroft / in the year 1760, which went soon to decay, and an elegant Stone Bridge was afterwards / Erected by T. Sandby Esqr - This drawing was made by the two Brothers T. and P Sandby, Esqrs., and Wrote by Paul Sandby / 1807.* Mount watermark: Strasburg Lily/WR, with countermark D & G BLAUW PROVENANCE Paul Sandby; Royal Collection by 1884 (exh. Nottingham, no.21)
Oppé 120; RL 14647

The wooden bridge which is the subject of this view was erected in the early 1750s across the newly formed Virginia Water. It was to carry the main carriage route that ran through the Park from north to south, without preventing the Duke of Cumberland's pleasure boats from sailing beneath it. A viewpoint from the south-west bank of Virginia Water was employed in 44; the newly built Belvedere to the south-east is seen on the horizon at the right-hand edge, and a tiny white hump (above the cart in the left foreground) indicates the grotto by the pondhead to Virginia Water to the east. The viewpoint is at upper left on the plan reproduced as 46.2, just to the right of the Great Bridge.

Paul Sandby's later inscription on the verso of the old backing sheet of 44 (44.3) gives the date of the bridge (erroneously) as 1760 and credits the design (correctly) to Henry Flitcroft, who acted as architect to William Augustus, Duke of Cumberland, in the late 1740s and 1750s. On a visit to Windsor in June 1757 Mrs Delany remarked of the Great Bridge that "the workmanship is most curious, and any piece of wood that is decayed may be taken out and repaired without weakening the rest. Carriages of all sorts go over it every day, but it is desperately steep, and we walked over it" (*Delany*, III, p.462). The torrential rainfall in September 1768 which destroyed the pondhead (see 45) damaged the foundations, such as they were, of Flitcroft's bridge and hastened its demise. An "elegant Stone Bridge" (so described on the verso of 44) with five arches was built as a re-

placement in the early 1780s, to the designs of Thomas Sandby. By 1817 Sandby's bridge was considered unsafe; a new bridge, which still stands, was built to the designs of Sir Jeffry Wyatville in 1826.

The Duke of Cumberland, shown on horseback at far right, doubtless considered Flitcroft's Great Bridge one of his most notable additions to the Great Park. The subject was accordingly included as one of the plates of Sandby's *Eight Views* published 1754/55. The print (44.2) is inscribed as the work of Paul Sandby after a design by Thomas. Even without Paul's inscription on the verso of 44 we would be forced to attribute the active and balletic figures to the younger brother: independent studies for a number of them are in the British Museum (LB 138 (nos. 21, 58 and 66)). The portrait of Cumberland himself is surely the work of Paul. However, the overall design and the carefully handled foliage of the two trees in the foreground are equally clearly the work of Thomas.

The status of 44 and its precise relationship with the engraving is far from straightforward. A preliminary study for the composition, concentrating on the bridge itself, is in the Royal Collection (RL 17851); a very fine, more finished, watercolour study is in the British Museum (44.1). When compared with both these studies and the published engraving, there are curious omissions from 44, especially in the architecture of the bridge, which lacks all but the most summary reference to the far rail and leaves the fence at the far end incomplete. It is at

44.1 Thomas Sandby, *The Great Bridge, ca.* 1754, watercolour and pen and ink, 7⅝" × 14¼" (194 × 362 mm), British Museum, London (LB TS 27(1))

44.2 Paul Sandby after Thomas Sandby, *The Great Bridge over the Virginia River*, 1754/55, etching and engraving, sheet size 13⅜" × 22⅜" (338 × 567 mm), Royal Library

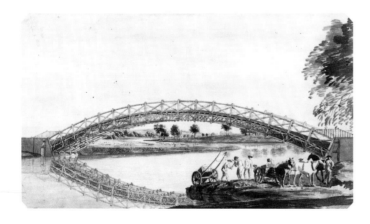

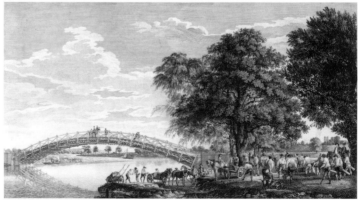

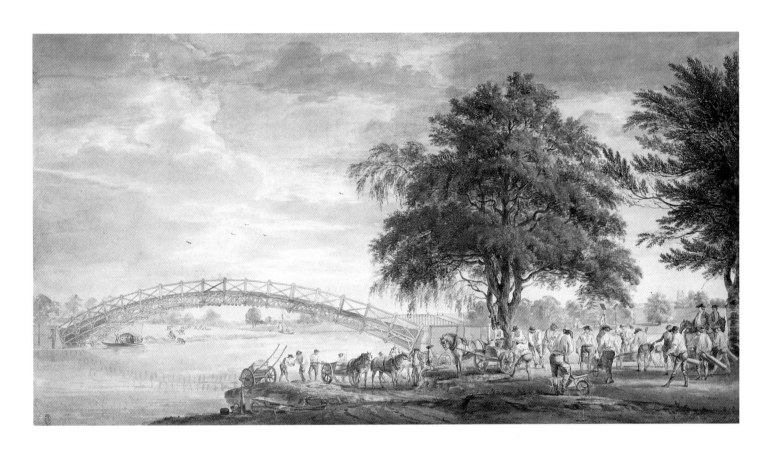

View of the great Wooden Bridge over the Virginia River in Windsor Great Park built for His Royal Highness William Duke of Cumberland, by Mr Fleatcroft. in the year 1760, which went soon to decay, and an elegant Stone Bridge, was afterwards Erected by T. Sandby Esqr. This drawing was made by the two Brothers T. and P. Sbys Esqrs

44.3 Inscription by Paul Sandby, 1807, on the old backing sheet of 44

least a possibility that the engraver, Paul Sandby, used the much more detailed drawing of the bridge now in the British Museum as a guide when engraving the left-hand side of the composition, and 44 (which includes much of his own work) for the right-hand side. The engraving includes several figures on the bridge which are only tentatively suggested in pencil in 44.

There is a parallel, possibly coincidental, between the Great Bridge and the Sandbys' view of it and Walton Bridge and Canaletto's painted records: the central arch of Walton Bridge was 180 feet (55 m) wide, as opposed to the Great Bridge's 165 foot (50 m) span. Walton Bridge was built in 1750 and was painted by Canaletto in both 1754 and 1755, at around the same time that Thomas and Paul were making records of the Great Bridge at Virginia Water.

45. THOMAS SANDBY

Design for the east end of Virginia Water, ca. 1782

Watercolour with pen and ink over graphite, 5⅞" × 15⅞" (148 × 402 mm) (formerly folded down centre)
VERSO inscribed in graphite: *Virginia Water.* Graphite studies of the ground-plan of a house, the elevation of a castellated building or gateway and the section of part of a sluice mechanism, with some measurements
WATERMARK Britannia
MOUNT Type 4. Inscribed in graphite: *Virginia Water* and *By T. Sandby Windsor.* Mount watermark: countermark 1794; also 1794/J WHATMAN. Drawing inlaid into wash border during conservation, 1994
PROVENANCE purchased by the Prince of Wales (later King George IV) from Colnaghi's, 2 February 1802 (?); among "Various Sketches for Virginia Water" by Thomas Sandby noted in the Royal Library by William Sandby in 1892 (Sandby, p.214) (?)
Oppé 138; RL 14660

The establishment of a great artificial lake, Virginia Water (for which see South, *passim*), in the southern area of Windsor Great Park was the greatest contribution of William Augustus, Duke of Cumberland, to the appearance of the Great Park. The first pond-head was introduced in 1749 and was recorded several times by Thomas Sandby. As in the case of the Great Bridge (see 44), the design of the pondhead and the cascade with which it was associated was probably the ultimate responsibility of Flitcroft.

In September 1768 the pondhead and cascade were swept away, leading to widespread flooding in the vicinity. As Deputy Ranger, and as unofficial architect to the Ranger, Henry Frederick Duke of Cumberland, it fell to Thomas Sandby to devise ways of repairing the damage. A large number of designs by Thomas relating to Virginia Water have survived. Many are in the Gough collection in the Bodleian Library, Oxford; others are in the Royal Collection and elsewhere. These designs were doubtless included in Thomas Sandby's posthumous sale under such titles as *Views around Windsor* (among "Drawings, rolled, &c.", lot 85), *Plans in Windsor Park* (lot 113), *Views in Great Park, Windsor* (lot 159) or *Plans in Windsor Great Park* (lot 181).

The original design for Virginia Water incorporated several basic faults: the pondhead was close both to the busy main road between London, *via* Staines, and the south-west – the present A30 – and to the junction, immediately to the east of the road, of the Virginia brook with the Wick stream, which fed into the same watercourse, the Bourne, and eventually entered the River Thames at Chertsey. A further fault, identified by Thomas Sandby himself, was that the sluices were "at the foundation of the Head

at its greatest depth" (Bodleian Library, Oxford, Gough 41A, f.15r).

By August 1781 the King had decided "that the water in the Great Park and Windsor should be restored with considerable Improvements (which Improvements his Majesty has approved of as well as of the Purchase of Lands necessary for that purpose)". After the King's intervention land immediately to the north, east and south of the old pondhead was acquired, the Wick stream was incorporated within the revised Park boundary and it was possible to envisage relocating the pondhead further to the east. In the narrow strip in 45 between the viewer, looking south-east, and the main road, which is shown diagonally across the left-hand section of the sheet, is the pondhead and steep landfall beyond. This design is associated with a ground-plan of the same area (45.1) which clearly shows (as a double parallel row of dotted lines crossing the lake) the first pondhead with the grotto still present at its northern end. The viewpoint for 45 is on the eastern bank facing the grotto. Duke William Augustus's plantations along the old boundary of the Great Park are indicated in a dark tone on the plan, and can be seen on the right horizon in 45; the planned new planting occupies the area between this line and the main road.

The Treasury was informed in January 1785 that the estimate for the Virginia Water works had been exceeded, and that the works remained far from complete, because of the many troubles that had been encountered there. These troubles probably included the collapse of Sandby's first pondhead as shown in 45. In 1787 Charles Cole (*ca.* 1738–1803) was employed by the Office of Woods and Forests to supervise the Virginia Water works. Thereafter fresh work was undertaken (by Sandby and others) on a new pondhead. Sandby was responsible for finding suitable stones for the cascade and made numerous designs for the rockwork (for instance, Herrmann 48–50). The house on the far bank of the lake was built, to Thomas Sandby's designs, as a Keeper's house. Because of its important position overlooking the Virginia Water pondhead the building acted as another 'eye-catcher' in the vicinity of Virginia Water; it is also shown in a small watercolour by Paul Sandby (Oppé 105).

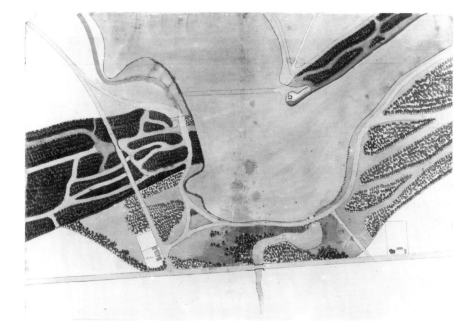

45.1 Thomas Sandby, *Ground-plan of the east end of Virginia Water, ca.* 1782 (with north to the right), watercolour, Bodleian Library, Oxford (Gough 41A, f. 17r)

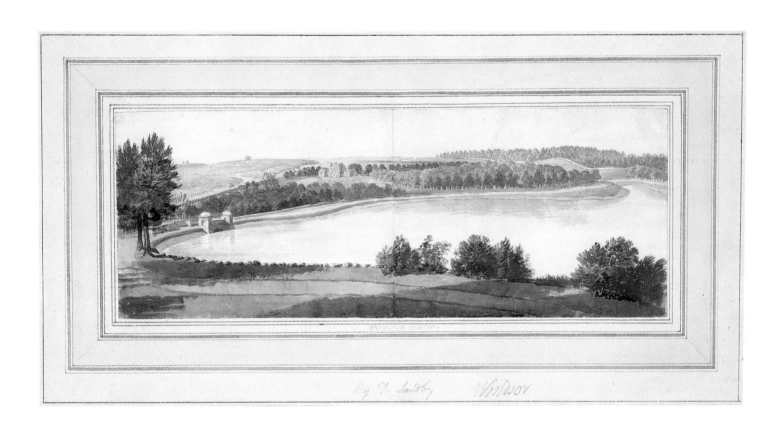

By T. Sandby Windsor

46. THOMAS SANDBY

Design for a bridge in the form of a ruined arch, ca. 1765

Watercolour with pen and ink over traces of graphite, with compass, 8½" × 18⅞" (217 × 480 mm)
VERSO inscribed in pen and ink: *No. 5 bt. of Chapman*
WATERMARK countermark J WHATMAN
PROVENANCE Messrs Spink; purchased 1948
Oppé 433; RL 17608

This is one of a number of Thomas Sandby's designs for the Great Park in the Gothic or 'castellated' style. The impetus for these designs was provided by the purchase by William Augustus, Duke of Cumberland, of the so called Holbein Gate, demolished in 1759 in an attempt to improve traffic flow in Whitehall. A careful drawing by Thomas Sandby in the Royal Collection (46.1) is inscribed "The Old Gate, Whitehall, with the Additions intended for the Termination of the Avenue, Great Park, Windsor", indicating an unrealised plan to re-erect the arch on Snow Hill, at the southern end of the Long Walk.

It appears that no decision had been reached on the fate of the Holbein Gate by the time of William Augustus's death in 1765. However, a plan by Thomas Sandby (46.2) of the Blacknest area of the Park, drawn between *ca.* 1760 and *ca.* 1770, shows the main road through the Park passing over the "intended Ruin of a Gothic Arch Compos'd from the old Gateway at White Hall" to the south of the Great Bridge (see 44) and just to the north of the Blacknest Gate.

This watercolour is a design for a road bridge that would carry one road above another; a carriage is shown at upper right. The viewpoint is due east towards the 'Clockcase' tower beyond the east end of Virginia Water. The proposal to site the castellated bridge to the north of Blacknest Gate was revived in the 1780s. It was considered by George III in May 1788, but in June (when the King first became ill) it was reported that the King had directed "That the Rustic Arch proposed to be built over the Road to Blackness [sic] Gate should be postponed" (PRO CRES 2/57). The castellated bridge proposal does not appear to have been revived thereafter.

Thomas Sandby's numerous designs for castellaed road bridges may date from any time between *ca.* 1760 and the late 1780s. Examples of such designs are to be found in the Victoria and Albert Museum (Herrmann 51), in the Achenbach Foundation, San Francisco (1964.137) and in the Royal Collection (Oppé 122–24 and 46). That these designs were being worked on at the same time as those for the new pondhead is suggested by the appearance of faint pencil sketches for castellated bridges on the verso of pondhead designs, including 45.

The empty circular spaces on either side of the bridge in 46 were presumably intended to receive two of the fine carved sixteenth-century roundels from the Holbein Gate, eight of which are shown in 46.1. Thomas Sandby's schemes for re-using the Holbein Gate proved as abortive in the 1780s as they had in the early 1760s. Although some parts of the Gate were described in 1807 (Smith, pp. 20–22) and two of the roundels are now appropriately and unobtrusively set into the Great Gatehouse at Hampton Court Palace, the fate of the rest of the fine sixteenth-century Gateway remains a mystery.

46.1 Thomas Sandby, *The Old Gate, Whitehall, with the additions intended*, ca. 1760, watercolour and pen and ink, 19" × 27⅜" (484 × 694 mm), Royal Library (Oppé 167; RL 14701)

46.2 Thomas Sandby, *Plan of the south-western area of Windsor Great Park* (detail), ca. 1760–70 (with north to left), watercolour and pen and ink, Royal Library

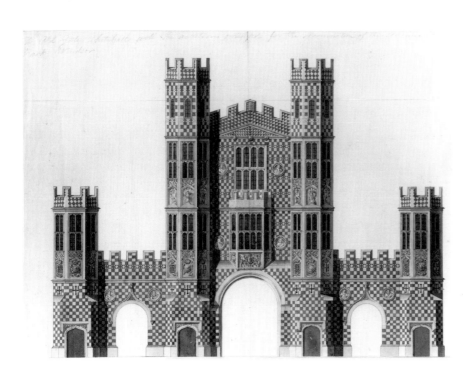

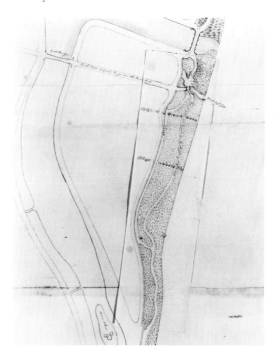

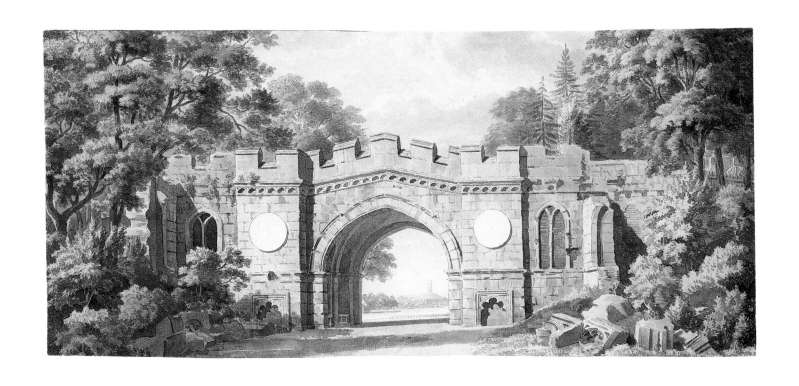

47. THOMAS AND PAUL SANDBY

Ascot Heath races,
ca. 1765

Watercolour with pen and ink over graphite, 19½" × 36" (495 × 914 mm) (two sheets of paper)
WATERMARK Strasburg Lily/LVG, with countermark J VILLEDARY
PROVENANCE Thomas Sandby (sale, Leigh & Sotheby's, 18 July 1799, lot 11); Colnaghi; purchased (5 gns.) by the Prince of Wales (later King George IV), 1 August 1799; by descent
Oppé 147; RL 14675

Ascot Heath is an area of flat open land to the west of the southern end of Windsor Great Park, just over five miles from Windsor Castle. It was formerly part of Windsor Forest. There are records of horse races at Ascot from the reign of Queen Anne. The royal family were among the earliest supporters of the sport of horse-racing and William Augustus, Duke of Cumberland, was active in reviving regular race meetings at Ascot and in improving the course there. Horse-racing at Ascot was also supported by King George III.

Cat. 47 appears to have been conceived as one of a series of records of Cumberland's equestrian interests commissioned from Thomas Sandby towards the end of the Duke's life.

The overall design of 47, with a great tree dominating the right foreground and a meticulously delineated distant landscape, is clearly the work of Thomas, but the figures – which bring the subject to life – are equally clearly the invention of Paul. Bruce Robertson (p. 56) considered that "[Sawrey] Gilpin clearly was employed in producing the final version [*i.e.* 47] from guides drawn by Paul Sandby". Individual studies by Paul may once have existed for the entire *dramatis personae* in this crowded stage set. Of the small number that have survived, three are at Windsor (Oppé 251, 252 and 348), one is in Paul Mellon's collection (47.1), another is at Birmingham City Museum and Art Gallery. The bringing together of this vast body of material, arranging it, scaling it, and lighting it uniformly was an extraordinary technical feat. As Thomas was the executant artist, it is to him that the praise is due – even if Paul (and Gilpin) made such a considerable contribution.

47.1 Paul Sandby, *Edward Mason, ca.* 1760, watercolour over graphite, 8" × 5¼" (203 × 131 mm), Paul Mellon Collection, Upperville, Virginia

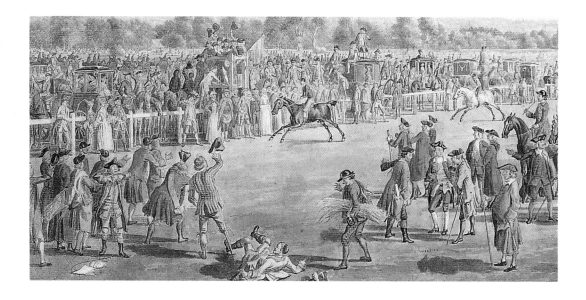

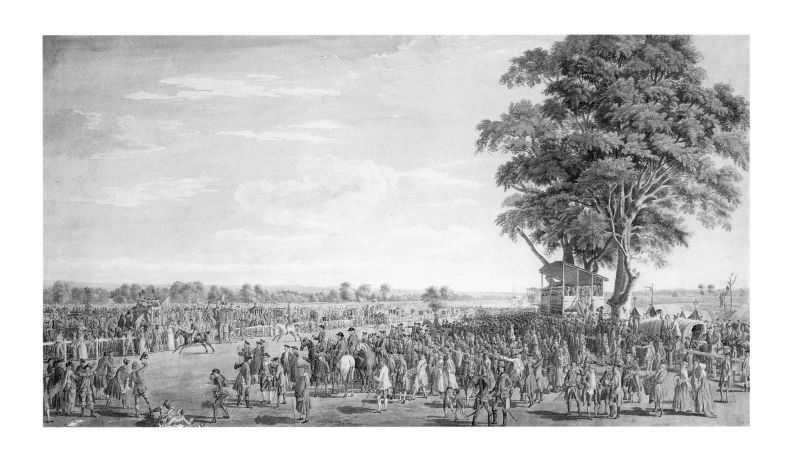

The provenance of the Sandby drawings in the Royal Collection

The watercolours in this exhibition have been selected from the unparallelled series of around five hundred and fifty drawings and watercolours by Thomas and Paul Sandby in the Royal Collection. The majority of these were included in Paul Oppé's seminal catalogue, published in 1947; this contained 418 entries, but some covered more than one drawing.[1] Seventeen supplementary Sandby entries were included by Oppé at the end of his catalogue of the English drawings at Windsor published in 1950. By March 1962 (the date of the last acquisition on a typescript list of additions in the Print Room) the figure of 473 (entries, rather than drawings) had been reached. Around ten additions have been made to the Sandby collection since then. Well over half of the drawings catalogued by Oppé in 1947 and 1950 were connected with the Windsor area. All the works by the Sandbys acquired since that time have been associated with Windsor.

The means by which this great collection has been formed can be traced with the assistance of the registers of acquisitions and transfers within the Royal Collection, and the records of payments in the Royal Archives. However, because inventory numbers have been applied to the watercolours only comparatively recently (since ca. 1920), precise identifications are difficult to make.

In spite of the close connection of both Thomas and Paul Sandby with Windsor, it appears that only two works in this exhibition, the view of the terrace at Cranbourne (42) and Ascot Heath races (47), were royal commissions, painted by Thomas for his patron, William Augustus, Duke of Cumberland. On Cumberland's death in 1765 his collection and library passed to his nephew, King George III. As noted above, Thomas was associated with several other members of the Royal Family and both brothers were founder members of the Royal Academy; however it is not possible to link the commissioning of any work by either of the brothers directly to King George III.

Thomas and Paul Sandby each formed major collections of books and graphic art which were the subject of sales both in their own lifetimes and following their deaths in 1798 and 1809 respectively.[2] These sales also released quantities of drawings and watercolours by both artists on to the London art market. The account of the Prince of Wales (Prince Regent from 1811, King George IV from 1820) with the London firm of Colnaghi includes numerous works "by Sandby" from 31 July 1799 onwards:[3] the main dispersal sale of Thomas Sandby's library and print collection, conducted by Leigh & Sotheby, had commenced on 18 July 1799 and continued over five days, to include a total of 400 lots.[4] Thereafter several of Thomas Sandby's designs for Windsor Great Park,[5] including 45, were purchased by the Prince of Wales. Thus the large view of Ascot Heath races (47), which probably remained unfinished on Cumberland's death in 1765, only entered the Collection in August 1799.

The major dispersal sale of Paul Sandby's collection took place over three days in May 1811. Most of the 342 lots were works by Paul himself, but there were also numerous items described in the sale catalogue as the work of Thomas. These included the view of Cumberland Lodge (37). This watercolour bears the collector's mark of Paul Sandby;[6] the works by Paul Sandby purchased for the Prince Regent at the same sale (1, 9, 10, 17, 20, 34 and 41) have no such mark. All eight are identifiable in Colnaghi's invoice to the Prince Regent relating specifically to purchases made at this sale.[7] None of the above drawings appears to have been framed at the time of the 1811 sale:[8] the original mount of 41 is still inscribed with a note of the sale day and lot number. Three other exhibits (16, 21 and 44) appear – from their mounts – to have passed through this sale although they are not specifically identifiable in the catalogue and their date of purchase is uncertain. The Prince Regent continued to acquire works by the Sandbys from Colnaghi during the months and years following the 1811 sale.[9] It is not clear when 37 and 44, which appear to be the finished drawings painted by Thomas Sandby for Cumberland (prior to their publication in the *Eight Views*), returned to the Sandbys; if they are replicas, the originals have not survived.

The 1811 sale was the first of several (in 1812, 1817, 1824 and 1827) organized by Paul's son, Thomas Paul Sandby. The various lots knocked down to "Seguier" at Christie's three-day sale in April 1817 may have been purchased by William Seguier on behalf of the Prince Regent;[10] however, no work in this catalogue is identifiable with any of Seguier's purchases.[11]

The exhibits so far mentioned are either works by Thomas associated with the Great Park, or views of the Castle by Paul. Their importance, either in the context of Windsor or in the wider context of Paul Sandby's work, pales into insignificance when set alongside the Windsor views offered for sale in 1876. On 23 May Christie's auctioned "Sixty-Seven Drawings by Paul Sandby, R.A.; being views of Windsor Castle, Eton, and the Vicinities, Painted for the late Sir Joseph Banks", which included most of the finest surviving Windsor views. Twelve lots were bid for by Queen Victoria's librarian, Richard Holmes,[12] for a total of £120. 5s. All but one of these (9.1) are included in this exhibition (2, 3, 5, 7, 8, 24, 25, 26, 27, 28 and 33). Ten lots were purchased at the sale by a dealer named Hogarth; five, including 4, 11, 23 and 30, appear to have been acquired subsequently from Hogarth for Queen Victoria.[13] Many of the remaining lots relating to Windsor (as opposed to Eton) have entered the Collection during the last hundred years. Of the five Windsor views purchased by William Seabrook, Inspector of Windsor Castle, three, including 12 and 22, were later acquired either from Seabrook himself or from his descendants.[14] Cat. 35 was acquired in 1920. Two lots were purchased by the Earl of Stair in 1876; both of these were acquired at a sale of the property of his descendant in 1936 (15 and 32). Other Banks watercolours in the Collection include 36, purchased by Queen Mary in 1930, and 14, acquired at auction in 1959.

Fig. 1 Inscription (in graphite) and Banks label (inscribed in pen and ink) from verso of old backing paper of 14.

This exhibition includes 22 watercolours positively identified in the 1876 sale, over one third of the total number (59) of Windsor views listed in the sale catalogue.[15]

Because of the importance of the Banks collection of Sandby views of Windsor, some account of their somewhat complicated early history may be helpful. The drawings were submitted for sale in 1876 by Sir Wyndham Knatchbull, 12th Baronet (1844–1917), in whose family they had been since the death of Lady Banks in 1828. No details are recorded concerning the acquisition of the drawings by Banks, who is known as an explorer and naturalist, and long-time President of the Royal Society, rather than as an art collector. As he had no children, that part of his collection which contained the Sandby watercolours was bequeathed to Sir Edward Knatchbull, 9th Baronet, the son of of Lady Banks's sister, Mary. Banks's series of Windsor views is first mentioned in a publication of 1801,[16] in which the watercolours ("Seventy views of Windsor and Eton") are said to have been painted shortly before Paul Sandby's visit to Wales (in 1773) in the company of Sir Joseph, and to have been purchased "at a very liberal price". The 1773 visit clearly provided an opportunity for close and regular contact between Sandby and Banks.[17] In the following December, Banks was to become godfather to Paul Sandby's infant daughter, Nancy. Banks is not known to have had any particular connection with Windsor before his unofficial appointment in 1787 as "royal shepherd", in charge of the royal flock of Merino sheep. He had

first met the King at Kew in 1771. Coincidentally, it appears that Banks's first encounter with Sandby may also date from around the same time, following Banks's return in 1771 from Cook's world voyage (which he had funded) and while he was searching for artists to record natural history specimens. Some of the pencil inscriptions (which are in more than one hand) on the verso of the backing paper of Banks's Windsor views may have been added by Paul Sandby at the time that the collection was transferred to Banks's ownership; the 'Banks labels' applied to several of the large watercolours were probably added soon after (this page fig. 1). According to William Sandby, who was almost certainly present at the 1876 sale, the Windsor views had "up to that time remained mounted in a large folio volume".[18]

Some time between *ca.* 1790 and 1818 Lady Banks wrote the following note in Princess Elizabeth's pocket book: "Lady Banks will have the greatest pleasure in lending H.R.H. The Princess Elizabeth Sandby's Drawings of Windsor for as long a time as it may be agreeable to Her Royal Highness to keep them".[19] Lady Banks's loan of the drawings (or rather watercolours) appears to have resulted in the production by the Princess of a small number of tracings (*e.g.* 8.2) which are now kept with the autograph Sandby drawings at Greiz (see pp. 23–24).

In addition to the ex-Banks purchases noted above, other Sandby watercolours have been added to the Collection at regular intervals during the last century. Queen Victoria's librarians seldom applied marks of ownership to items in the Print Room collection; however, the backing paper of a number of drawings (including 9 and 12) bear 'VR' drystamps. The gouache of the south-east corner of the Castle (31) was first recorded in the Collection in the biography of the artists by William Sandby (Thomas's great-grandson) published in 1892. The presence of Edward VII's mark on numerous works by the Sandbys provides May 1910 as the *terminus ante quem* for their entry into the Collection. The comet view (18), formerly in the collection of William Esdaile,[20] bears such a mark (see Media, fig. 5). Acquisitions that are datable to King Edward VII's reign include 6, 13

and 29.[21] St John Hope's lavish publication on the history of Windsor Castle, published in 1913, included illustrations in both black and white and colour of a number of Sandby's Windsor views.[22] Purchases made during the reign of King George VI included two items (39 and 40) from the collection of Princesses Helena Victoria and Marie Louise, and one of Thomas Sandby's designs for Virginia Water (46). During the present reign, a view of Windsor from Cranbourne Lodge (43) was purchased from the Earl of Derby's collection, while the fine view of the Round Tower steps (14) is the most recent addition to the ex-Banks collection series. Many items were purchased from the William Sandby sales at Christie's in March and May 1959, but none is included in this exhibition. The fragile condition of the most notable recent Sandby acquisitions (3.1 and 30/31.1), painted in bodycolour sometimes directly on to panel, has necessitated their exclusion from the present exhibition.

NOTES

1. For instance, Oppé 417 covered 62 separate drawings.

2. See under Lugt 2457 and 2112.

3. WRA Geo 27096. Other purchases by the Prince of Wales from Colnaghi's prior to 1811 are recorded in WRA Geo 27097 (including 47), 27171, 27172, 27173 (including 45), 27174, 27266, 27267 and 27293.

4. See Lugt 2457; the 1799 sale raised a total of £549. 2s. The associated mark has not been found on any of Thomas Sandby's drawings in the Royal Collection. It is likely that the plans of Windsor in the Gough collection (Bodleian, Oxford) were purchased at this sale: the collection was formed by the topographer Richard Gough, who died in 1809.

5. These designs were made as part of Thomas Sandby's work for the successive Rangers of the Great Park, William Augustus, Duke of Cumberland, and Henry Frederick, Duke of Cumberland. However, they were evidently retained by the artist.

6. Lugt 2112.

7. The Colnaghi invoice is WRA Geo 27634. Other manuscript lists of purchases are bound up with the Print Room copy of the sale catalogue. Colnaghi bid for some lots himself; others were purchased in the name of Shepperd. Forty-eight lots relating to watercolours in the 1811 sale were knocked down to Colnaghi and Shepperd, in addition to a group of pencil views of the Castle (Oppé 1, 7, 11, 15, 17, 18, 21, 23, 34,

46, 47, 77 and 83) and a volume of figure studies. The initial account was for £263. 14s.; five lots were returned, leading to a final account of £255. 3s. 6d.

8. However, several other lots purchased for the Prince Regent were specified either in the sale catalogue, or in the manuscript summary of acquisitions (in the Print Room) as being framed and/or glazed. These included second day, lot 107 and third day, lots 46, 68, 70, 71, 72 and 77.

9. E.g. WRA Geo 27637: Colnaghi's invoice dated 5 June 1811, for Design for the King's Booth at Ascot, identifiable with lot 5 on the third day of the 1811 sale; now Oppé 148. Colnaghi was regularly employed to arrange the Prince Regent's collection during these same years: see, for instance, Colnaghi's invoice for 5 April 1813 (WRA Geo 27839) for "A weeks Attendance for the arranging of His Royl. Highness's Collection of Drawings & Prints £3".

10. William Seguier (1771–1843), Surveyor of Pictures to George IV, William IV and Queen Victoria and first Keeper of the National Gallery.

11. These included (among "Drawings framed and glazed") an unattributed Portrait of His Royal Highness William Duke of Cumberland inspecting the Mares and Foals in his Royal Highness's racing stud, at Windsor Great Park – animals by Gilpin', and (among "Oil Pictures by P. Sandby") Windsor Castle terrace looking Eastward. The latter may be identified with the oil in the Royal Collection (Millar 1055), although Richard Dorment has recently concluded that this is an early copy, by Benedictus Antonio Vanassen (died ca. 1817), of Sandby's original (Dorment, p.359).

12. Richard Holmes (1835–1911), Librarian 1870–1906. He was also an amateur painter. The Banks watercolours now in the collection of Her Majesty Queen Elizabeth The Queen Mother were all purchased in 1876 by Colonel Hibbert; they passed into Her Majesty's collection from that of the Hon. Sir Richard Molyneux (1873–1954): see below, note 15.

13. Banks sale, lots 2, 3, 5, 7, 14, 29, 32, 44, 47 and 53 were purchased by Hogarth. The first five of these were apparently later in Queen Victoria's collection; lot 32 (now RL 17807) was purchased for the Collection in 1955. Among the records of expenditure for the Royal Library in the Privy Purse Ledger for 1875–79 (WRA) are payments to Christie's on 13 June 1876 for £120. 5s., and to J. Hogarth & Sons on 19 July 1876 for £119. 17s. (although the total value of Hogarth's purchases at the May 1876 sale was only £57. 14s.).

14. Banks sale, lots 8, 9, 11, 20 and 24 were bought by Seabrook. Lot 9 is now RL 14585 (Oppé 61); lots 20 and 24 are respectively 12 and 22.

15. Other ex-Banks Royal Collection drawings by Sandby not included in this exhibition are Oppé 32, 41, 61 and RL 17807. Six lots from the Banks sale (lots 12, 17, 30, 36, 38 and 65) are in the collection of Her Majesty Queen Elizabeth The Queen Mother.

16. Public Characters 1800–01, p.464 (I owe this reference to Bruce Robertson). The start of Paul Sandby's close association with Banks is also recorded in the posthumous biography by the artist's son, Thomas Paul: "this journey [in South Wales, 1773] he [Paul Sandby] ever after remembered with the fondest delight, having experienced from Sir Jos. Banks an attention and kindness, which called forth in him the highest feeling of respect and affection for his liberal patron and worthy friend" (Monthly Magazine, no. 213, 1 June 1811, p.437).

17. The figure of Joseph Banks appears in one of Sandby's Welsh views, The tide rising at Briton Ferry, with autograph inscription by Paul Sandby on the verso concerning Banks and his servant (with umbrella) in Sandby's company (National Gallery of Art, Washington, 1988.19.1; see Great Age, cat.254).

18. Sandby, p. 46. "Sandby" (presumably William) is named as the buyer of lots 21, 33 and 41 in Christie's copy of the sale catalogue. He also appears to have acquired many of the lots that were bought in at the sale.

19. Staatliche Museen Greiz, EB o.Nr. 113/1: I owe this reference to Mr Georg Sauerwein. Princess Elizabeth was a close friend of Sir Joseph's sister Sarah Sophia (1744–1818), and exchanged various gifts with Miss Banks particularly in the years around 1810.

20. William Esdaile (1758–1837), banker and collector. For an exhaustive description of his collection see under Lugt 2617. It was dispersed in a series of sales at Christie's in March 1838 and June 1840 but 18 is not recognisable in the sale catalogues.

21. In addition to the Banks collection watercolours mentioned above, in 1930 King George V added a group of early figure studies by Paul Sandby, acquired from Sir Francis Dyke Acland, to those purchased for the Prince Regent in 1811. These had been acquired by Sir Thomas Dyke Acland in the 1817 Sandby sale (see Oppé, p.2).

22. The colour plates, with some additional views, were also released for sale as the "Windsor Castle Series" (Oppé, Preface).

Media, paper, watermarks and mounts

ALAN DONNITHORNE

MEDIA

In the eighteenth century the predominant style of watercolour painting was that of the 'tinted' drawing.[1] The composition was first outlined in black lead (graphite) pencil, and the lines gone over with pen and ink to 'fix' the details.[2] The inks most commonly used for this were Indian ink, made from soot (carbon) mixed with gum, and sepia, a dark-brown fluid obtained from the cuttlefish. Both Thomas and Paul Sandby worked in this way.[3] All but six of the watercolours exhibited have visible graphite underdrawing and all but nine have ink; thirty-six have both, as in 35 where the foreground figures are sharply defined in grey ink but the trees and buildings are drawn in graphite.

Colour saturation and tonal density were built up by means of transparent washes in shades of grey to produce a monochrome wash drawing. Finally, local colour was applied to complete the tinted drawing. Sometimes a coating of gum was added to dark areas in order to increase the depth of colour, as in 10.

Both artists used a limited range of colours. Hardie lists only ivory black, indigo, burnt sienna and yellow ochre,[4] but study of the drawings themselves shows in addition the use of light red, gamboge, crimson lake, Prussian blue and probably blue verditer (basic copper carbonate).[5]

Paul Sandby also painted in bodycolour, or opaque watercolour, often referred to as gouache. The term gouache should strictly be used to describe bodycolour where pigment is mixed with gum water. Another kind of bodycolour is distemper, where animal glue is used as the binding medium instead of gum. A contemporary account of Paul Sandby's bodycolour technique describes his use of isinglass rather than glue,[6] and also gum mixed with isinglass, thus making a precise definition of Paul Sandby's medium problematic.

The basic ingredients of a bodycolour

paint of a given hue are the relevant colour pigment, an opaque white pigment, and the binder (whether gum, isinglass or other). Inert fillers such as clay were also sometimes used to increase opacity and give more 'body'. William Sandby lists the following pigments used by Paul Sandby in 1802: Indian ink (carbon grey), Prussian blue, verditer, "common powder blue", sap green, Naples yellow, yellow ochre, brown ochre, "treacle brown", bistre, "lake" (presumably crimson lake, though possibly madder), and of course "white" (white lead). In 1805 Paul Sandby was using indigo, gamboge, "patent yellow", and Spanish liquorice.[7] Sometimes a moisturising substance such as honey or glycerine was added to reduce the tendency of the paint to crack or flake on drying. Paul Sandby even used gin as an additive to speed up the drying process.[8]

Only three of the works in this exhibition (31, 34 and 40) are executed entirely in bodycolour, but there are twenty-three examples of its use in combination with watercolour (19, 22 and 39 are notable examples). Of this last group there are several where the use of bodycolour is confined to white highlights (17, 20, etc.). At the period in which Paul Sandby was working, the only suitable opaque white was the pigment white lead (basic lead carbonate), which unfortunately has the property of turning black when exposed to sulphurous fumes.[9] This had occurred to some extent in the cases of 17, 22, 31 and 39, but fortunately conservation treatment enabled the problem to be rectified.

On the whole the pigments of the watercolours are remarkably well preserved. This is both because the colours chosen were relatively stable to light and because they have been subject to only limited exposure. The watercolours in the Banks collection, for example, were described as having been "mounted in a large folio volume" up to the time of the sale of 1876,[10] and would thus have been largely protected from light for their first hundred years.

PAPER

Since watercolour is a transparent medium the quality of the paper support is of vital importance in determining the brilliance and luminosity of the colours. Both

Thomas and Paul Sandby generally used white papers of good quality. Most of these have survived in good condition, with little discoloration: 8, for example, has been described as being in an exceptionally fine state of preservation, and this is as much due to the whiteness of the paper as to the unfaded colours.[11]

It was not until towards the end of the eighteenth century that papermakers began producing papers specifically for drawing and watercolour painting.[12] It follows that most of the Sandbys' watercolours were executed on what were intended as writing or printing papers. Such papers were hand-made from white rags, well beaten and sized with gelatine, giving a paper which was bright, dense, and received ink and watercolour well. However, as with all manufacturing processes, some impurities inevitably got into the papers, as described below.

All the papers in the exhibition are of the 'laid' variety; they have a ribbed appearance resulting from the close-set parallel rows of wires laid across the papermaker's mould on which the sheets were formed. Also visible are the more widely spaced 'chain' lines running at right angles to the laid lines. The side of the paper which rested on the wire mould during formation is called the 'wire side'. The other side, which was pitched, or 'couched', on to a woollen felt immediately after formation is called the 'felt side'.

Generally, the wire side of a sheet of hand-made paper is noticeably more textured: the indentations stand out more in a glancing or raking light (though sometimes the difference in the two sides may be lessened by after-treatments such as pressing or burnishing). An artist had the option of choosing which side of the paper to use, depending on the kind of surface texture desired. In practice, however, he may simply have used whichever side presented itself first. An analysis of the papers in the exhibition shows a slight preference for drawing on the felt side.

A further complication to the study of paper texture in these watercolours is that many of them are pasted to a backing sheet. When a drawing is 'laid down' on to a thick or stiff backing surface its texture becomes enhanced: the thin parts

of the sheet are 'sucked' in towards the backing as the paste dries. Also thrown into relief are any lumps or imperfections in the sheet, such as clumps of fibres ('knots') which have escaped complete separation in the pulp beater.

Other foreign bodies present include particles of iron or copper from mill machinery. These fragments corrode, giving rise to circular spots of brownish discoloration, one of the types of 'foxing'. The other type of foxing spot, caused by biological activity, is normally more diffuse and irregular in outline.

Many of the papers have small splintery specks embedded in them. These are 'shives' – fragments of plant material such as straw or bark – showing that some raw plant fibres, flax for example, have been added to the rag pulp. These are particularly noticeable on the warm-toned papers, chosen perhaps for their suitability for morning or evening views (9, 10, 16 and 21), and also on several of the mount borders (9, 10, 16, 17 and 20).

Sometimes imperfections in the sheet become visible only at the moment of applying the paint. Where the sizing is uneven or missing altogether, ink or watercolour will be found to have sunk into the paper, staining it more intensely at that point. The mount of 30 is a striking example of this effect, with darker spots in the green wash. Such spots are often visible in sky areas (20). When this happened in the sky of 9, 10, 16 and 21, Paul Sandby apparently was not dismayed: with a couple of strokes of the pencil or brush he turned the accidental spots into birds (this page, fig. 1).

Some of the watercolours show evidence

Fig. 1 Detail of 16 (upper left) showing the artist's conversion of two accidental spots into birds

of having been framed in the past. In the case of 9 and 10 there are stains on the back of the mounts from their having been in contact with a wooden framing backboard. Cat.38 had the appearance of having been pasted to canvas and stretched on a wooden strainer for framing 'close' in the manner popular for exhibiting watercolours until the gilt window mounts of the nineteenth century supplanted the method.[13] Cat.37 was framed early this century, but was not framed when purchased in 1811. Cat.42 belongs to a series which was described as hanging in Cumberland Lodge in 1765; they remain framed, but the mid-eighteenth-century frames have not survived.

WATERMARKS

Of the watercolours in this exhibition no less than 34 are on paper with visible watermarks. By far the most common is the Strasburg Lily, a fleur-de-lys in a crowned ornamental shield with a figure 4 symbol and lettering appended below (this page, figs.2, 3). The letters are LVG in eleven cases (3, 7, 11, 12, 20, 25, 35, 37, 39, 44, 47),[14] GR in three (18, 41, 43),[15] and VDL in one (15).[16] The Strasburg Lily is very common in eighteenth-century English and Dutch papers. In some cases the sheet is of sufficient dimensions and appropriate orientation to show a countermark: IV (39)[17] or IHS/I VILLEDARY (17, 22).[18] The IV countermark is found, alone, on 1, 2, 4, 5, 16, 26 and 27. The mark I VILLEDARY is also found (9, 10, 21) as is J VILLEDARY (14), and the latter is also found as countermark to a Strasburg Lily/LVG (44). The countermark I TAYLOR is found with Strasburg Lily/GR on 18 (see this page, figs.4, 5).[19] Both the IV mark and the initials LVG were used to denote papers of exceptional quality – a kind of 'hallmark of excellence'.[20]

Other watermarks occurring are the Posthorn (30), Britannia (45)[21] and J WHATMAN (38, 43 and 46).[22] Similar marks are found on the mount papers, as discussed below. Unfortunately, it is not possible to identify the exact date of any of the papers of the watercolours, as no precise match could be found by comparison with the examples illustrated in Heawood, Churchill or Shorter.

2

3

4

Figs.2, 3 Details (reduced) of verso of mount of 15 in raking light showing (on the left) IHS/I VILLEDARY countermark and (on the right) Strasburg Lily/LVG watermark

Figs.4, 5 Details (reduced) of 18 in raking light showing (on the left), in reverse, Strasburg Lily/GR watermark and (on the right) I TAYLOR countermark. The manuscript monogram in the lower right corner of the wash border is that of the collector William Esdaile

5

Fortunately, thirty-three of the water-colours exhibited have retained their original eighteenth- or early nineteenth-century mounts or painted borders. This has contributed greatly to their generally fine state of preservation by protecting them from excessive handling.

The practice of mounting drawings on a secondary sheet of paper or card dates from at least the early sixteenth century, when drawings were mounted in albums, often with a decorative border drawn round each one. The border could vary from one or two lines to an elaborate cartouche or pseudo-architectural composition, as in the distinctive mounting styles of Giorgio Vasari (1511–1578) and Pierre-Jean Mariette (1694–1774).

The most popular style of mount border in eighteenth-century England derived from that of the artist and connoisseur Jonathan Richardson the Elder (1665–1745).[23] The design consists of a gold band, several ruled ink lines and a band of water-colour wash, the colour of the wash being chosen to complement the overall tone of the drawing.

This kind of mounting for graphic art became so much the norm that artists themselves began mounting their works in a similar fashion.[24] Thomas and Paul Sandby were no exceptions to this. There is evidence that artists sometimes drew or painted on paper prepared by laying down on to a home-made pasteboard, which also functioned as the mount.[25] Close examination of 9, 10 and 20, mounted similarly, reveals local 'overspills' of watercolour around the edges of the drawing (see illus. on p.142), supporting the idea that the artist worked on the drawing sheet when it had already been mounted. Paul Sandby even added aquatint borders to his *XII Views in Aquatinta in South Wales* published in 1775 (this page, figs.6, 7).

The style of the borders and construction of the mounts of the watercolours in this exhibition is closely associated with their provenance. There are four main groups of mount style, three of which are illustrated overleaf in actual-size colour details.

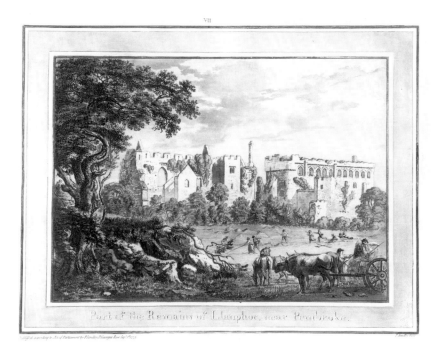

Fig.6 Paul Sandby, *Part of the Remains of Llanphor, near Pembroke*, 1775, aquatint, platemark 9⅜ × 12⅜ (239 × 314 mm) (Plate VII from *XII Views in Aquatinta ... in South Wales*, 1775), Royal Library

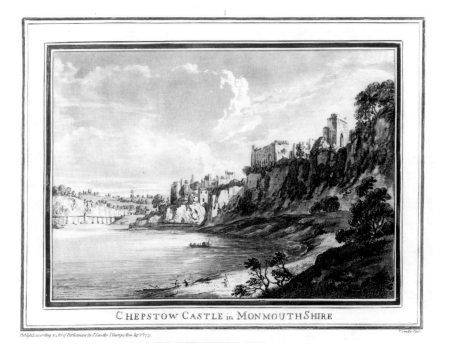

Fig.7 Paul Sandby, *Chepstow Castle in Monmouthshire*, 1775, aquatint, platemark 9⅜ × 12⅜ (238 × 314 mm) (Plate I from *XII Views in Aquatinta ... in South Wales*, 1775), Royal Library

Detail of 10 (Type 1)

TYPE 1: associated with works known to have been acquired at the Paul Sandby sale of 1811 (1, 9, 10, 17, 20), but also found on 16, 21 and 44 (the last with inner element only). Though the mounts of this type are uniform in design and appear to be by the same hand, the colours used for the wide wash band differ. The difference in overall effect is striking when, for example, the warm tone of 17 is compared with the cooler tone of 16. Cats. 9, 0 and 20 have lettering, probably in the artist's hand, placed centrally below the drawing. The form of the lettering is similar to that on many of the printed borders to Sandby's Welsh views (see previous page, fig. 6). Also included stylistically in this group are two mounts (2 and 27) which are clearly later reproductions made at Windsor of this style, but in each case applied (inappropriately) to drawings with a Banks provenance.[26] The construction of the mounts is either two-ply or three-ply, of mixed fibre content. Watermarks found are the Strasburg Lily/GR with IV countermark (16), the Strasburg Arms/GR with the I TAYLOR countermark (20), and A STACE (17).[27]

Detail of 28 (Type 2)

TYPE 2: associated with works acquired at the Banks sale in 1876 (4, 5, 7, 11, 14, 15, 24, 25, 26, 28). The design of the borders is a variation of that shown in the detail from 28 here reproduced. In some examples (11, 26, 28) the first, gold or yellowish band is actually painted on the margin of the watercolour itself. The mount sheets are laid, mostly two-ply, but some are single-ply. Most of the papers are watermarked with the monogram PvL.[28]

TYPE 3: from the Banks sale, but with strips of coloured paper pasted around the drawing as well as various ink lines (8, 33, 35). Comparison of 8 with 33 shows what a difference the choice of border colour can make, the bright blue of 8 complementing the blue sky, whilst the more muted tone of 33 echoes the greyer tone of the foreground. One other watercolour (32) originally had this type of mount, but it has not survived.[29] Of the three that survive, 8 has the Strasburg Lily/LVG watermark with the IHS/I VILLEDARY countermark and the other two have the monogram PvL mark.

TYPE 4: miscellaneous styles, from various provenances. One of these, 18, is of three-ply (wove/laid/laid) paper with a design characteristic of the collection of William Esdaile (1758–1837), bearing his manuscript monogram (fig.5, p.140) and other inscriptions in his hand.

Detail of 35 (Type 3)

NOTES

1. In the catalogue for the Paul Sandby sale of 1811, the entry for lot 94, first day, which Oppé identifies with 20 in the present exhibition, describes it as a "high finished tinted drawing".
2. This technique is described in many drawing manuals of the period: see, for example, Ibbetson.
3. Paul Sandby was known for his improvisation and use of experimental media. William Sandby records his use of bistre (soot from wood burning) recovered from the hollow branch of a tree in Windsor Great Park in which a charcoal burner had been living, and also his experiments with burnt brioche and split peas (Sandby, pp.111–12).
4. Hardie, p.108.
5. It should be emphasized that these identifications have not been substantiated by means of analytical tests. They are inferred from the appearance and certain properties of the pigments, such as their fluorescence under ultraviolet light, the solubility of gamboge in alcohol, a characteristic staining on the verso from copper-containing pigments, etc.
6. William Sandby quotes observations made by Colonel Gravatt over three days in October 1802 and again on 7 December 1805 (Sandby, pp.116–21).
7. Sandby, pp.120–21.
8. Ibidem, p.117.
9. It was not until 1834 that Chinese White (zinc oxide) was commercially available as an artists' pigment in Britain (Church, p.134).
10. Sandby, p.46.
11. Oppé, p.26.

12. Krill, p.79. John Balston cites 1759 as the earliest use of the term "Drawing Paper" (Balston, p.284, note 10).
13. The method of stretching watercolours on canvas is described in drawing manuals of the early 19th century, e.g. J.H. Clarke's treatise of 1807.
14. Signifying Lubertus van Gerrevink, a Dutch papermaker: see Heawood 1808–10.
15. This is the British Royal Cipher of the period: see Heawood 1840 (J. Whatman) and 1856 (J. Taylor).
16. Signifying Van der Ley: see Heawood 1833, 1838.
17. The initials of Jean Villedary, a 17th-century French papermaker working for the Dutch market, whose mark was adopted by many other makers; it is found throughout the period 1668–1812 (Churchill, p.21); see Churchill 406.
18. See Churchill 411, Heawood 1829A.
19. John Taylor (ca. 1750–1802) of Basted Mill, Wrotham, Kent (Balston, I, p.285; Shorter, p.196), although Bower ascribes the mark to James Taylor (1746–1794) of Poll Mill, Maidstone, Kent. It is interesting to note that one of J.M.W. Turner's earliest extant watercolours, dated 1787, is on a laid paper watermarked I TAYLOR (Bower, p.44), apparently identical save in the relative position of the chain lines to that of 18 (dated 1783).
20. Churchill, p.22. Balston calls the LVG mark a "stereotype" (Balston, II, pp.271–72).
21. See Heawood 217. The small Crown/GR mark found on 13 is commonly used as countermark to the Britannia mark (see, for example, Heawood 208, 209, etc and Shorter 109, 164).

22. Cf. Heawood 1848A, 1849, 3457–62, though none of these matches exactly.
23. Richardson probably borrowed ideas from the mounting styles of Italian collectors such as Sebastiano Resta (1635–1714) and Anton Maria Zanetti the Elder (1680–1767). James (chapter 1), and Fusconi both illustrate collectors' mount borders.
24. Watercolour artists such as Alexander Cozens, William Pars, Thomas Rowlandson, John 'Warwick' Smith and Francis Towne all mounted their works with characteristic wash-line border styles. For examples of illustrations of these styles see Stainton (plates 37, 38) and Nugent (passim).
25. A drawing manual of 1820 gives precise instructions for constructing a three-ply mount (Nicholson, p.96).
26. One of these (27), a Whatman paper, was found during conservation to have the remains of a smaller wash-line border underneath the drawing, suggesting that it was re-used during remounting at Windsor earlier this century.
27. Signifying Austen Stace, Cheriton Mill, Kent (active 1781–1801, Shorter, p.200): see Shorter 154, 155.
28. Signifying P. van der Ley: see Heawood 3021.
29. However, the Banks label, which is particularly associated with this mount style, has survived and is now attached to the back of the new mount. Cat.36, which appears to have lost its original mount before entering the Collection in 1930, also retains its Banks label.

Bibliography

The principal discussion of the Windsor views by the Sandby brothers remains that by Oppé, published nearly fifty years ago. Valuable additional material concerning the Sandbys is included in Oppé's *Sandby Memoir* and in the writings of Christian, Colvin, Herrmann, Ramsden and Robertson listed below; William Sandby's biography and Johnson Ball's monumental study contain useful (but occasionally misleading and peripheral) biographical details. For recent discussions of the rôles occupied by the two brothers in the development of the art of watercolour painting and of the teaching of architecture, see Stainton, Nugent, *Great Age*, and Worsley.

The history of Windsor Castle and of the buildings and other features in the Great Park is covered (among others) by St John Hope, Tighe and Davis, Harwood, *King's Works*, Morshead, Hudson, and South.

Ball J. Ball, *Paul and Thomas Sandby, Royal Academicians. An Anglo-Danish Saga of Art, Love and War in Georgian England*, Cheddar (Somerset) 1985

Balston J.N. Balston, *The Elder James Whatman*, 2 vols., West Farleigh (Kent) 1992

Becker W. Becker, *Das Sommerpalais zu Greiz und seine Kunstschätze*, Greiz 1983

Berks RO Berkshire Record Office, Reading

Bower P. Bower, *Turner's Papers*, London 1990

Christian J. Christian, 'Paul Sandby and the Military Survey of Scotland', in *Mapping the Landscape*, edd. N. Alfrey and S. Daniels, Nottingham 1990, pp.18–22

Church A.H. Church, The *Chemistry of Paints and Painting*, 3rd edn., London 1901

Churchill W.A. Churchill, *Watermarks in Paper*, Amsterdam 1935

Clarke J.H. Clarke, *Essay on the Art of Colouring and Painting Landscapes in Water Colours*, London 1807

Colvin H. Colvin, *Biographical Dictionary of British Architects 1600–1840*, London 1978

Defoe D. Defoe, *A Tour through the whole Island of Great Britain*, London 1725

Delany The Autobiography and Correspondence of Mary Granville, Mrs Delany, ed. Lady Llanover, London 1861

Dorment R. Dorment, *British Painting in the Philadelphia Museum of Art*, London 1986

Faigan J. Faigan, *Paul Sandby Drawings*, Sydney 1981

Farington *Diary* The Diary of Joseph Farington, edd. K. Garlick and A. MacIntyre, New Haven and London 1978–

Fusconi G. Fusconi, A. Petrioli Tofani, S. Prosperi Valenti Rodino and G.C. Sciolla, *Drawing – The Great Collectors*, Turin 1992

Great Age The Great Age of British Watercolours 1750–1880, exhibition catalogue by Andrew Wilton and Anne Lyles, London, Royal Academy of Arts, 1993

Hardie M. Hardie, *Watercolour Painting in Britain. I. The Eighteenth Century*, London 1966

Harwood T.E. Harwood, *Windsor Old and New*, London 1929

Heawood E. Heawood, *Watermarks mainly of the 17th and 18th centuries*, Hilversum 1986

Herrmann L. Herrmann, *Paul and Thomas Sandby*, London 1986

Hudson H. Hudson, *Cumberland Lodge*, Chichester 1989

Ibbetson J. Ibbetson, *Process of Tinted Drawing*, London 1794

James C. James, C. Corrigan, M.C. Enshaian and M.R. Greca, *Manuale per la conservazione e il restauro di disegni e stampe antichi*, Florence 1991

King's Works History of the King's Works, ed. H. Colvin et al., 1963–

Knight C. Knight, *Passages of a working life during half a century with a prelude of reminiscences*, London 1864

Krill J. Krill, *English Artists Paper*, London 1987

LB L. Binyon, *Catalogue of Drawings by British Artists ... in the Department of Prints and Drawings in the British Museum*, London 1898–1907 (the numbering refers to the listing of works by Paul Sandby, unless otherwise stated)

Lugt F. Lugt, *Les Marques de Collections de dessins et d'estampes*, Amsterdam 1921; *Suppléments*, The Hague 1956

Millar O. Millar, *The Tudor, Stuart and Early Georgian Pictures in the Collection of Her Majesty The Queen*, London 1963; and *The Later Georgian Pictures in the Collection of Her Majesty The Queen*, London 1969

Morshead Owen Morshead, *George IV and Royal Lodge*, Brighton 1965

Nicholson F. Nicholson, *The Practice of Drawing and Painting Landscape from Nature, in Water Colours ...*, London 1820

Nugent C. Nugent, *From View to Vision, British Watercolours from Sandby to Turner in the Whitworth Art Gallery*, Manchester 1993

Oppé A.P. Oppé, *The Drawings of Paul and Thomas Sandby in the Collection of His Majesty The King at Windsor Castle*, Oxford and London 1947. Continued (as **Oppé Supplement**) in A.P. Oppé, *English Drawings, Stuart and Georgian periods, in the Collection of His Majesty The King*, London 1950

Palmer *Style and rendering in the architectural drawings of Thomas Sandby*, exhibition catalogue by J.W. Palmer, Vassar College Art Gallery, 1990

Parthey G. Parthey, *Wenzel Hollar*, Berlin 1853; expanded in R. Pennington, *A descriptive catalogue of the etched work of Wenceslaus Hollar*, Cambridge 1982

Pococke Travels The Travels through England of Dr Richard Pococke, ed. J.J. Cartwright, Camden Society, 1888

PRO Public Record Office, London

Pyne W.H. Pyne, *The History of the Royal Residences*, London 1817–19

Ramsden E.H. Ramsden, 'The Sandby Brothers in London', *Burlington Magazine*, LXXXVII, 1947, pp.15–18

RL Inventory of the drawings and watercolours in the Royal Library, Windsor Castle

Roberts J. Roberts, 'Henry Emlyn's Restoration of St George's Chapel', *Report of the Society of the Friends of St George's*, V, no.8, 1976–77, pp. 331–38

Robertson *The Art of Paul Sandby*, exhibition catalogue by B. Robertson, New Haven, Yale Center for British Art, 1985

Robertson, *Turner Studies* B. Robertson, 'In at the Birth of British Historical Landscape Painting', *Turner Studies*, IV, no.1, 1984, pp. 44–46

St John Hope W.H. St John Hope, *Windsor Castle*, 2 vols., London 1913

Sandby Memoir P. Oppé, 'The Memoir of Paul Sandby by his son', *Burlington Magazine*, LXXXVIII, 1947, pp. 143–47

Sandby W. Sandby, *Thomas and Paul Sandby – Royal Academicians*, London 1892

Shorter A.H. Shorter, *English Paper Mills and Papermakers in England 1495–1800*, Hilversum 1957

Smith J.T. Smith, *Antiquities of Westminster*, London 1807

South R. South, *Royal Lake: The Story of Virginia Water*, Buckingham 1983

Stainton L. Stainton, *British Landscape Watercolours 1600–1860*, London 1985; revised as *Nature into Art: British Landscape Watercolours*, Cleveland 1991

Tighe and Davis R.R. Tighe and J.E. Davis, *Annals of Windsor, being a history of the Castle and Town*, 2 vols., London 1858

Worsley G. Worsley, *Architectural Drawings of the Regency Period*, London 1991

WRA Royal Archives, Windsor Castle

Concordance

Oppé	Exh. Cat.
2	16
4	17
12	11
13	12
14	13
16	28
19	26
20	27
24	25
25	24
26	1
28	2
29	3
30	7
31	4
33	5
37	8
38	15
42	9
43	10
50	23
51	33
52	32
53	18
54	30
55	31
57	34
58	36
59	35
60	19
69	20
70	21
72	22
82	29
92	41
100	37
111	42
120	44
138	45
147	47
190	38
428	39
429	40
433	46
435	6

Not in Oppé: 14, 43